John Ruskin

Twayne's English Authors Series

Herbert Sussman, Editor
Northeastern University

TEAS 369

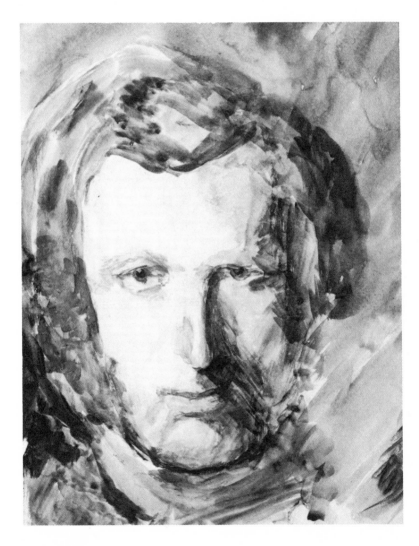

JOHN RUSKIN
(1819–1900)
Watercolor self-portrait (1874)
Photograph courtesy of the
Goodspeed-Ruskin Collection,
Wellesley College Library

John Ruskin

By Frederick Kirchhoff

Indiana University–
Purdue University at Fort Wayne

Twayne Publishers • Boston

John Ruskin

Frederick Kirchhoff

Copyright © 1984 by G. K. Hall & Company
All Rights Reserved
Published by Twayne Publishers
A Division of G. K. Hall & Company
70 Lincoln Street
Boston, Massachusetts 02111

Book Production by Marne B. Sultz
Book Design by Barbara Anderson

Printed on permanent/durable acid-free
paper and bound in the United States of
America.

Library of Congress Cataloging in Publication Data

Kirchhoff, Frederick, 1942–
 John Ruskin.

 (Twayne's English authors series ; TEAS 369)
 Bibliography: p. 149
 Includes index.
 1. Ruskin, John, 1819-1900—
Criticism and interpretation. I. Title. II. Series.
PR5264.K57 1984 828'.809 83-22698
ISBN 0-8057-6855-6

For Karole, Andrew, and Lisa

Contents

About the Author

Frederick Kirchhoff was born in Jacksonville, Florida, in 1942, and received A.B. and Ph.D. degrees from Harvard. Associate professor of English at Indiana University-Purdue University at Fort Wayne, he has published on a wide range of nineteenth-century subjects and is author of the TEAS study of William Morris.

Preface

In keeping with the format and purpose of the series in which it is written, the present study attempts a broad survey of Ruskin's literary achievement with at least some commentary on all of his major works. To do so in short space is necessarily to oversimplify. I take comfort in the recognition that no study of Ruskin, however detailed, can compete with the complexity of its subject, and in the hope that readers of this book will be encouraged to correct its shortcomings by turning to Ruskin's own prose and to the perceptive commentaries it has received in recent years.

I wish to thank Professors Jerome Hamilton Buckley and I. Bernard Cohen of Harvard University, who directed my first efforts to understand Ruskin, and Herbert Sussman, my present editor, for their encouragement and criticism. I am grateful to *Victorian Newsletter* for permission to include material on *The Queen of the Air* that originally appeared in that journal and to the Wellesley College Library for permission to use the 1874 Ruskin self-portrait from the Goodspeed–Ruskin Collection as the frontispiece to this volume.

Frederick Kirchhoff

Indiana University–
Purdue University at Fort Wayne

Chronology

1819 John Ruskin born 8 February at 54 Hunter Street, London.

1823 Family moves to Herne Hill, four miles south of London.

1830 First published poem, "On Skiddaw and Derwent Water."

1832 Receives birthday gift of Samuel Rogers's *Italy* with vignettes by Turner.

1833 First extended continental tour with parents.

1834 First published prose, "On the Causes of the Colour of the Water of the Rhine."

1835 First visits Venice.

1837 Enters Christ Church, Oxford University, as a Gentleman Commoner.

1838 Publishes *The Poetry of Architecture* under the pseudonym "Kata Phusin."

1840 Receives personal income of £200 a year on his twenty-first birthday. Becomes a Fellow of the Geological Society. Meets Turner. University studies interrupted by physical breakdown. Winters in Italy with parents.

1841 Completes Oxford degree.

1843 *Modern Painters*, volume 1.

1845 First continental tour unaccompanied by his parents.

1846 *Modern Painters*, volume 2.

1848 10 April, marries Euphemia ("Effie") Gray.

1849 *The Seven Lamps of Architecture.* Summer in the Alps (with parents and without Effie). Winter in Venice (with Effie).

1850 *Poems* (privately printed) and *The King of the Golden River.*

1851 *The Stones of Venice*, volume 1, "Notes on the Construction of Sheepfolds," "Pre-Raphaelitism." Winter in Italy. Death of Turner.

1853 *The Stones of Venice*, volumes 2–3. First public lectures (published the next year as *Lectures on Art and Painting*).

1854 Annulment of marriage. Teaches classes at Working Men's College. Begins association with Dante Gabriel Rossetti.

1855 Begins annual series of *Academy Notes*.

1856 First acquaintance with Charles Eliot Norton and Edward Burne-Jones. *Modern Painters*, volumes 3–4.

1857 *The Elements of Drawing* and *The Political Economy of Art*.

1858 Meets Rose La Touche. Experiences a crisis in his religious beliefs.

1859 *The Elements of Perspective* and *The Two Paths*.

1860 *Modern Painters*, volume 5, and four essays on political economy in *Cornhill Magazine* (published as *"Unto this Last"* in 1862).

1862 "Essays on Political Economy" in *Fraser's Magazine* (republished as *Munera Pulveris* in 1872).

1864 Death of John James Ruskin. Ruskin becomes a wealthy man.

1865 *Sesame and Lilies*.

1866 *The Crown of Wild Olive* and *The Ethics of the Dust*. Proposes marriage to Rose La Touche.

1867 *Time and Tide, by Weare and Tyne*.

1868 Delivers lecture on "The Mystery of Life and Its Arts" (subsequently included in *Sesame and Lilies*) in Dublin.

1869 *The Queen of the Air*. Appointed Slade Professor of Fine Art at Oxford.

1870 First Slade lectures.

1871 Commences monthly issues of *Fors Clavigera* (continued, with interruptions, until 1884). Purchases Brantwood. Endows Ruskin School of Drawing at Oxford. Death of Margaret Ruskin.

1872 *Aratra Pentelici* and *The Eagle's Nest*. Moves to Brantwood.

1873 *Love's Meinie* and *Ariadne Florentina*.

1874 *Val d'Arno*.

1875 First parts of *Mornings in Florence, Proserpina*, and *Deucalion*. Death of Rose La Touche. Experiments with spiritualism.

1876 Beginning in September, spends nine months in Venice. Receives "messages" from Rose.

1877 First parts of *The Laws of Fésole* and *St. Mark's Rest*. Attacks Whistler's *Nocturne in Black and Gold* in July issue of *Fors*.

1878 Guild of St. George legally established. Suffers severe mental breakdown. Loses libel suit by Whistler.

1879 Resigns Slade Professorship.

1880 "Fiction, Fair and Foul."

1881 Suffers attacks of mental instability into the next year.

1883 Reappointed Slade Professor; delivers lectures published as *The Art of England*.

1884 Public lectures on "The Storm-Cloud of the Nineteenth Century." Slade lectures on *The Pleasures of England*.

1885 Resigns Slade Professorship. First sections of *Praeterita*. Mental condition continues to deteriorate until completely incapacitated at the end of the decade.

1888 Last tour of the Continent.

1889 Final sections of *Praeterita*. Until the end of his life, at Brantwood in the care of Joan and Arthur Severn.

1900 Ruskin dies on 20 January.

Chapter One
Life

Family Background and Early Years

Ruskin's story begins forty years before his birth, when his grandfather, John Thomas Ruskin, left London for Edinburgh, where he established himself as a grocer and married the orphaned daughter of a Presbyterian minister. By 1785, when his second child and only son, John James, was born, he had taken to calling himself "Merchant," but, by Edinburgh's conservative standards, even a merchant was not a gentleman. Whether John Thomas expected his son to achieve the status he himself could not is unclear. He sent him to school and encouraged his interest in literature and art, but he did not allow him to study law at the university—the only sure way for a Scotsman to rise from the middle class. Instead, he dispatched the sixteen-year-old boy to London, where family connections, he hoped, would find him a situation with a mercantile firm. It was not until 1805, however, that John James found a position and not until 1813—after nine years without a holiday—that his perseverance was rewarded. Juan Pedro Domecq, a fellow clerk, asked him to join him as British agent for his family's sherries. John James agreed and, together with Henry Telford, they founded the firm of Ruskin, Telford, and Domecq. Domecq returned to Spain to manage his vineyards; Telford remained largely a silent partner, assuming responsibility for the firm when John James was out of London. Through his own efforts—along with the quality of the sherry—John James steadily built the business and in time became a wealthy man.

In 1809 John James had become engaged to Margaret Cock, daughter of his father's sister Margaret and William Cock, a Croydon tavern keeper. The girl had come north to live with her aunt and uncle about the time of their daughter Jessie's marriage in 1804. Margaret was four years older than John James and her family background was hardly an asset. John Thomas came to oppose the marriage, but it was not his opposition that prolonged the engagement. In 1808 John Thomas's business failed and his son determined—

against the advice of friends—to pay off his father's debts before he married. It took him until 1817 to do so. In the same year, after the sudden death of his wife, John Thomas Ruskin "ended his life by cutting his throat."[1] As soon as his father's affairs had been wound up, John James and Margaret were hastily married.

A man who worked nine years without a vacation and postponed his marriage another nine years was obviously a person of singular, even obsessive, will. And that will determined the program he established for his son's life—a son who would be, without question, a gentleman and who would be encouraged to pursue all the artistic and intellectual attainments denied his father. Yet it is not John James but Margaret Ruskin who emerges as the more strong-willed of Ruskin's parents, largely because she was the more insecure. Raised by her Scottish aunt, she was, in effect, a poor relation adopted by "superior" kin, who looked with longing at her dashing cousin long before he seems to have regarded her as a possible wife. She was, Ruskin himself believed, "the more deeply in love."[2] And the businesslike manner of his courtship suggests that John James was led to marriage by no overwhelming passion. To be acceptable as his wife, Margaret, in Ruskin's words, "showed her affection chiefly in steady endeavour to cultivate her powers of mind, and form her manners, so as to fit herself to be the undespised companion of a man whom she considered much her superior" (35:126). Margaret admired her husband's intellect and taste, just as she looked up unquestioningly to her Scottish relations; and John James, in turn, accepted his wife's stern morality, just as he accepted his mother's, on which it was modeled. Each fulfilling the other's needs, neither secure in the affluent middle-class London world in which they found themselves, husband and wife led a life to themselves, acting out an intensely stable relationship without, as Ruskin later recognized, intense passion.

John, their only child, was born 8 February 1819, at 54 Hunter Street, London. Four years later, the family moved to a house at Herne Hill, a suburb four miles south of the city. This house, with a "notable view from its garret windows" and front and back gardens with fruit trees and flowering shrubs, became "the little domain" of Ruskin's childhood (35:36)—a domain largely shut off from the outside world. Without friends his own age—at least in earliest childhood—Ruskin had only his parents, their servants, and his own imagination for companionship. He was allowed few toys—a bunch of keys, a cart and a ball, and, when he was "five or six years old,

two boxes of well-cut wooden bricks" (35:21); and even his play in the garden was severely restricted. "Steadily whipped if I was troublesome," Ruskin later reported, "I soon attained serene and secure methods of life and motion; and could pass my days contentedly in tracing the squares and comparing the colours of my carpet" (35:22, 21). Ruskin came to attribute his power of accurate observation to this childhood habit. We might also attribute to it the importance he came to place in the *act* of observation. The child enthralled by the pattern of a carpet was soon cataloging and recataloging his collection of minerals and never outgrew his fascination with the process of arrangement. The child whose being was expressed in the gesture of meticulous perception became an adult whose sense of self-esteem lay in his capacity for seeing things exactly as they are.

This concern for accuracy was reinforced and extended by his mother's daily Bible readings. From as soon as the boy was able to read (age four) until he entered Oxford in 1836, Margaret and her son sat together after breakfast and read alternate verses of two or three chapters of the Bible. Her concern was perfect pronunciation, perfect accent; and they repeated the difficult passages until the boy had mastered them: "In this way she began with the first verse of Genesis, and went straight through, to the last verse of the Apocalypse; hard names, numbers, Levitical law, and all; and began again at Genesis the next day" (35:40). Then he was required to memorize and repeat selections from the Bible and the Scottish paraphrases of the Psalms that she considered of particular importance. This regimen accounts for the fabric of biblical references that characterizes Ruskin's mature prose, as well as for the King James resonance of his prose itself. It also accounts for Ruskin's attitude toward the written word—his inclination to pause and scrutinize a passage and to elevate prized texts to the status of scripture.

Margaret Ruskin also supervised her son's early study of the classical languages; however, Ruskin's education was not exclusively in the hands of his parents. There were miscellaneous tutors and, for two years beginning in 1834, there was the Reverend Thomas Dale's private school, where Ruskin studied classics as a day scholar. But these influences were minor and it is fair to say that Ruskin was in large part self-educated, his parents only too happy to promote interests like minerology and drawing that happened to take his fancy. Thus Ruskin's development is characterized by the same mixture of permissiveness and rigor, intellectual freedom and submission to

moral authoritarianism that he came to expect from his own readers
when he had adopted the role of teacher and sage.

The Bible was not the only book Ruskin knew as a child. There
were, of course, "improving" children's books and, in the evenings
after dinner, John James read aloud to his wife and allowed his son
to listen. The list of his selections is significant—"all the Shakespeare
comedies and historical plays again and again,—all Scott and all *Don
Quixote*. . . . Pope, Spenser, Byron . . . Goldsmith, Addison, and
Johnson" (35:61). Despite the Evangelical sternness of the Ruskin
household, where "the horror of Sunday used even to cast its prescient
gloom as far back in the week as Friday" (35:25), there was no bowd-
lerization of its reading. Ruskin recollects when having turned twelve
"I was allowed to taste wine; taken to the theatre; and, on festive
days, even dined with my father and mother at four: and it was then
generally at dessert that my father would read any otherwise sus-
pected delight: the *Noctes Ambrosianæ* regularly when they came out—
without the least missing of the naughty words; and at last, the
shipwreck in *Don Juan*,—of which, finding me rightly appreciative,
my father went on with nearly all the rest" (35:142). Byron's *Don
Juan*, in 1831, was still regarded as a "wicked" book. Smollet's *Hum-
phrey Clinker*, which Ruskin's parents also enjoyed, was to be found,
according to the *Christian Observer* of 1815, "in no decent family."[3]
This reverence for literature—a reverence strong enough to overcome
the puritanism that ordinarily characterized the Ruskins—played a
decisive role in John Ruskin's life: it made him a writer.

Ruskin began writing almost as soon as he began reading. At the
age of seven he produced a forty-page sequel to Maria Edgeworth's
Harry and Lucy, complete with title page and "copper plates." Along
with drawing, writing was one of the few positive means by which
Ruskin could assure himself of his parents' affection. And for this rea-
son, the written word became, as we shall see, Ruskin's chief mode
of relating himself to the world.

Appropriately, then, it was a book that introduced Ruskin to
painting—in particular, to the painter whose work was to be a life-
time passion. In 1832, Henry Telford gave Ruskin as a birthday pres-
ent a copy of Samuel Rogers's deluxe, copiously illustrated edition of
his travel poem *Italy*. It was these illustrations, not Rogers's pedes-
trian verse, that excited the young Ruskin. Rogers's inclusion of
landscapes by J. M. W. Turner led to John James's beginning his
own collection of Turner's work and, a decade later, to his son's de-

fense of Turner in *Modern Painters*. A more immediate result, however, was the family's decision to visit some of the continental sites celebrated in Rogers's poem. The Ruskins had long been accustomed to traveling together—to Perth to visit John James's sister Jessie and her family, to various parts of England in which John James had customers. The 1833 tour, inspired by Rogers's *Italy* and Samuel Prout's *Sketches in Flanders and Germany,* took Ruskin on a three-month circuit through Belgium, southern Germany, Switzerland, Italy, and France.

From early on, travel had been an occasion for writing, both literary and scientific. Ruskin's first publication was a poem "On Skiddaw and Derwent Water" written after a tour of the English Lakes in 1828; two years later he commemorated another visit to the Lakes in a poem more than two thousand lines long called the *Iteriad*. The 1833 excursion generated a sequence of topographical poems and two geological essays, "On the Causes of the Colour of the Water of the Rhine" and "Facts and Considerations on the Strata of Mont Blanc," which appeared the following year in Loudon's *Magazine of Natural History*. For the next continental tour in 1835, Ruskin planned—and partly executed—"a poetic diary in the style of *Don Juan,* artfully combined with that of *Childe Harold*" (35:152) and a prose *Chronicles of St. Bernard*.

In part because his parents had at one time encouraged him to write by paying him a penny for every twenty lines of original composition, Ruskin always thought of these activities as "work." R. H. Wilenski argues that Ruskin never escaped his mother's fundamental belief "that the taking of any kind of pleasure was a sin,"[4] hence that he needed to justify pleasure as a form of work. The opposite interpretation is more useful: Ruskin's early experience identified work with pleasure. And for this reason, in his later social theory, he was unwilling to accept the value or necessity of work from which no pleasure was possible.

John James and Margaret hoped that their son would enter the church and become a bishop—at least. John's own earliest ambition was to be president of the Geological Society. "From Boyhood," John James later wrote, my son "has been an artist, but he has been a geologist from Infancy" (26:xxvi). But neither science nor the church was a possible career without formal education. In 1837 Ruskin entered Christ College, Oxford. The circumstances of his university education were unconventional. Margaret Ruskin followed him to

Oxford, established herself in lodgings, and expected her son to take tea with her every evening—an expectation he did not, to his credit, invariably gratify. John James spent the business week in London, but was able to join his wife and son weekends. Moreover, John James, ever mindful of status, enrolled Ruskin as a Gentleman Commoner—the rank usually reserved for nobility. Ruskin found himself thrust among a set of gaming, drinking, rowdy, and decidedly unacademic youngbloods with whom it is an understatement to say he had little in common. What is remarkable is that Ruskin got along with them as well as he did.

Meanwhile, Ruskin's other interests continued to develop. In January 1837 he attended a meeting of the Geological Society of London, where he met Sir Charles Lyell, foremost British geologist of the day, and William Buckland, Reader of Geology at Oxford and recently president of the British Association for the Advancement of Science. Back at Oxford, Buckland took an interest in Ruskin, who assisted him by preparing drawings for his lectures. It was at dinner with Buckland a few months later that Ruskin and Charles Darwin "got together, and talked all the evening."[5] In the same year, J. C. Loudon began a *Magazine of Architecture* and invited Ruskin to contribute to it. Under the pseudonym "Kata Phusin" ("According to Nature"), Ruskin began a series of articles "On the Poetry of Architecture; or, The Architecture of the Nations of Europe Considered in its Association with Natural Scenery and National Character," which ran through December 1838.

Ruskin's chances for academic distinction were lost, however, by his removal from the university in his final year for reasons of health. His physical breakdown appears to have been related to the marriage of Adèle Domecq, the second daughter of his father's business partner. Ruskin first met Adèle in Paris in 1833; three years later, when the four youngest Domecq girls visited Herne Hill, he fell in love with her. Both fathers appear to have favored the match, but Margaret Ruskin was horrified at the prospect of her thoroughly Protestant son marrying a Roman Catholic. She was saved this fate by Adèle, who refused to take Ruskin seriously as a suitor. Characteristically, he attempted to win her with a literary romance ("Leoni, a Legend of Italy"), but she merely laughed at his efforts.

Adèle nevertheless remained an idealized figure—and the subject of perfervid verse—through the next four years. And two months

after she was married (March 1840), Ruskin was diagnosed consumptive. Ordered to spend the winter in a warm climate, he traveled with his parents in the south of France and Italy. In time, his strength returned, and in April 1842 he completed his degree. This was the point, had he been so inclined, at which Ruskin might have entered the church. However, by 1842, art, not religion, had become the central concern of Ruskin's life.

Marriage and *Modern Painters*

In the spring of 1840, Ruskin had been introduced to Turner, whom he found "a somewhat eccentric, keen-mannered, matter-of-fact, English-minded—gentleman" (35:305). The painter had listened politely to his young admirer, but said nothing to encourage his enthusiasm. So it was not this meeting that provided the impetus for *Modern Painters*. Rather, Ruskin's decision to write a book about Turner—and, in the course of it, modern landscape painting in general—seems simply to have been the most practical answer to the question "What should I be, or do?" (35:312). The hostile reviews of Turner's 1842 Royal Academy pictures nudged him into action. After a summer on the Continent with his mother and father, he settled down, first into his old room at Herne Hill, then into his study at the family's new, grander suburban home at Denmark Hill and, in the space of eight months, completed the first volume of *Modern Painters*.

The book appeared in May 1843 in an edition of five hundred underwritten by John James. Ruskin did not use his own name, but the description "A Graduate of Oxford." By the end of the year, only one-hundred-and-fifty copies had been sold. And, although a second edition was published within twelve months, Ruskin remained unknown as a writer.

He had traveled on the Continent with his parents in the summers of 1840, 1841, and 1842. In 1844 he again traveled with them— this time with the aim of gathering materials on the Alps for his examination of "Truth" in the next volume of *Modern Painters*. At Chamounix he met Joseph Couttet, who was to be his guide in the Alps for the next three decades; and at Simplon he met the geologist J. D. Forbes, whose work Ruskin was later to champion. More important, however, in passing through Paris on the return home, Ruskin discovered the Titian, Bellini, and Perugino paintings at the

Louvre. His defense of Turner had necessarily to be rethought in light of his broader experience of art. Moreover, he realized that his work demanded that he visit the great cities of Renaissance Italy. Consequently, the next year, for the first time in his life, Ruskin traveled outside England without his parents. He spent seven months abroad, part of it among the Alps where, against Turner's advice, he attempted to compare the painter's "St. Gothard" with its actual setting; part of it in lowland Italy—at Venice with the painter J. D. Harding, from whom he had studied drawing a few years earlier. For the first time in his life he broke the Sabbath by climbing a hill after church. And, also for the first time in his life, he encountered the work of Tintoretto, whose paintings in the Scuola di San Rocco in Venice he cataloged and copied.

Back at Denmark Hill in 1845, Ruskin wrote volume 2 of *Modern Painters*. Then, the next summer, he returned to Italy with his father, whom he attempted to convert to his new enthusiasm for Italian art. By now *Modern Painters*, volume 1, had gone into a third edition and Ruskin had grounds for self-confidence. Yet his father, despite his general sensitivity to the arts, did not respond to the Italians as his son had hoped. This was the point in Ruskin's life—belated, perhaps—at which he might have separated himself spiritually and even physically from his parents and, whatever their objections, established his independence.

Marriage was a logical way to accomplish this separation, and in the next year Ruskin found himself emotionally involved with Euphemia Gray, the daughter of old family friends living in Perth. Effie was nine years younger than Ruskin. They had first met when she visited Herne Hill in 1841, at which time Ruskin, to cheer her after the death of a younger sister, had written the fairy tale *The King of the Golden River*. And Effie herself later believed the circumstances of this first encounter determined the nature of Ruskin's attachment to her. She was a young girl in a state of emotional depression, and he subsequently thought of her less as a sexual object than as a being with whom he could establish a relationship akin to that between himself and his own parents.

Effie stayed at Denmark Hill on her way to school in December 1843, but it was not until a later visit in 1846 that Ruskin seems to have felt any strong feelings for her.[6] He saw her again the following April, when she again visited Denmark Hill. His parents were now aware of their attachment and objected to it on several grounds.

Among others, Mr. Gray had lost a considerable sum of money from speculation in railway shares, and John James suspected he was trying to marry off his daughter as part of a general program of financial retrenchment. But the attempt to separate the lovers backfired. When Effie returned to Perth in June, Ruskin had a physical collapse reminiscent of that following Adèle's marriage. Fears for their son overcame his parents' objections to Effie, and on 10 April 1848 John Ruskin and Euphemia Gray were married.

The ceremony took place in the Grays' drawing room, and Mr. and Mrs. Ruskin were not present. But the absence of his parents was not the only problem for Ruskin. During the months since his engagement, he had seen Effie for the first time among her family and friends, and he did not know what to make of her flirtatious nature. "The fact is that you like everybody—and anybody—and that's many bodies too many," he wrote in January.[7] The 1848 Revolution in Paris had put an end to the couple's plans for a honeymoon on the Continent—and thus a long period to themselves before returning to live in London under the surveillance of Ruskin's parents; and it had also meant a further decline in Mr. Gray's railway shares. Effie was worried about her family and her depression had physical side effects. Ruskin himself had a bad cold the day of the wedding. Immediately after the ceremony he and Effie drove to Blair Atholl to begin a short honeymoon in Scotland and the British Lakes. They arrived late and exhausted and did not, this first night as husband and wife, consummate their marriage. Nor, as it turned out, did they ever.

Writing to Effie from France, a little more than a year later, Ruskin looks forward to his "*next* bridal night: and to the time when I shall again draw your dress from your snowy shoulders: and lean my cheek upon them, as if you were still my betrothed only." He refers to her "trial at Blair Athol," and assures her "it will be much nicer next time, we shall neither of us be frightened."[8] Whatever happened the night of his wedding, Ruskin did not in 1849 regard it as an insurmountable obstacle to sexual relations with his wife. If he came to regard it as such in later years, it was because circumstances—notably, his inability to separate himself from his parents and the conflict between his wife and his parents that resulted—had further estranged him from Effie.

Friction began almost immediately. When the newlyweds traveled with John James and Margaret to Salisbury—the first stage in an abortive tour of the English cathedrals—Ruskin fell ill and his

mother insisted on nursing him with an extravagance that both amused and annoyed Effie. Beginning the first week in August, Ruskin and Effie spent eleven weeks in Normandy, where Ruskin gathered materials for *The Seven Lamps of Architecture*. In mourning for a favorite aunt, Effie showed little sympathy for Ruskin's work, and he in turn showed little patience for her feelings. What might have been a belated honeymoon merely further alienated husband and wife. Back in London, they set up housekeeping in a fashionable London neighborhood. Ruskin, however, returned to his parents' home as often as he could, and Effie's distrust of them grew steadily. Then, at the beginning of February 1849, Effie unexpectedly returned to Perth with her mother, who had been visiting her in London. Ruskin promptly returned to Denmark Hill, where he worked on *The Seven Lamps of Architecture* until April; then he and his parents set off— without Effie—for a summer in the Alps. Thus, he did not see his wife for nine months.

When he returned to England in September, Ruskin went immediately to Perth for Effie, who suggested that, instead of returning to London, they spend the winter in Venice. Ruskin eagerly agreed and in a few weeks they were on the way. The choice was fortunate. Not only would they be clear of John James and Margaret, but they would also be in a city Ruskin associated with his independent self.

This winter in Venice was the happiest time of their marriage. John taught Effie chess; they teased crabs at the Lido, and played hide-and-go-seek among the windings of the city. But most of the time John, who had begun work on a study of the relationship between Venetian architecture and Venetian history, was left to his favorite pastimes—reading, sketching, and writing—while Effie was allowed to indulge her curiosity about the city and its society, usually in the company of her friend Charlotte Ker. "We can do anything we like," she wrote her mother, and John "does not care how much people are with us or what attention they pay us. I understand him perfectly and he is so kind & good when he is in the house that his gentle manners are quite refreshing after the indolent Italian and the calculating German, but we ladies like to see & know every thing and I find I am much happier following my own plans & pursuits and never troubling John, or he me."[9]

Two months after their return to London in April, Effie was presented at court and commenced a period of social activity that climaxed in the series of "At Homes" she held in February and March.

Ruskin meanwhile was turning his Venetian researches into *The Stones of Venice*. Pleased by Effie's social success, he was nevertheless annoyed by the distraction from his work it caused him. Effie herself, despite her London pleasures, preferred the freedom of Venice and persuaded John to return there at the end of the summer.

Their second winter in Italy was both more eventful and more trying than the first. Admitted to Venetian high society and feted by the Austrian military officers—two of whom, reportedly, fought a duel over her—Effie's life style was increasingly at odds with John's. He made efforts to join her amusements. On one occasion he even appeared in mask for the Carnival festivities—behavior he did not mention in his letters home. Yet he could not escape the fact that, as he wrote his father in December, "It may literally be as impossible for Effie to *live solitary* without injury as for me to *go into company* without injury."[10] Their departure from Venice was held up by the robbery of Effie's jewels, an event which almost led Ruskin into a duel and soured their concluding days in Italy. When they returned to England, their marriage steadily disintegrated.

Instead of the expensive house in London, the Ruskins installed Effie and John next door to their old home at Herne Hill—a choice in which Effie had no say and which did not please her. She was sure that the Ruskins—parents and son—did not "care any of them what becomes of me or what I do so that they are left to enjoy themselves selfishly alone."[11]

Two months after the publication of *The Stones of Venice* in 1851, Ruskin had responded to yet another attack on contemporary art. This time it was the work of the Pre-Raphaelite Brotherhood—in particular, the paintings of John Everett Millais and William Holman Hunt—he felt called upon to defend, first in two letters to the *Times,* then in a pamphlet "Pre-Raphaelitism," in which he linked the younger painters with Turner. Ruskin was by now a voice of at least modest authority, and so the Pre-Raphaelites gladly accepted his patronage. In March 1853, the twenty-four-year-old Millais began his painting *The Order of Release,* for which Effie sat as a model. Ruskin, who was inevitably gratified rather than jealous when another man showed attentions to his wife, encouraged her relationship with the painter. Effie, on the other hand, suggested that his parents were doing their best to get her into a situation that would "lower herself in John's eyes and in the eyes of the world even if she did not give them evidence for divorce."[12] Both sides seem to have begun suspect-

ing the worst of the other. And it is clear that by this time in the marriage John James and Margaret would have been glad to get rid of their daughter-in-law. (Ironically, the fact of Effie's childlessness may have contributed to their disfavor.) However, her blame of them may have simply been a projection of her growing interest in Millais—interest that became overt during the four months, later in 1853, in which she, her husband, Millais and, for part of the time, Millais's brother William stayed together at Glenfinlas in central Scotland. While Ruskin worked at the eighty-page index for *The Stones of Venice* and the lectures on art he planned to give at Edinburgh in November, Millais painted—both Ruskin and Effie—while Effie posed and—one assumes—fell in love with Millais. The situation must have been extraordinarily awkward, especially for Millais, but Ruskin seems not to have noticed.

The four Edinburgh lectures, of which his parents disapproved, objecting to the indignity of their public delivery, were a great success. Over a thousand persons attended. Perhaps this success encouraged Ruskin to confess more frankly his problem with Effie. "When we married," he wrote his parents, "I expected to change *her*—She expected to change *me*. Neither have succeeded, and both are displeased."[13] His own solution, however, was not divorce but separation. "Perhaps for *my health,* it might be better that I should declare at once I wanted to be a Protestant monk: separate from my wife and live in that hermitage above Sion which I have always rather envied."[14] And he seems to have meant it, for years later Effie recollected his having offered her "£800 a year to allow him to retire into a Monastery and retain his name."[15]

When they returned to London, it was clear that something had to happen. Pushed to the breaking point, Effie finally wrote her father, explaining the situation in its entirety. With the advice of an attorney, her parents arranged for her to leave Ruskin, and, on 25 April 1854, she secretly removed herself from Herne Hill and joined her family in Perth. A month later, she returned to London to be examined by the court, and, on 15 July, a Decree of Nullity was granted her on the grounds that "the said marriage . . . between the said John Ruskin and the said Euphemia Chalmers Gray falsely called Ruskin was had and celebrated whilst the said John Ruskin was incapable of consummating the same by reason of incurable impotency."[16]

Ruskin, as he was later to regret, did not oppose the charges. He was too happy to end the marriage to interpose any obstacle to its

dissolution. Moreover he was no longer in the country: he had left with his parents to spend the summer in the Alps, where, for the first time in many years, he thoroughly enjoyed his experience of the mountains. In October he returned to Denmark Hill and began work on volumes 3 and 4 of *Modern Painters*. Effie married Millais the next year.

Middle Years

Ruskin's four lectures in Edinburgh and the dubious celebrity of his break with Effie began a new period in his life—a period in which he was to become increasingly a public man, and in which his interests and energy were to spread over an increasingly broad area. Men whom he had known before, like Thomas Carlyle, became regular acquaintances. The poets Elizabeth Barrett and Robert Browning also became friends. And it was at this period that Ruskin first met the American scholar Charles Eliot Norton, who became a lifelong correspondent, and Octavia Hill, whose slum renewal projects he was later to underwrite. The Pre-Raphaelite artist Dante Gabriel Rossetti now became a close associate. By agreeing to buy his original work on a regular basis, Ruskin in effect subsidized the painter. Although they never became intimate friends, it was through Rossetti that Ruskin developed important relationships with the younger artist Edward Burne-Jones, whose work he was to champion, and with Burne-Jones's friend William Morris, who later, both as a designer and as a social activist, carried many of Ruskin's ideas into practice. Although far from the zenith of his reputation, Ruskin now moved freely in the circle of artists and writers whose work has come to represent the achievement of the Victorian Age.

Another sign of Ruskin's attempt to discover a new role was his decision to teach a course in drawing at Frederick D. Maurice's Working Men's College. Ruskin's aim was not to turn his pupils into professional artists, but to foster the artistic ability he believed innate in every human being. He had written about this ability in *The Stones of Venice*, and its chapter "On the Nature of Gothic" was reprinted as the manifesto of the college. Nor was this the only practical aspect of Ruskin's concern with British art. Beginning in 1855, the year in which he set to work on the third and fourth volumes of *Modern Painters*, Ruskin also published the first of a series of annual "Notes on the Royal Academy and other Exhibitions." Many professional artists still regarded him with contempt—including Sir George East-

lake, president of the Academy, whose wife had become a close friend
of Effie—but for the general public Ruskin was beginning to speak
with an influential voice.

Turner had died in 1851, when Ruskin was in Venice. His will
left a vast body of his work to the English nation and named Ruskin
one of the executors. It also assigned substantial property for the es-
tablishment of "a Charitable Institution for the Maintenance of Poor
and Decayed Male Artists." His next-of-kin contested the latter be-
quest, and Ruskin, to avoid the prospective litigation, resigned his
executorship. In 1856, however, when the will was finally settled and
Turner's "pictures, drawings, and sketches . . . deemed as well given
for the benefit of the public,"[17] Ruskin's concern for the exhibition
and general handling of these materials, along with his sense that in
naming him executor Turner had expected him to take responsibility
for them, led him to write, first to the *Times,* then to Lord Palmer-
ston, the new prime minister, offering his services. Palmerston
recommended Ruskin to the trustees of the National Gallery and
eventually—and reluctantly—Ruskin was allowed to catalog all and,
at his personal expense, mount some of the 19,000 sketches. Ruskin
worked for nearly a year in the basement of the gallery, "every day,
all day long, and often into the night" (7:5) on this project.

Volumes 3 and 4 of *Modern Painters* were published in 1856. In the
same year Ruskin published the first of two books that derived from
his teaching at the Working Men's College—*The Elements of Drawing,*
followed by *The Elements of Perspective* in 1859. He was, at the same
time, becoming a popular lecturer—and turning from painting and
architecture to socioeconomic questions. It took his father's warning
that he might not live to see the completion of *Modern Painters* to
push Ruskin into finishing the fifth volume, which he published in
1860.

The socioeconomic questions that interfered with the completion
of *Modern Painters* were more than an extension of Ruskin's earlier in-
terests. They represented a turning point in his career, at which he
redefined both the purpose of his work and his relationship with the
English public. Ruskin had delivered two lectures in Manchester on
"The Political Economy of Art" in 1857. These were followed by a
series of related lectures in other cities on the relationship between
art and manufacture, the more important of which he published in
The Two Paths (1859). It was not until 1860, however, that Ruskin's
radical attack on Victorian economic theory assumed definite form.

At the request of the editor of *Cornhill*, the novelist William Make-peace Thackeray, he published a series of essays on political economy in the August, September, October, and November issues of the journal. His views on this subject were greeted almost immediately with ridicule and anger from all sides, and *Cornhill* was pressured into canceling the series. Among his close friends, only Carlyle, whose ideas are the major influence behind the essays, seems to have fully supported Ruskin. Not only did the essays sell poorly when they were assembled into the small book *"Unto this Last"* in 1862; the controversy they generated may even have lessened sales of his other writings.

Ruskin was no stranger to adverse criticism, but the abuse heaped on him from *"Unto this Last"* contributed to the general depression that characterized his life in the early 1860s. However, the tension between Ruskin and his parents was perhaps a stronger cause. His mother, who was to live until 1871, grew increasingly set in her ways; his father, who was seventy-five in 1860, and who still reviewed his son's writing before its publication, was distressed by Ruskin's ventures into political economy. In many respects, little had changed in Ruskin's relationship with his parents since his childhood. Yet he had changed. The Evangelical Christianity of his early years had given way to religious skepticism. He was now in open disagreement with his parents over both his religious beliefs and his political theories, and the atmosphere at Denmark Hill was clouded with conflict and reproach.

It was clear to Ruskin that he needed a home of his own. "Living with two old people, however good," he wrote Rawdon Brown, "is not good for a man."[18] But it was also clear that as long as his parents were living he could not make a home for himself in England. Ruskin began spending considerable time at Margaret Bell's Winnington Hall girls school in Cheshire, where he gave an occasional lecture, played games with the students, and generally functioned as a celebrity in residence. He also began spending more time—on his own—outside England. After a tour of northern Italy with Burne-Jones and his wife Georgiana in 1862, Ruskin lingered in the Alps, eventually leasing a cottage at Mornex in Haute Savoie. Determined to live in Switzerland, Ruskin nearly bought the hilltop land on which to build a house, but was in the end dissuaded from the project.

He returned to England in the summer of 1863, but the difficulties with his parents remained unresolved. As always, Ruskin was

able to be most honest when he put his thoughts into writing: "The two terrific mistakes which Mama and you involuntarily fell into," he wrote his parents,

were the exact reverse in *both* ways—you fed me effeminately and luxuriously to that extent that I actually now could not travel in rough countries without taking a cook with me!—but you thwarted me in all the earnest fire and passion of life. About Turner you indeed never knew how much you thwarted me—for I thought it was my duty to be thwarted—it was the religion that led me all wrong there; if I had had courage and knowledge enough to insist on having my own way resolutely, you would now have had me in happy health, loving you twice as much (for, depend upon it, love taking much its own way, a fair share, is in generous people all the brighter for it), and full of energy for the future—and of power of self-denial: now, my power of *duty* has been exhausted in vain, and I am forced for life's sake to indulge myself in all sorts of selfish ways, just when a man ought to be knit for the duties of middle life by the good success of his youthful life. (36:461)

Three months after this letter, John James died (3 March 1864), and Ruskin found himself a wealthy man. Ever since he had had an income, he had been generous in his gifts to others, extravagant toward himself only in a few areas—buying minerals and works of art. Now his generosity was to become bounty. Ironically, the father who treated his forty-year-old son like a spendthrift adolescent, left him a fortune to spend as he wished. His mother, now companioned by his seventeen-year-old cousin Joan Agnew, continued to have things her own way at Denmark Hill, but, with the death of his father, Ruskin experienced an intellectual freedom he had not known before. John James had never reconciled himself to John's appearances as a public lecturer and had heavily censored his letters to the press. Now lecturing became one of Ruskin's main activities, and his letters to the press became increasingly outspoken. Some form of public utterance lay at the origin of most of the books he published in the late 1860s: *Sesame and Lilies* (1865)—in its original version two lectures (later three) on education that became de rigeur reading for young girls and thus established Ruskin as a household name; *The Ethics of the Dust* (1866), a group of imaginary dialogues on crystallography (and other subjects) with the girls at Winnington Hall; *The Crown of Wild Olive* (1866), three lectures related to the theme of *Sesame and Lilies; Time and Tide* (1867), a series of letters on economics addressed

to the Sunderland cork cutter Thomas Dixon and originally published in newspapers; *The Queen of the Air* (1869), a collection of lectures on "Greek Myths of Cloud and Storm" that in many ways sum up the thought of the first fifty years of his life.

Meanwhile, a love affair was pushing Ruskin to the edge of emotional collapse.[19] In 1858, he had responded to the request of Maria Price La Touche, wife of a wealthy Anglo-Irish banker and landowner, and met her children, including Rose, the younger daughter, then nine-and-a-half years old, whom she hoped he would instruct in drawing. The La Touches came to Denmark Hill to visit Mrs. Ruskin and see the Turners, and in the next few years Ruskin carried on a playful correspondence with Rose. They addressed each other in nicknames and gradually developed a profound mutual dependence. Late in August 1861, Ruskin visited the La Touche estate at Harristown. A month after his visit, Rose, always high-strung and given to religious fervor, experienced an attack of nervous illness.

The details of their relationship are long and painful. Mrs. La Touche probably thought Ruskin in love with herself and only gradually came to realize—to her embarrassment—that it was her daughter who actually preoccupied his imagination. And, indeed, it was imagination that led both Ruskin and Rose into deeper attachment. Each came in time to represent a complex of meanings to the other. For Rose, Ruskin was the apostate whose reconversion would prove her own faith. For Ruskin, Rose was a rose—an emblem from Christian typology and an embodiment of the purely natural beauty he had celebrated in his studies of art; and she was also Kore—the archetypal divine maiden Ruskin identified with Cordelia, Proserpina, and, ultimately, Carpaccio's St. Ursula; and, at least to his unconscious mind, she represented the nonsexual womanhood he had been drawn to in prepubescent Effie and, more recently, the girls at Winnington School. He in turn identified himself with Ravenswood, the tragic hero of Scott's *Bride of Lammermoor,* in love with a woman forbidden him by her headstrong, domineering mother, doomed to lose both his mistress and his own life.

In the winter of 1865–66, Rose came to London and visited Denmark Hill. Ruskin, who had not seen her for three years, proposed marriage and she asked him to wait three years for an answer. (In three years she would be twenty-one, he fifty.) Her parents, aside from Mrs. La Touche's feelings about Ruskin and their general distress over his religious sentiments, were understandably nonplussed

by his courtship of their daughter. Ruskin's chief ally in these trans-
actions was a woman who came to play a significant role in his life—
Mrs. William Cowper (who became Mrs. Cowper-Temple in 1869,
then Lady Mount-Temple in 1880). Mrs. Cowper visited Harristown
and corresponded on Ruskin's behalf with Rose's parents. Yet noth-
ing was settled. Any time Ruskin was able to convince himself to
give up all hope, Rose was sure to give him a sign to the contrary.

At the beginning of 1867, Rose started writing Ruskin again, but
when she visited London in March she was forbidden to see him.
When Ruskin delivered his lecture "The Mystery of Life and Its Arts"
in Dublin, in March 1868, Rose sent him a symbolic gift of flowers,
but could do no more. In desperation, Mrs. La Touche wrote Effie
Millais, who responded with the argument that if Ruskin married
Rose and fathered a child, her own divorce would be invalid, as
would Ruskin's second marriage. Pushed to the wall, Ruskin spoke
frankly both to Mrs. Cowper and to a new friend, the novelist George
MacDonald, laying out the exact circumstances of his marriage to Ef-
fie and denying the charge of impotence.

The tension for both parties was becoming unendurable. In Octo-
ber 1868, the wallpaper at Abbeville appeared to Ruskin to be "all
turning into faces."[20] About the same time, Rose was suffering at-
tacks of violent, undiagnosed pain and was forbidden all letters. It
was not until 1870 that Ruskin again saw her. They met by chance
at the Royal Academy, and the next month she wrote him: "I will
trust you. I do love you. I have loved you, though the shadows that
have come between us could not but make me fear you and turn from
you. . . . I believe God meant us to love each other, yet life—and it
seems God's will has divided us.[21] Threatened by this rapproache-
ment, Mrs. La Touche again wrote Effie, whose response summarizes
her as yet hostile judgment of her first husband:

His conduct to me was impure in the highest degree, discreditable and so
dishonourable that I submitted to it for years not knowing what else to do,
although I would have often been thankful to have run away and envied the
people sweeping the crossings. His mind is most inhuman; all that sympa-
thy which he expects and gets from the female mind it is impossible for him
to return excepting upon artistic subjects which have nothing to do with
domestic Life. . . . From his peculiar nature he is utterly incapable of mak-
ing a woman happy. He is quite unnatural and in that one thing all the rest
is embraced.[22]

Effie's conception of sexual abstinence as a form of "impurity" may surprise a modern reader. The letter, however, had its desired effect. Ruskin had only one sure means of communication with Rose left—his published writings. He wrote and he waited. But he also took the practical step of seeking a legal opinion on Effie's charge that a second marriage would invalidate his annulment. The answer was that it would not.

In the next two years, Rose alternately encouraged and rejected Ruskin. Recognizing her precarious health, her parents now allowed her to write him and to receive his letters, and in the fall of 1874 Ruskin visited Rose repeatedly in London. But by now her physical state was past recovery. She returned to Harristown in December and a month later he wrote that "the woman I hoped would have been my wife is dying" (28:246). Rose returned to London for medical treatment, and in February he saw her for the last time. On 25 May 1875, Rose La Touche died.

The Professor, the Sage

As early as 1855, Henry Acland, his old college friend who was soon to become Regius Professor of Medicine at Oxford, had attempted to draw Ruskin into the academic community by interesting him in the construction of the Oxford Museum. Largely through Ruskin's influence, an Italian Gothic design was chosen, the completion of which Ruskin himself came down from London to supervise. Fourteen years later, in 1869, with the urging and support of Acland and Henry George Liddell, another old friend, now dean of Christ Church, Ruskin was elected to the newly endowed Slade Professorship of Fine Art at Oxford. From now on, Ruskin was no longer an amateur. His university position, even after he had resigned the Slade Professorship, confirmed him as a public authority on art. And it also gave him—for awhile—a congenial environment in which to work.

Ruskin gave the first of his Oxford lectures in February 1870, and from the start they were successful. The first lecture had been moved from its initial location into a larger hall, and even here it was necessary to turn away some of the crowd. Later, he began giving his lectures twice, in order to accommodate all who wanted to hear him speak. His classes at the Working Men's College had been popular, as had his public lectures. And now, speaking before an audience of university students and members of the British intelligentsia, his el-

oquence was all the more carefully prepared, all the more memorable. But it was not merely his manner of speaking that drew crowds. His social ideas, now inseparable from his views on fine art, exercised a powerful influence on the undergraduates who came to hear him speak. Concerned with fostering art at the university, Ruskin donated or loaned important pieces of his private collection to Oxford and, in a gesture of grand beneficence, endowed a drawing school, which now bears his name. Some of the other uses to which Ruskin put his inherited wealth may appear more quixotic. In 1872 he hired three street sweepers to show "a bit of our London Streets kept as clean as the deck of a ship" (18:309). And two years later he set up two superannuated family servants in "Mr. Ruskin's Tea Shop," to sell coffee, tea, and sugar at the same rate for small quantities as for large, thus giving a fair price to the poorest customers. The sweeping project lapsed when the head sweeper enlisted in the army, and the tea shop languished for want of clientele, but Oxford was another matter. Here Ruskin was able to inspire a crew of undergraduates to repair a stretch of road at a nearby village, not only for the sake of showing just how nice such a road might be, but also "to let my pupils feel the pleasures of *useful* muscular work" (20:xli–xliii). The Hincksey Road workers were a remarkable lot—well-dressed Oxford undergraduates like Oscar Wilde, Arnold Toynbee, and Andrew Lang. And the project attracted national notoriety—although, like the street sweeping and the tea shop, its result fell short of Ruskin's hopes.

Ruskin's Oxford lectures were published year by year in a sequence of volumes: *Lectures on Art* (1870), *Aratra Pentelici* (1872), *The Eagle's Nest* (1872), *Love's Meinie* (1873), *Ariadne Florentina* (1873–76), and *Val d'Arno* (1874). However, these books were not Ruskin's major literary achievement of the 1870s.

On the first of January 1871, Ruskin inaugurated the monthly "Letters to the Workmen and Labourers of Great Britain" he titled *Fors Clavigera*—a project he continued, with interruptions, until 1884. In the monthly numbers of *Fors* the one-to-one relationship with his audience Ruskin enjoyed in his lectures was extended to a larger audience. Aside from their place in his literary and intellectual development, the *Fors Clavigera* letters also entailed the most significant of his attempts to carry his ideas into practice: the Guild of Saint George.

"The object of the Society," as he explained it in 1875,

is to buy land in England; and thereon to train into the healthiest and most refined life possible, as many Englishmen, Englishwomen, and English children, as the land we possess can maintain in comfort; to establish for them and their descendants, a national store of continually augmenting wealth; and to organize the government of the persons, and administration of the properties, under laws which shall be just to all, and secure in their inviolable foundations on the Law of God. (28:421)

To these ends, he established an organization—with three classes of "Companions" headed by himself as "Master"—and a fund, the affairs of which he recounted in detail month by month in *Fors*. Contributions—except his own gift of a tenth of his inheritance—were slow in coming. There were a few legacies, including one for £2500, and some gifts of unproductive land. And there were a few accomplishments—the encouragement of some traditional handicrafts and, most notable, the establishment of a museum at Sheffield.

In addition to the projects associated with the Guild of St. George, *Fors Clavigera* also led to several literary undertakings, including the first volumes of the *Bibliotheca Pastorum* ("Peasant's Library")—a translation of Xenophon's *Economist* and an edition of the metrical paraphrases of the Psalms by Sir Philip Sidney and his sister—and the scientific studies *Proserpina* (1875–76) and *Deucalion* (1875–83).

In December 1871, Margaret Ruskin died. Her son, who had maintained the expensive Denmark Hill household largely for her sake, was now finally free to live as he chose. As if anticipating her death—she was, after all, ninety—Ruskin had already begun negotiating to buy a house and sixteen acres of land on the eastern shore of Coniston Water in the English Lakes. "A small place," he described it to Charles Eliot Norton, with "on the whole the finest view I know in Cumberland and Lancaster."[23] The house, Brantwood, was in disrepair, and he spent more money making it habitable than the original cost of the property itself. He sold the house at Denmark Hill and established his cousin Joan and her husband Arthur Severn at the Ruskins' old home at Herne Hill, where, in his former nursery, Ruskin slept whenever he visited London. His art and manuscripts, along with his parents' heavy mahogany furniture, he sent to his new home at Coniston.

The spring and summer after his mother's death, he traveled on the Continent with the Severns. Then, in September 1872, he finally took up residence at Brantwood, which remained his home for the

last three decades of his life. Here, as a middle-aged, then as an old man, he carried out projects akin to those his parents had forbidden him in the garden at Herne Hill. He constructed a harbor and designed a boat. He terraced the slope behind his house and dug water works to drain the marshy hillside—thus carrying out in small scale his long-dreamed-of plan to control Alpine floods. He planted flowers and fruit trees, and generally set about making Brantwood into an Eden analogous to but different from his childhood home—different, because here, at long last, he was in charge.

The early 1870s confirmed Ruskin's identity in important ways: he was an Oxford professor, he had found in *Fors Clavigera* and the Guild of St. George a practical outlet for his social theory, and he had at last a home of his own. Yet these activities did not alleviate the pain of his relationship with Rose and the general frustration of his emotional life. In 1871 he came down with an unspecified illness. "I have not been so near the dark gates since I was a child," he wrote Acland (22:xviii–xix). His mother's death was a relief, but it was also a loss. Pressures on all sides mounted, and in the months that followed Rose's death the strain became too much for him.

Ruskin had been introduced to spiritualism by Mrs. Cowper-Temple after his father's death in 1864, but had not taken the seances he attended very seriously. Now, though, he was again persuaded to join her seances at Broadlands. And it was here, in December 1875, that Ruskin was convinced he had encountered the spirit of Rose. The following September he traveled to Venice, where he stayed for the next nine months, obsessively copying Carpaccio's paintings of St. Ursula. A series of coincidences that Christmas intensified his belief in the presence of Rose, who became confused in his mind with the saint. And a year later, in February 1878, he suffered a complete mental collapse, precipitated by a dream in which he married Rose— a dream he was for a time unable to distinguish from reality.

By April he had recovered sufficiently to return to work on *Proserpina*. However, it was not until February 1880 that he recommenced the *Fors Clavigera* letters.

In the interim, Ruskin experienced yet another humiliation. Stung by Ruskin's criticism of his painting *Nocturne in Black and Gold,* the American-born artist James McNeil Whistler decided to sue for libel. Both men expected to win the case—Whistler, in order to vindicate the cause of art against the ignorance of art criticism; Ruskin, ignoring the irony of a critical position remarkably similar to that he had

attacked in his own defenses of Turner, to establish his freedom of speech and the values of representational art to which he had devoted his life's work. But neither side won. The trial itself was a farce, and the verdict in favor of Whistler with damages of one farthing without costs forced Whistler into bankruptcy and Ruskin into resigning his professorship, on the grounds that he could not "hold a Chair from which [he had] no power of expressing judgment without being taxed for it by British law" (29:xxv).

Despite a second mental breakdown in 1881, Ruskin continued to lecture in public and continued to write, accommodating himself to life by repressing his aggressive self to such an extent that his general mildness and courtesy were proverbial. But when the mechanism of repression broke down, as happened more and more often in his later life, he became irrationally, destructively hostile. In part, his self-control depended on his ability to control his environment—to maintain the order and emotional restraint of his childhood. And when this control was threatened—usually by his own passions—he reverted to the simplistic categories of childhood, in which the forces of disorder were reified as a malevolent storm cloud threatening to overwhelm England or, at the height of his mania, "the Evil One, powerful and obscene, bidding him to commit some hideous wrong."[24]

In 1883, after hinting his willingness to return, Ruskin was re-elected to the Slade Professorship. Again his lectures appeared as books: *The Art of England* (1883), *The Pleasures of England* (1884–85). Crowds flocked, as before, to hear him speak. But he was no longer the vigorous middle-aged man he was in the 1870s. Nor was Oxford quite the same place it had been for him a decade earlier. He felt at odds with the growing scientific orientation of the university. His lectures became a personal crusade against these changes and, at the same time, grew embarrassingly eccentric. When he allowed himself—against his will—to be persuaded by friends (including Acland) to give up his plan to attack the scientific community in lectures on "The Pleasures of Sense" (Science) and "The Pleasures of Nonsense" (Atheism), he realized he could no longer remain part of the university, and used the occasion of a vote permitting vivisection to resign his chair.

From this point in his life, Ruskin's decline accelerated. He suffered another attack of madness in July 1885, and the next year he made his last report as Master of the Guild of St. George. Recogniz-

ing the precarious balance of his mental state, he turned to activities
that demanded little emotional outlay. He rearranged his collection
of minerals, entertained visitors at Brantwood, wrote letters to young
girls, and composed his autobiography *Praeterita* (1885–89)—a nos-
talgic recollection of a largely idealized past which contains some of
Ruskin's most genial prose.

The attacks of madness continued, and after 1890 his recoveries
became increasingly difficult. He was still able to enjoy the sunsets
over Coniston Water, and he was still able to receive visitors, who
flocked to see the man whose work was now enjoying its greatest in-
fluence. He had given away his fortune, but the proceeds from his
books amply supported both himself and the Severns, who now be-
came his guardians. His eightieth birthday in 1899 was a national
occasion. But it is doubtful that he was able to grasp the significance
of the deputations and epistolary tributes that arrived at Brantwood.

On the twentieth of January 1900, after two days illness with in-
fluenza, Ruskin died. His death, like his birthday, was an event of
national—even international—significance. A place in Westminster
Abbey was offered, but, according to his wishes, Ruskin was buried
in Coniston churchyard. A runic cross marks his grave.

Chapter Two
Beginning a Career: *Modern Painters,* volumes 1–2

The series of papers on *The Poetry of Architecture* (1837–38) Ruskin published as a university student lay out the general areas of concern to which he returned in his first mature writings. Chauvinistic, confused, and cocksure, they nevertheless exemplify real strengths of mind—the drive to confront a subject in all its complexity, the disdain for the boundaries of conventional disciplines, the capacity to connect the apparently unrelated. Ruskin's subject is "the distinctive characters of the architecture of nations," and this he finds "not only in its adaptation to the situation and climate in which it has arisen," but also in the expression of "the prevailing turn of mind by which the nation who first employed it is distinguished" (1:5). Ruskin's remarks on national character are often jejune and his logic unconvincing, but his effort to place architecture in the context of social history anticipates the researches of *The Stones of Venice.* More successfully argued is his contention that a house "must not stand by itself, it must be part and parcel of a proportioned whole" (1:187). Architecture is for this reason inseparable from landscape; like landscape painting itself, architecture's highest aim is "rousing certain trains of meditation in the mind" (1:5); and so the laws by which the architect works must in some way echo the laws that determine the beauty of a natural setting. This stricture, reapplied to artists, is the central argument of *Modern Painters.* When Ruskin sat down to write his defense of Turner, he had only to apply to landscape painting the line of reasoning he had, four years earlier, with less sophistication, applied to architecture.

Modern Painters, volume 1 (1843)

Published over eighteen years (1843–60), the five volumes of *Modern Painters* reflect the profound transformation in Ruskin's understanding of art, religion, and society that took place during this

period. They share a common theme—"the essence and the authority of the Beautiful and the True" (3:4)—but their relationship to this theme, once it has been stated, is revisionary, not developmental. Volume 1 defines the problem to be solved; subsequent volumes offer a series of alternative, never entirely adequate, solutions. Ruskin was never satisfied with the work. In later years he planned various recastings of its materials. At the same time he was careful to disavow the aspects of *Modern Painters* he could no longer countenance. In the preface to the 1873 edition, he acknowledged that "many parts of the first and second volumes are written in a narrow enthusiasm" (3:54); "the Religious teaching" of *Modern Painters* and *The Stones of Venice,* he explained to the readers of *Fors Clavigera* in 1877, "all the more for the sincerity of it, is misleading—sometimes even poisonous; always, in a manner, ridiculous; and shall not stand in any editions of them republished under my supervision" (29:90n.).

Ruskin felt the need to revise *Modern Painters*—rather than dismiss it altogether—because he continued to identify himself strongly with the book. By virtue of its formidible length and scope, *Modern Painters* was his strongest credential as a critic of art and, by synecdochic extension, as a critic of life in general. At the same time, even though he changed his mind about many of its tenets—particularly those of its first volumes—it remained the basis for much of his later writing and as such is a necessary introduction to any study of his thought and its development.

As originally conceived, *Modern Painters* was to have logically unfolded from the definition of "Greatness in Art" Ruskin offers in its opening pages: "The greatest picture is that which conveys to the mind of the spectator the greatest number of the greatest ideas" (3:92). To explain this definition, he defines the kind of ideas that can communicate themselves to the spectator. Examining these, he determines which are greatest; and the treatise that follows takes up, in succession, the three he selects—Ideas of Truth, Ideas of Beauty, and Ideas of Relation. Volume 1, after its introductory exposition "Of General Principles," devotes itself to the first of these three categories.

If Ruskin's aim were merely to refute criticisms that Turner was not "true to nature," he need not have set forth an elaborate justification for the value of truth. It was implicit in the criticisms themselves. But he needed to do more than merely demonstrate that Turner was "true"; he had also to demonstrate that, in being true to

nature, Turner was a profound moralist, and thus justify his own interest in landscape painting by elevating it to the status of moral truth—by seeing it, in effect, as divine revelation.

The inadequacy of the "elder masters" he contrasts with Turner is that their work "has never taught us one deep or holy lesson; . . . has never made us feel the wonder, nor the power, nor the glory of the universe" (3:22); while English landscape artists, "although frequently with little power and with desultory effort, . . . have yet, in an honest and good heart, received the word of God from clouds, and leaves, and waves, and kept it, and endeavoured in humility to render to the world that purity of impression which can only render the result of art an instrument of good, or its labour deserving of gratitude" (3:44–46).

Ruskin's Evangelical upbringing had much to do with this insistence on a moral significance to art. On an elementary level, *Modern Painters* attempts to rationalize the mixture of puritanism and aesthetic self-indulgence that characterized the Ruskin household. However, the book is more than an effort to accommodate a set of narrow religious beliefs to a taste for landscape painting. It seeks to affirm in landscape painting, in landscape itself, and in aesthetic experience generally an equivalence to the meaningfulness and universality Ruskin had been taught to identify with religious truth. Such an effort would not merely elevate the status of art; it would also offer the internalized faith of Protestantism a set of objective correlatives in art and its subject matter. Thus, both art and religion stood to profit from the success of Ruskin's enterprise.

A similar impulse lies at the heart of British romanticism, and Ruskin's awareness of this antecedent is explicit in the slightly altered quotation from Wordsworth's *Excursion* that appeared on his title page:

> Accuse me not
> Of arrogance, . . .
> If, having walked with Nature,
> And offered, far as frailty would allow,
> My heart a daily sacrifice to Truth,
> I now affirm of Nature and of Truth,
> Whom I have served, that their Divinity
> Revolts, offended at the ways of men,
> Philosophers, who, though the human soul
> Be of a thousand faculties composed,

> And twice ten thousand interests, do yet prize
> This soul, and the transcendent universe,
> No more than as a mirror that reflects
> To proud Self-love het own intelligence.[1]

Both Wordsworth and Ruskin are seeking to repudiate the rationalist philosophy of the eighteenth century, with its assumption that truth is timeless, abstract, and impersonal, and to affirm the significance of another kind of truth, based on an awareness of historical or individual development, concrete sensuous experience, and the individual consciousness. The problem for both is that an affirmation of the latter values too easily becomes the espousal of a relativism in which truth is reduced to temporary feeling and self-consciousness becomes a trap from which the intellect is unable to extricate itself. Wordsworth attempted to circumvent this problem by denying self-love and arrogance while in the same breath affirming the greatness of his soul. Two strategies are at work here: he splits the self into distinct components ("Self-love," "intelligence," "soul") and he reifies his experience of landscape into a transcendent entity called "Nature," in which the concrete particularity of the natural world is fused with the inner truth of Protestantism. Ironically, both strategies return him to the rationalist perspective he was trying to deny. The first replaces the romantic notion of the self as a whole with an eighteenth-century view of the self as a bundle of separate faculties; the second replaces both landscape and inner consciousness with an abstraction. Wordsworth, in other words, is unable to free himself from the very kind of thinking he is trying to repudiate.

Modern Painters, attempting to solve the same problem, finds itself in a similar dilemma. Ruskin's epigraph contains two signals to the reader. It dissociates his argument from the rationalism he identifies with philosophy, and it identifies bad landscape painting with subjectivism. Yet the analytic mode in which he originally conceived the book—its division into discrete "Ideas"; its later distinction between Typical and Vital Beauty—is essentially a rationalist approach; and the artistic style he aims to defend—that of Turner's later paintings—is based on a deeply subjective response to nature. The significant purpose of *Modern Painters,* Ruskin's effort to demonstrate the moral and religious status of artistic "truth," is thus at odds both with its methodology, which implies the superiority of abstract, linear thought to the analogical representation of art, and with its assump-

tions about the nature of the artistic consciousness. It follows that to succeed in that purpose it will have to overcome both.

Ruskin's antisubjective bias is explicit in his view that "the power of the masters is shown by their self-annihilation" (3:23) and that "the cause of the evil . . . in the system of ancient landscape art . . . consists, in a word, in the painter's taking upon him to modify God's works at his pleasure, casting the shadow of himself on all he sees" (3:24–25). The problem with this view is not only that it denigrates the Italian primitives whom Ruskin soon found himself admiring, but, as already suggested, that it promotes an ideal of photographic realism completely unlike Turner's later style. Unconditional acceptance of the ideal of selflessness reduces the painter to a passive receptor of nature and brings into question any elements of his work that express his special qualities as an individual human being. "Painting, or art generally," Ruskin at one point argues, "with all its technicalities, difficulties, and particular ends, is nothing but a noble and expressive language, invaluable as the vehicle of thought, but by itself nothing" (3:87).[2]

Ruskin may be seeking to connect art with morality, but, by advancing a version of the semiotic distinction between signifier and signified that distinguishes the technical medium and practice of the artist from the set of ideas expressed by means of his art, he implies that the connection between art and morality is arbitrary or possibly nonexistent. The value of a work of art may, by this logic, have nothing whatsoever to do with the skill or labor of its artist. Conversely, since its moral valuation is not essential to the work of art, art for its own sake becomes a legitimate rationale for the artist. Ruskin's analytic methodology thus creates the very problem he is seeking to solve.

For this reason, the task of the first volumes of *Modern Painters,* as well as *The Stones of Venice,* turns out to be overcoming the division between art and morality on which Ruskin, paradoxically, grounds their argument. His definition of "the greatest painting" as "that which conveys . . . the greatest number of the greatest ideas" not only demands a stipulation of "the greatest ideas," but an account of them that, by one means or another, makes technical accomplishment and the individuality of the painter valid criteria for the judgment of art: that replaces an analytic approach with a synthetic one and thus reintegrates the signifier with the signified.

Ruskin lays out the five "greatest ideas" with confident systemati-

zation: Ideas of Power, Ideas of Imitation, Ideas of Truth, Ideas of Beauty, Ideas of Relation. However, only the final three are his real concern. Ideas of Power, which he defines as "the simple perception of the mental or bodily powers exerted in the production of any work of art" (3:94), would seem to value the painting over its subject. Indeed, he assures us that Ideas of Power are "independent of the nature or worthiness of the object from which they are received" (3:95). But, by means of a dubious analogy to Newton's Third Law of Dynamics, he argues that it is impossible to employ a great power on anything but a great object. Applied to a lesser object, the power itself is perforce lesser (although it may remain potentially great). And so the subject of the painting—in this case, the difficulty of the subject—becomes once again an index of value.

The Idea of Imitation is set forth in order to clarify what Ruskin means by the Idea of Truth. The first he deliberately restricts to refer only to the experience of recognizing a deception—the pleasure we receive from perceiving "that something produced by art is not what it seems to be" (3:103). So conceived, imitation is no better than foolery, and a painting that depends for its effect on imitation ranks somewhere below the performance of a good juggler.

The purpose of this definition is to make it clear that whatever Ruskin means by an Idea of Truth does not entail the spectator's mistaking a picture for something other than what it is. "The word Truth, as applied to art, signifies the faithful statement, either to the mind or senses, or any fact of nature" (3:104), and, insofar as an Idea of Imitation may be prompted by the statement of facts, the two Ideas are not incompatible; however, the response to imitation is always the recognition of difference, followed by pleasure in the artist's ability to achieve a near deception. Imitation, in other words, both emphasizes the distinction between the painting and its subject and, at the same time, draws attention from the subject to the technique of the painter.

Ideas of Beauty, as Ruskin defines them, derive from the pleasure taken in contemplating the "outward qualities" of an object "without any direct and definite exertion of the intellect" (3:109). As such, Beauty is as inexplicable and arbitrary as the physical tastes of sweet or bitter. The fact that human beings experience Beauty is a function of the way they were (divinely) created. Inasmuch as the artist's perception of Beauty is nonintellectual, it is free of self-love. And the recognition of Beauty in a work of art implies the moral fitness of the

artist, who has not allowed his God-given sense of Beauty to change
or decay.

Ruskin admits his term "Ideas of Relation" is "inexpressive." He
uses it to refer to "the vast class of ideas . . . which are the subjects
of distinct intellectual perception and action, and which are therefore
worthy of the name of thoughts" (3:112). It would seem, therefore,
that Ideas of Relation would be the surest grounds for a morality of
art. In fact, however, they proved the most difficult category to treat,
since, on one hand, they encourage an oversimplification of Ruskin's
argument into a matter of which artists held the right beliefs, and,
on the other, if treated with greater sophistication, they give priority
to the mind of the artist—and that of the spectator—over the work
of art itself. And so he postponed his consideration of Ideas of Rela-
tion—as it turned out, until *Modern Painters,* volume 5—and took up
instead the apparently easier questions of Truth and Beauty.

The extended discussion of Truth, to which Ruskin turns after es-
tablishing his general definitions, vacillates between acknowledgment
of the special insight of the artist and concern for the objective "fac-
tuality" of his work. He affirms two kinds of Truth—truths of fact
and truths of thought: truths to nature only and truths to the artist's
perception of nature. Because they entail human experience, truths of
thought are the greater. But, unlike truths of fact, they can only be
understood by the few and are commonly misjudged by the unquali-
fied. Thus, the more important aspect of Truth is both the more dan-
gerous—because "a false thought is worse than the want of thought"
(3:136)—and the more difficult for Ruskin to explain to the general
reader.

He evades this problem by arguing that, since true thought must
be based on true fact, fact is an index of thought:

And thus, though we want the thoughts and feelings of the artist as well as
the truth, yet they must be thoughts arising out of the knowledge of truth,
and feelings arising out of the contemplation of truth. We do not want his
mind to be like a badly blown glass, that distorts what we see through it,
but like a glass of sweet and strange colour, that gives new tones to what
we see through it; and a glass of rare strength and clearness too, to let us
see more than we could ourselves, and bring nature up to us and near to us.
(3:137)

Even the mannerisms of an artist can be reduced to factuality. Differ-
ences in style, Ruskin argues, are not peculiar modes of getting at

the same truths, but the artist's "*only* mode of getting the particular facts he desires" (3:193–94).

But of course making objective fact the index of thought tends once more to devalue the special mind of the artist. Hence, Ruskin must emphasize that the facts of nature are not to be discerned by the uneducated. Most of us see what we think we should see and commonly identify objects by their least essential characteristics. Certain privileged individuals, however, are more accurately sensitive to external nature than others. And "with this kind of bodily sensibility to colour and form is intimately connected that higher sensibility which we revere as one of the chief attributes of all noble minds, and as the chief spring of real poetry" (3:142–43). Thus factuality and "higher sensibility" are linked in the work of the truly creative artist. And even the greatest art is necessarily flawed, since no human being is without weaknesses or imperfections.

Ruskin's line of argument, by presupposing the wholeness of the artist's work and the interrelationship of its parts, has thus rejected his own original premise of a clear distinction between technique and morality. It is this about face that enables him to make fact an index of "higher sensibility"; moral vision, an evidence of factual truth. For any part, taken in isolation, is a clue to the whole; every element of the artist's work is witness to the success or failure of its entirety: "he who cannot make a bank sublime will make a mountain ridiculous" (3:491).

What differentiates *Modern Painters,* volume 1, from Ruskin's later accounts of these interrelationships is that his argument is not based on an assumption about human nature itself, but on the assumption of a providential order informing all aspects of human experience, including the material world. The second half of volume 1 is a comprehensive survey of the "truths" that express this providence: "general truths" of tone, color, chiaroscuro, and space; specific truths of sky and clouds, of mountains and earth, of water, and of vegetation. And what Ruskin writes about the sky he believes true for nature in general: "there is not a moment of any day of our lives, when nature is not producing scene after scene, picture after picture, glory after glory, and working still upon such exquisite and constant principles of the most perfect beauty, that it is quite certain it is all done for us, and intended for our perpetual pleasure" (3:343). The universe Ruskin offers in the first volumes of *Modern Painters* works according

to rational law ("principles"), but, because its purpose is human pleasure, its laws are aesthetic and can only be understood in terms of their relationship to a human observer. Moreover, because nature has a plan, it can be perceived as a work of art in its own right: "take any single fragment of any cloud in the sky, and you will find it put together as if there had been a year's thought over the plan of it, arranged with the most studied inequality, with the most delicate symmetry, with the most elaborate contrast, a picture in itself" (3:374). Ruskin's discussion of truth is thus both an examination of landscape art and an attempt to demonstrate the "natural composition" (3:384) of landscape itself. Nature so conceived is an organic whole. Clouds are not objects floating in the sky like boats on water; they are part of the sky (3:347). Hills are not "laid upon the plains": "the mountains must come from under all, and be the support of all; and . . . everything else must be laid in their arms, heap above heap, the plains being the uppermost" (3:428). Moreover, the mountains do not merely support the earth; they are also the "link between heaven and earth" (3:449)—a phrase Ruskin means both literally and figuratively.

Perceiving the natural landscape as a work of art meaningful in its own right might seem to—once again—preclude the special role of the artist. And Ruskin seems to support this interpretation when he argues that "the moment the artist . . . can make us think that *he* has done nothing, that nature has done all, that moment he becomes ennobled, he proves himself great" (3:470). However, instead of reducing the role of the artist, Ruskin is redefining it by elevating the ability to grasp and therefore portray the organized beauty of the actual landscape. So defined, the artist is at once a natural historian and a kind of divinity. To understand nature, one must understand the principles of growth and development that account for its present form. Turner, because he is able to draw correct mountain structure, "is as much of a geologist as he is of a painter" (3:429). As a result, his work offers us an experience of a kind with the experience of nature itself: "We never get to the top of one of his hills without being tired with our walk; not by the steepness, observe, but by the stretch; for we are carried up towards the heaven by such delicate gradation of line, that we scarcely feel that we have left the earth before we find ourselves among the clouds" (3:467). And because it is possible to describe "nature's work and Turner's with the same words" (3:485),

the artist participates—by implication—in the creative idea that underlies nature:

> to trace among the grass and weeds those mysteries of invention and combination by which nature appeals to the intellect; to render the delicate fissure, and descending curve, and undulating shadow of the mouldering soil, with gentle and fine finger, like the touch of the rain itself; to find even in all that appears most trifling or contemptible, fresh evidence of the constant working of the Divine power "for glory and for beauty," and to teach it and proclaim it to the unthinking and the unregarding; this, as it is the peculiar province and faculty of the master-mind, so it is the peculiar duty which is demanded of it by the Deity. (3:483)

For the obscurity in Turner's last works, Ruskin gives three very different explanations. It is "the obscurity . . . of prophecy; the instinctive and burning language which would express less if it uttered more, which is indistinct only by its fulness, and dark with its abundant meaning" (3:611). At the same time, it signals the inadequacy of any artistic means to represent nature accurately. The artist's bright color, Ruskin reminds us, is white paper; nature's, the blinding light of the midday sun. It is Turner's greatness that he never forgets this discrepancy; that he never attempts to deceive the viewer into thinking he has captured the complete truth of his subject. Yet Turner's obscurity is also a function of his point of view. Ruskin's chapters on tone, color, chiaroscuro, and space define the subject of landscape painting not as nature unto itself, but as nature experienced by the human observer. For Ruskin, these truths entail an understanding of matters like visual focus and the effects of distance on color and light. Taken in isolation, these chapters suggest an argument for impressionism. Taken with the chapters on natural history, they extend the tension previously observed between Ruskin's demand for objective factuality and his recognition of the primacy of subjective thought.

This tension is not a sign of indecisiveness, much less self-contradiction; rather, it is an attempt to assert a vision of human experience in which the facts of subjective impression and the facts of objective "science" are treated as part of the same whole. If the first volume of *Modern Painters* is naive, it is not because Ruskin has chosen so great a problem, but because he did not yet recognize how very difficult it would be for him to solve. Landscape painting—in particular, the paintings of Turner—seemed to be the solution, because they seemed

able to fuse the two different kinds of thought. Ruskin had yet, however, to find an intellectual mode capable of reduplicating in language Turner's achievement in the medium of graphic art.

Modern Painters, volume 2 (1846)

Volume 2 of *Modern Painters*, in which Ruskin addresses himself to the religious and philosophical assumptions underlying his judgment of art, is, by virtue of its dogmatism and hyperliterary style, the least accessible part of the work for modern readers. Ruskin later acknowledged these shortcomings, and the rearranged edition of volume 2 he published in 1883, with its copious notes retracting, amending, or, in some cases, reaffirming his earlier opinions, is in effect a dialogue—often a debate—between Ruskin at the beginning and Ruskin at the end of his career.

Volume 2 of *Modern Painters* is not simply a theoretical justification of volume 1. It represents at least one significant change in Ruskin's knowledge of art—his newfound admiration for the painters of medieval and early Renaissance Italy. Turner remains an object of veneration, but he is no longer the central figure. Fra Angelico and, especially, Tintoretto now receive the praise and attention formerly reserved for Turner. Moreover, this redirection is more than a symptom of Ruskin's growing awareness of art history. It represents an important shift of interest from landscape to human subjects. The world of *Modern Painters*, volume 1, consists in sky and clouds, mountains and sea; the world of *Modern Painters*, volume 2, consists in human passions and human feelings.

Ruskin justifies his concern for man with the assumption that "Man's use and function . . . are, to be the witness of the glory of God, and to advance that glory by his reasonable obedience and resultant happiness" (4:28–29). The operating phrase is "witness of the glory of God," for it is this that explains what Ruskin terms "the Theoretic faculty." He chose the Greek word *theoria* rather than the English "contemplation" as an appeal to the "pre-established authority" of Aristotle (4:7), whose distinction between *theoria* and *praxis* ("action") is important for Ruskin's argument. Being "witness of the glory of God" is a primary end; the practical means to that end—the activities necessary for human survival—are secondary. But Ruskin's antiutilitarian notion of art for God's sake comes close to being a defense of art for art's sake—to the belief that the experience of art is an end in itself. For this reason he is careful to define *theoria* as "the

moral perception and appreciation of ideas of beauty" (4:35), and to "deny that the impressions of beauty are in any way sensual; they are neither sensual nor intellectual, but moral" (4:42). "It is evident," he insists, "that the sensation of beauty is not sensual on the one hand, nor is it intellectual on the other, but is dependent on a pure, right, and open state of the heart" (4:49).

It is important for Ruskin that the sense of beauty be more than a matter of taste or convention. It must, by definition, be essential to the nature of man as a God-created being. At the same time, it is important that it be more than a mere function of animality. It must be judged by moral standards of right and wrong. Hence, while he affirms an instinctual sense of beauty, he also insists that instinct may be wrong and demands that it be cultivated. "The sensation of beauty is intuitive and necessary, as men derive pleasure from the scent of a rose," but "there are some sources from which it is rightly derived, and others from which it is wrongly derived; in other words, . . . men have no right to think some things beautiful and no right to remain apathetic with regard to others" (4:52). And for this reason man has a duty "to bring every sense into that state of cultivation in which it shall form the truest conclusions respecting all that is submitted to it, and procure us the greatest amount of pleasure consistent with its due relation to other senses and functions" (4:56).

The beauty which is the object of this sensibility falls into two categories—Typical and Vital. Typical Beauty is so called because it is "in some sort typical of the Divine attributes"; Vital Beauty entails "the appearance of felicitous fulfillment of function in living things, more especially of the joyful and right exertion of perfect life in man" (4:64).

Ruskin analyses Typical Beauty into six classes: infinity, unity, repose, symmetry, purity, and moderation. He relates these to the particular attributes of God they exemplify (incomprehensibility, comprehension, permanence, justice, energy, and law). But he argues from human experience, not a preconceived notion of God. His principal model for this experience, other than himself, is Wordsworth, whose accounts of his own childhood—not in *The Prelude,* which was not yet published, but in poems like "Ode: Intimations of Immortality" and "Lines Composed a Few Miles Above Tintern Abbey"—illustrated the "innate" response of human nature to natural beauty.

Ruskin's consideration of the idea of infinity exemplifies his approach. He recollects his childhood emotion "caused by all open

ground, or lines of any spacious kind against the sky, behind which there might be conceived the Sea." He then argues the development of this response into the love, "common to all . . . of a light distance appearing over a comparatively dark horizon." This he reports having tested "too frequently to be mistaken, by offering to indifferent spectators forms of equal abstract beauty in half tint, relieved, the one against dark sky, the other against a bright distance. The preference is invariably given to the latter; and it is very certain that this preference arises not from any supposition of there being greater truth in this than the other, for the same preference is unhesitatingly accorded to the same effect in Nature herself" (4:79). Questioning the source of this response, he determines "there is one thing that it has, or suggests, which no other object of sight suggests in equal degree, and that is—Infinity. It is of all visible things the least material, the least finite, the farthest withdrawn from the earth prison-house, the most typical of the nature of God, the most suggestive of the glory of His dwelling-place" (4:81).

One could, of course, argue that the spatial experience of apparently infinite distance explains the notion of infinity, hence, the attribution of infinity to God. By anchoring his theological concept in a materialist view of human development, Ruskin lays the grounds for an interpretation very different from the one he espouses.

Vital Beauty, which Ruskin relegates to secondary status, is more difficult to explain, and the easy categories of the first part of the volume give way—despite the chapter titles—to a less organized approach. Vital Beauty troubles Ruskin because it is inherently amoral. He tries to get around this problem by falling back on the medieval—Aristotelian—notion of a hierarchical organization of the natural world: "Hence we find gradations of beauty, from the impenetrable hide and slow movement of the elephant and the rhinoceros, from the foul occupation of the vulture, from the earthy struggling of the worm, to the brilliancy of the moth, the buoyancy of the bird, the swiftness of the fawn and the horse, the fair and kingly sensibility of man" (4:155–56). He is not, however, entirely satisfied with this view, and therefore suggests "we should sometimes check the repugnance or sympathy with which the ideas of their destructiveness or innocence accustom us to regard the animal tribes, as well as those meaner likes and dislikes which arise, I think, from the greater or less resemblance of animal powers to our own . . ." (4:157). Yet he leaves us with a sense that his ability to enjoy the vital beauty of a

creature, plant or animal, is a function of its immutable place in an immutable chain of being. And he is reluctant to accept the implication of his stated belief in the peculiarly organized significance of individual species: instead of its botanical structure, the moral qualities of "courage and strength" and "right doing of its hard duty" (4:171) seem to him the real essence of an alpine flower. Vital Beauty, again and again, shades into Typical.

Man, moreover, poses a particularly difficult problem. There is no "ideal" human form—no single criterion of Vital Beauty—a fact Ruskin attempts to explain with reference to the Fall of Man—to the necessary division of human nature and the impossibility of uniting all virtues in a single being. Moreover, the business of representing human individuality raises another question. If, as Ruskin argues, it takes a "right Christian mind" to "find its own image wherever it exists" (4:191)—to perceive the various possible forms of Vital Beauty in fallen man—then how does one account for the fact that impious men have been able to paint beauty when pious men have failed? This puzzle—which will continue to disturb Ruskin in *The Stones of Venice*—elicits several possible solutions. He falls back on the distinction between aesthetic and moral, arguing that an unchristian painter may delineate sensuous but not moral beauty (4:211). And he takes the view that much good may be done in the world without good intentions behind it (4:213–14). Yet he leaves his conclusive explanation for a future occasion.

The concluding section of *Modern Painters,* volume 2, which takes up the Imagination, is an attempt to substantiate the distinction between Fancy and Imagination in Wordsworth's 1815 preface to *Poems*. In keeping with the analytic method of the volume, Ruskin divides Imagination into three functions—associative, penetrative, and contemplative. The Imagination Associative, "the grandest mechanical power that the human intelligence possesses" (4:234), is defined as the power of uniting two or more imperfect ideas (or images) into a perfect whole. Thus, taken by themselves, the individual trees in a Turner landscape may be ugly, but placed in conjunction by the artist, they form a coherent, beautiful whole (4:245). This power is thus a form of genuine creativity and "indeed something that looks as if man were made after the image of God" (4:236). Moreover, the Imagination Associative and the Theoretic faculty are complementary. While the second seizes upon all possible forms of beauty, the first is able to take "hold of the very imperfections which the Theo-

retic rejects; and, by means of these angles and roughnesses, it joints and bolts the separate stones into a mighty temple, wherein the Theoretic faculty, in its turn, does deepest homage" (4:241).

Ruskin admits that readers may object to his choice of the term "Imagination" to describe the faculty that penetrates to the essence of the thing it describes. His use of "Imagination" would seem to be an attempt to connect the creative power of association with the intellectual power of apprehension. By definition, this form of Imagination is the power to grasp the thing in itself; in practice, it seems to refer to the artist's capacity to express richness of meaning through the telling use of details. Thus, in the background of Tintoretto's "Crucifixion," the apparently trivial incident of an ass "feeding on the *remnants* of *withered palm-leaves*" calls to mind the ironic relationship between the crucifixion and the events of Palm Sunday (4:271). And because the Imagination Penetrative often manifests itself in symbolic or typological expression of this kind, it is sharply distinguished from realism.

Ruskin's notion of the Imagination Contemplative is at best vaguely expressed. The concept refers to the mind's capacity to contemplate certain aspects of the mental image of an object apart from others, to be able to dwell with pleasure on details that in their concrete form would be painful or distasteful. This form of the Imagination is more usual in literature than in the plastic arts (which are, of course, concrete), and Ruskin's examination of it is somewhat tentative. He suggests, for example, that the treatment of form in unpainted sculpture is a manifestation of the Imagination Contemplative, as are also various kinds of idealization, abstraction, or stylization.

If Ruskin feared his point of view might be mistaken for aestheticism, he had good cause. Take away the hypothesis of a God, and the arguments of *Modern Painters,* volume 2, become a case for sharpening the sensibilities in order to increase purely human capacities for pleasure—a philosophy akin to Walter Pater's belief that "art comes to you proposing frankly to give nothing but the highest quality to your moments as they pass, and simply for those moments' sake."[3] It was this misreading of his early work that the 1883 republication of *Modern Painters,* volume 2, was designed to counter.

Ruskin found Pater's view inadequate not because of its atheism, but because it reduced the significance of art to a single aspect of a narrowly defined experience of beauty. The thrust of *Modern Painters*

is to give art a necessary role in man's life as a whole and to elevate the experience of beauty—in the actual world or in art—into the highest form of human experience. The rhetoric of Evangelicalism enables him to put forth this view in good conscience, but the argument continued to stand long after the rhetoric had been disavowed. Admittedly, it continued to stand with various provisos and amendments. And what remained in 1883 was a significantly chastened view of art, in which what turns out to be important is not the primacy of the experience of beauty, but its integration with the range of human activities. It is this integration, Ruskin came to believe, that justifies the application of moral categories—right and wrong, worthy or degraded—to works of art and the application of artistic categories—beautiful or ugly—to factory production, politics, and all the other businesses and pleasures of humankind.

Insofar as this synthesis seemed, in 1846, to depend on a particular set of religious beliefs, it was vulnerable—a vulnerability that may be detected in the slightly hysterical rhetoric of the second volume. The narrow Evangelicalism of *Modern Painters*, volume 2, was already at odds with the growing catholicity of its author's vision.

Chapter Three

New Concerns:
The Seven Lamps of Architecture
and The Stones of Venice

It is easy to ignore the positive effects of Ruskin's six-year marriage to Euphemia Gray; however, Mary Lutyens's three-volume chronicle of their relationship makes it clear that Effie brought her husband into contact with persons and circumstances he had never known before—in London and in the heterogeneous world of mid-nineteenth-century Venice. His letters home during the two winters he spent in Venice record a strong effort to sustain the values of his parents; the speed with which he returned to the forms of his old life-style after Effie's flight suggest an impulse to act as if the marriage had never occurred. But if Ruskin could stop going to parties, he could not so easily forget his newfound experience of a world very different from his parents' fireside—or the Oxford of his undergraduate years. Even as Millais had painted his fateful portrait of Effie at Glenfinlas, Ruskin had been preparing a new career for himself as a public lecturer. Three months after the annulment of his marriage, Ruskin began teaching at the Working Men's College, and the next year he began the series of annual "Academy Notes" that involved him intimately, often acrimoniously, with the London art world. Partly under the influence of, partly in reaction to Effie, Ruskin had become a public man. And the subject matter on which this transformation worked itself forward was, appropriately, the most public of the arts—architecture.

The Seven Lamps of Architecture (1849)

Both in *The Poetry of Architecture* and in the first volumes of *Modern Painters,* Ruskin had treated architecture as an element of landscape, and *The Seven Lamps of Architecture* is based on material "originally thrown together" (8:280) in preparation for *Modern Painters,* volume 3.

The architect differs from the landscape painter, of course, because architecture is not a copy of nature, but "is itself a real thing" (8:176). Yet, because his work is conceived as a part of the landscape, it is—or should be—governed by the same laws that determine the forms of natural beauty. Not "every happy arrangement of line is directly suggested by a natural object; but . . . all beautiful lines are adaptations of those which are commonest in the external creation" and "in proportion to the richness of their association, the resemblance to natural work, as a type and help, must be more closely attempted, and more clearly seen." "Beyond a certain point," Ruskin insists, "man can not advance in the invention of beauty, without directly imitating natural form" (8:139).

And yet architecture is an expression of man, not nature. Its laws necessarily derive from the necessities of structure and materials, from human needs, human labor, and the workings of the human mind. *The Seven Lamps of Architecture* attempts to resolve the conflict between these two viewpoints—between an architectural style determined by external considerations (such as conformance to a predetermined standard of beauty) and one determined by structural constraints and the human ability to make the most of them. The latter Ruskin associates with "Power": If "whatever is in architecture fair or beautiful, is imitated from natural forms," then "what is not so derived, but depends for its dignity upon arrangement and government received from human mind, becomes the expression of the power of that mind, and receives a sublimity high in proportion to the power expressed" (8:101–2).

This distinction between beauty and power is a version of the distinction between truth and technique left unresolved in *Modern Painters*. It is also a struggle—somewhat undefined, but nevertheless real—between academic architecture and modernism; and this struggle accounts both for the inner contradictions of *The Seven Lamps of Architecture* and for Ruskin's attempts to resolve them. Architecture may have started out as part of landscape, but the human issues it posed forced Ruskin to rethink his philosophy of beauty. The study of architecture did not merely interrupt the composition of *Modern Painters;* it made it impossible for Ruskin to complete the book as he had originally planned it and, ultimately, redirected his life's work.

Ruskin's "Seven Lamps"—Sacrifice, Truth, Power, Beauty, Life, Memory, and Obedience—are not meant as an exhaustive analysis of architectural values. Rather, they offer him points of departure for a

series of meditations on architecture. Looking back on the book in 1880, he judged it yet another example of the "rabid and utterly false Protestantism" (8:15) that tainted *Modern Painters,* volumes 1–2. Yet the meditative form of *The Seven Lamps of Architecture* is at odds with this dogmatism. Ruskin's premises may be narrow, but once his mind is set free to explore a subject, he is not reluctant to call them into question.

The treatment of ornament in *The Seven Lamps of Architecture* illustrates this self-correction. "The Lamp of Sacrifice" begins with a distinction between architecture and building. "To build," Ruskin explains, is "to put together and adjust the several pieces of any edifice or receptacle of a considerable size" (8:27–28). "Architecture," in contrast, "concerns itself only with those characters of an edifice which are above and beyond its common use" (8:29). So defined, architecture is purely ornamental and has nothing to do with structural form or utilitarian function. "No one," Ruskin insists, "would call the laws architectural which determine the height of a breastwork or the position of a bastion. But if to the stone facing of that bastion be added an unnecessary feature, as a cable moulding, *that* is Architecture" (8:28–29).

There is a purpose to this extraordinary definition. Ruskin is using it to substantiate his notion of Sacrifice—"the offering of precious things, merely because they are precious, not because they are useful or necessary" (8:30). He means to attack "the prevalent feeling of modern times, which desires to produce the largest results at the least cost" (8:31). Yet, taken in isolation, these definitions place Ruskin on the side of the worst excesses of Victorian design—of that superabundance of irrelevant ornamentation the popular imagination identifies with "Victorianism." It is in attempting to disavow this interpretation that Ruskin significantly revises his original position. "I am no advocate for meanness of private habitation," he writes, "but I would not have that useless expense in unnoticed fineries or formalities; cornicing of ceilings and graining of doors, and fringing of curtains, and thousands such; . . . things which cause half the expense of life, and destroy more than half its comfort, manliness, respectability, freshness, and facility" (8:38–39).

This declaration entails no radical inconsistency. Unnecessary expense designed for show is not truly an act of sacrifice. Expense of labor or materials that will pass unnoticed by all but a few—"one or two shafts out of a porphyry whose preciousness those only would

know who would desire it to be so used" (8:40)—is the gesture Ruskin honors. However, porphyry is not necessary for sacrifice: "if you cannot afford marble, use Caen stone, but from the best bed; and if not stone, brick, but the best brick; preferring always what is good of a lower order of work or material, to what is bad of a higher" (8:45). Sacrifice has thus become less a question of superfluous ornament than one of integrity of materials; and so, while his belief in the need for sacrifice remains unshaken, the distinction between architecture and building, on which it was originally based, is no longer relevant.

This revised interpretation of the bases of sacrifice leads in turn to Ruskin's "Lamp of Truth." Truth is violated by architecture when there is "a direct falsity of assertion respecting the nature of material, or the quantity of labor" (8:59). Honest architecture disdains "the suggestion of a mode of structure or support other than the true one"; "the painting of surfaces to represent some other material than that of which they actually consist . . . or the deceptive representation of sculptured ornament upon them"; and "the use of cast or machine-made ornaments of any kind" (8:60). Ornament, in other words, is subservient to structure (insofar as any ornamental strategy that obscures structure is a form of deceit). Similarly, the true nature of materials is a value in itself. Ruskin has trouble resolving this belief with his recognition that marble and other precious stones are often inappropriate for structural members and are used, if at all, as facings. He attempts to circumvent this difficulty by arguing that "a marble facing does not pretend or imply a marble wall," and so "there is no harm in it" (8:79). But he is uncomfortable with this logic and finally acknowledges "that a better manner of design, and a more careful and studious, if less abundant, decoration would follow, upon the consciousness of thoroughness in the substance" (8:79). And so honesty of structure and materials, not "unnecessary" ornament, becomes the standard of excellence: "Let, therefore, the architect who has not large resources, choose his point of attack first, and, if he chooses size, let him abandon decoration; for, unless they are concentrated, and numerous enough to make their concentration conspicuous, all his ornaments together will not be worth one huge stone" (8:105). "And, for my own part, I think a smooth, broad, freshly laid surface of gesso a fairer thing than most pictures I see painted on it; much more, a noble surface of stone than most architectural features which it is caused to assume" (8:115).

Ruskin's injunction against cast or machine-made ornaments has less to do with Truth than with Sacrifice. Pleasure in ornament he believes to derive from recognition of the labor and therefore the love that went into it. If there is no labor, then ornament is valueless. It is appropriate for workers to give time and effort to the carvings of a Gothic church, because their work is a sign of religious devotion. If their handwork is replaced by machine-made ornament, or ornament made by men reduced to the level of machines, it is a form of deliberate hypocrisy. If machine-made ornament appears in places where ornament itself is inappropriate—in buildings "belonging to purposes of active and occupied life" (8:157)—then its presence simply violates common sense. There is, for Ruskin, no purpose in the Greek moldings of shopfronts or—he emphasizes scornfully—in the decoration of railway stations: a building devoted to speed of travel should not have ornaments designed for the lingering eye; such belong instead where the eye is at rest, where leisure gives time for contemplation. "We have," he notes, "a bad habit of trying to disguise disagreeable necessities by some form of sudden decoration" (8:160). Ornament is fine in theory, but when it comes to Victorian England, there are few places he finds it appropriate. And so Ruskin is led to espouse an architecture of functionalism as the style appropriate to a modern industrial society.

If the strength of *The Seven Lamps of Architecture* is its anticipation of the architectural renaissance of the twentieth century, its weakness is Ruskin's inability to imagine that renaissance. He is only able to judge among existing styles; he cannot conceive of a new one. He does not recognize that there might be a style right for the railway station, expressive of the speed and efficiency railroads epitomized to his countrymen. When he attempts to recommend a style appropriate for Victorian England, he can only list four from the past—Pisan Romanesque, early Gothic of the western Italian republics, Venetian Gothic, and English earliest decorated—and conclude that "the most natural, perhaps the safest choice, would be of the last" (8:258).

Ruskin's attitude toward structural ironwork is the best evidence of this failure to imagine an architectural style of the future. "True architecture," he assumes, "does not admit iron as a constructive material" and such works as use iron for support "are not architecture at all." His rationale for this assumption is worth setting forth in detail: Since architecture "is necessarily the first, of arts," it "will always precede, in any barbarous nation, the possession of the science nec-

essary either for the obtaining or the management of iron." For this reason, its earliest forms "depend on the use of materials accessible in quantity, and on the surface of the earth; that is to say, clay, wood, or stone." And so, if architecture is to maintain "consistency of style, it will be felt right to retain as far as may be, even in periods of more advanced science, the materials and principles of earlier ages." This is the case because materials determine principles, and therefore "every idea respecting size, proportion, decoration, or construction, on which we are at present in the habit of acting or judging, depends on presupposition of such materials" (8:66–67).

It is easy to see the weakness of this argument, which favors sterile academism over innovation. Viewed from a late twentieth-century perspective, Ruskin's prohibition of structural iron appears to place him foremost among reactionaries. To understand his true position, however, one must understand both the significance Ruskin attributed to architecture and his notion of an architectural style. Architecture, he contends, "must be the beginning of arts": "the prosperity of our schools of painting and sculpture . . . depends upon that of our architecture" (8:255). This dependence is true for all times; however, architecture in modern times has yet another, even more important, role. For modern man, alienated from the influence of the natural world by the rush and turmoil of industrial civilization, "the only influence which can in any wise . . . take the place of that of the woods and fields, is the power of ancient Architecture" (8:246). There are two elements to this power. One is inherent in architecture itself—in the sheer power of its physical presence. The other is a function either of its history or of its participation in historical tradition.

Ruskin vehemently opposes "restoration" because it attempts to ignore the passage of time. For him, architectural style is a means of integrating society with its history. It is a mode of continuity in time that is at once a form of historical knowledge and a concrete link between past, present, and future. To perform this function, architecture cannot simply copy an earlier style. It must be conceived in the style indigenous to a nation. Hence, the style Ruskin recommends to his countrymen is English decorated, not because it is his favorite, but because it is native to England.

An architectural style that is truly indigenous becomes a uniquely expressive medium. Indeed, "the architecture of a nation is great only when it is as universal and as established as its language" (8:252). To work in such a style—to wield its enormous power of expression—is

necessarily to submit oneself to it: "the work shall be that of a *school*," and "no individual caprice shall dispense with, or materially vary, accepted types and customary decorations" (8:252). Yet working within the constraints of a national style, while it entails obedience, is, Ruskin believes, not a stifling of individual creativity, but the means to freedom:

> Freed from agitation and embarrassment of that liberty of choice which is the cause of half the discomforts of the world; freed from the accompanying necessity of studying all past, present, or even possible styles; and enabled, by concentration of individual, and co-operation of multitudinous energy, to penetrate into the uttermost secrets of the adopted style, the architect would find his whole understanding enlarged, his practical knowledge certain and ready to hand, and his imagination playful and vigorous, as a child's would be within a walled garden, who would sit down and shudder if he were left free in a fenceless plain. (8:259)

Working within a school, architects would participate in a cooperative enterprise. Freed from the enforced "originality" of modernism, they would be more willing to learn from one another. And because their work would be determined by a universal style, it would be accessible to the people of the nation. It would be able to shape their feelings and lead their thoughts in a manner lost to the architecture of originality. Moreover, because it would be a national style, it would be applicable to all forms of building, grand or humble. There would be an improvement in all work and a generally integrated appearance to cities and towns.

Ruskin qualifies this notion of a national school in "The Lamp of Life," arguing that the "dignity and pleasurableness" of architecture depend "in the utmost degree, upon the vivid expression of the intellectual life which has been concerned in their production" (8:191). Opposed to this "intellectual life" is the "false life . . . of custom and accident in which many of us pass much of our time in the world" (8:192). Although he is to work within the guidelines of a school, Ruskin's ideal architect is never merely a creature of conventionalisms. His work, if it is good work, must be an expression of his individual vitality. And this criterion extends to the workmen as well: "I believe the right question to ask, respecting all ornament, is simply this: Was it done with enjoyment—was the carver happy while he was about it? It may be the hardest work possible, and the harder because so much pleasure was taken in it; but it must have been

happy too, or it will not be living" (8:218). Thus, an architectural style must be a medium of vital joy to all who labor in it; otherwise, it is more than tritely conventional. "There is a Gothic church lately built near Rouen," Ruskin writes, "vile enough, indeed, in its general composition, but excessively rich in detail; many of the details are designed with taste, and all evidently by a man who has studied old work closely. But it is all as dead as leaves in December; there is not one tender touch, not one warm stroke, on the whole façade. The men who did it hated it, and were thankful when it was done" (8:218).

Writing about architecture, Ruskin finds himself writing about the loves and hates of his fellow human beings. They have become important to him, not as responses to a predetermined order, but as the determinants of order itself. This lesson Ruskin will never forget.

The Stones of Venice (1851–53)

"Since first the dominion of man was asserted over the ocean, three thrones, of mark beyond all others, have been set upon its sands: the thrones of Tyre, Venice, and England." With these words Ruskin commences a book ostensibly about the architecture of an Italian city, but, at heart, about the mercantile power of nineteenth-century England. The thrones of Tyre and Venice, he notes, have fallen; "the Third, which inherits their greatness, if it forget their example, may be led through prouder eminence to less pitied destruction" (9:17). Ruskin's discourse will wander from the fate of his countrymen, but its ultimate justification is its ability to avert the disaster he had begun to fear would befall them. Venice, he explained in a letter to his father, "is simply a heap of ruins, trodden under foot by such men as Ezekiel describes, xxi. 31; and *this* is the great fact which I want to teach" (9:xxxvi).

The preface to the third edition (1874) of *The Stones of Venice* summarizes the contents of the three volumes:

The first contains an analysis of the best structure of stone and brick building, on a simple and natural scale. . . .

The second and third volumes show how the rise and fall of the Venetian builder's art depended on the moral or immoral temper of the State. It is the main purpose of the book to do this; but in the course of the demonstration it does two other pieces of work besides. It examines the relation of the life of the workman to his work in mediaeval times, and its necessary

relation to it at all times; and it traces the formation of Venetian Gothic from the earliest Romanesque types until it perished in the revival, so called, of classical principles in the 16th century. (9:14)

Ruskin's analysis of structure in volume 1 ("The Foundations") is based on careful study of individual buildings, but his approach is theoretical. "The man who first propped a thatched roof with poles" discovered the principle of the shaft (9:113), but this probable "fact" is of no interest to Ruskin. There is no reason, he insists, to assume that "the order of architectural features which is most reasonable in their arrangement, is most probable in their invention" (9:113).

His own derivation of the shaft begins with a threefold division of architecture into three basic elements—walls, roofs, and apertures. Walls perform two functions—partition or enclosure, in which case "it remains a wall proper," and sustaining vertical or lateral pressure: "If the pressure becomes very great, it is gathered up into *piers* to resist vertical pressure, and supported by *buttresses* to resist lateral pressure" (9:75). A wall which ceases to function for partition or enclosure but continues to sustain vertical pressure readily evolves into a line of piers. A pier (or shaft) is thus defined as "a coagulated wall" (9:100).

Given this theoretical derivation for the shaft—which typifies Ruskin's treatment of structural members—it follows that the form of the shaft will be modeled on the form of the wall. The base of the wall becomes the base of the column; the cornice of the wall "is cut to pieces, gathered together, and becomes the capital of the column" (9:102). And the special forms taken by base and capital simply indicate their specialized application to the wall's general function of sustaining pressure. The best forms are those that perform this function best: a column designed in such a way as to lessen its sustaining power is a bad column, even if it is still adequate to its job. However, form is not dictated by physical principles alone. It is not enough that a building be securely built; its design must convey the idea of that security, and so "features necessary to express security to the imagination are often as essential parts of good architecture as those required for security itself" (9:106).

Appearance of security is important because the ultimate test of architecture is its capacity to stir the imagination: "Much of the value both of construction and decoration, in the edifices of men, depends upon our being led by the thing produced or adorned, to some con-

templation of the powers of mind concerned in its creation or adorn-
ment" (9:64). Hence, the security we admire in a structure is not
produced by massive overbuilding, but by "the intelligence and reso-
lution of man in overcoming physical difficulty" (9:64).
Ruskin's theoretical analysis of architectural structure is, for this
reason, a celebration of human intelligence. His account of the shaft
leads—or should lead—us to admire the intellect that designed it.
Tradition, as he makes clear in *The Seven Lamps of Architecture,* is im-
portant. But to see architecture merely as the product of tradition,
built in a certain way because other buildings had been built that way
before, is to miss an awareness of the specific human intelligence be-
hind it. Conversely, we fully appreciate a traditional style only when
we grasp the collective mind of its builders. Hence, he denies the
theory that the precipitous vertical lines of Northern Gothic derive
from the spiritual aspirations of the Northern consciousness; they de-
rive, he asserts, from the need to throw off snow and the "natural
tendency" for men in wet climates "to live as high as possible, out of
the damp and the mist" (9:185).

If a Northern consciousness shows itself in Gothic architecture, it
does so, as we shall see, in the character of Northern ornamentation.
Intelligence manifests itself in structure; the affections in ornament.
Ideal architecture is a balance of both, but achieving this balance is
a problem for Ruskin. In *The Seven Lamps of Architecture,* he tried to
dismiss intelligence altogether, but his distinction between "architec-
ture" and "building" proved untenable. In *The Stones of Venice,* he
grants structure and ornament equality, but denies their interdepend-
ence: "Above all, do not try to make all these pleasures reasonable,
nor to connect the delight which you take in ornament with that
which you take in construction or usefulness. They have no connec-
tion; and every effort that you make to reason from one to the other
will blunt your sense of beauty, or confuse it with sensations alto-
gether inferior to it" (9:72).

The format of *The Stones of Venice* carries out this injunction by di-
viding the analysis of structure from the analysis of ornament. But
this division is not always sustained. Features, such as the cusps on
the inside of arches, which might be classed as ornamental, Ruskin
justifies in terms of structure. Indeed, his delight in being able to
discover a structural rationale for the cusp suggests Ruskin's under-
lying preference for structural explanations. And when he argues that
there can be "no specific decoration" of the lintel because "it has no

organism to direct its principle" and that, in contrast, "the archhead has a natural organism, which separates its ornament into distinct families" (9:388), he implies the general principle that the form of ornament is determined by the form of structure.

If we ask, then, why Ruskin insists upon denying the relationship between structure and ornament, several responses suggest themselves. He felt the need to oppose a utilitarian view of architecture. In an age defined by its concern with profit and loss, he wanted to affirm the values of love and affection—of beauty, although he would not have called it that, for its own sake—underlying ornamentation. At the same time, his desire to read architecture as the expression of cultural values encouraged him to emphasize its purely expressive elements, and this emphasis necessarily privileged ornament, since it is the element of architecture most akin to written language. Finally, Ruskin's denial of a relationship between structure and ornament suggests his inability to connect the notion of structural determination learned from his architectural studies with the notion of beauty advanced in *Modern Painters*. As long as he could explain beauty as a response to God-created natural form or its representation, he was comfortable. But when the response to architecture is a response to human creativity, it replaces a vision of the world based on the immutable laws of God with one based on the mutability of human behavior. And this, Ruskin, with his deep-seated need for order, was unable to accept.

The stones of Venice are important because Venice itself—in ways he had yet to fully understand—is important to Ruskin. His decision to spend two winters in Venice with Effie identified the city with his own adulthood, with his freedom from the authority of his parents and, despite the failure of his marriage, his adult sexuality. Byron had taught him to associate the city with self-indulgence and amorality; the artists of Venice—Tintoretto, Veronese—taught Ruskin to respond to his own sensuality. The city, both as he conceived of it and as he seems to have experienced it, is a locus of confrontation and change. In *The Stones of Venice,* volume 1, he wrote of it as the place where the characteristics of the Northern and Southern races, Lombard and Arab, met in their struggle over the ruins of classical civilization: "Opposite in their character and mission, alike in their magnificence of energy, they came from the North and from the South, the glacier torrent and the lava stream: they met and con-

tended over the wreck of the Roman empire; and the very centre of
the struggle, the point of pause of both, the dead water of the op-
posite eddies, charged with embayed fragments of the Roman wreck,
is VENICE" (9:38). Venice is the city where North meets South; it is
also the city where East meets West—where Byzantine architec-
ture (Roman style modified by Oriental love of color and surface or-
nament) gave way to Gothic. And, foremost within the plan of *The
Stones of Venice,* it is the city where historical periods come together—
where the remnants of the classical world meet the Middle Ages;
where the Middle Ages are in turn supplanted by the Renaissance; where
the relics of this remarkable architectural history are confronted by
the modern consciousness.

Venice, too, is the place where economics and religion intermin-
gle. The history of the city and therefore its architecture witness the
relationship between commercial power and religious feeling. And
both are influenced by questions of politics—the conditions that led
to the founding of a city on a tidal flat and, later, to its wealth and
power—and of geography—the tidal flat itself, including the exact
rise and fall of tides that determined the proportions of its buildings,
the proximity to or distance from the materials that gave them their
characteristic appearance, the place of Venice in the Mediterranean
basin that enabled it to become a dominant mercantile power. Thus,
if the Ducal Palace of Venice "is the central building of the world"
(9:38), it is so not only because its architecture reflects elements of
the Roman, Arab, and Lombard imagination, but also because the
palace, along with its companion structure, St. Mark's, is overdeter-
mined by the economics, religion, politics, geography, and geology
of Venice.

These conditions gave birth to the first of the three architectural
periods in which the city flourished. Ruskin's account of Venetian
Byzantine style, which opens volume 2 ("The Sea-Stories") follows
the model of volume 1, deducing architectural form from material
considerations—in this instance, from the fact that the exteriors of
buildings were encrusted with stone. The surviving Byzantine struc-
ture is St. Mark's, and the two characteristics of St. Mark's that ex-
emplify Byzantine architecture are its harmonious proportions and its
rich use of color. The five doorways at the front of the church typify
the Byzantine architect's intuitive notion of variation in proportion.
Relying on no mathematical model, he nevertheless designed with a
sense of the most harmonious relations between structural elements.

At the same time, his feeling for color is "the root of all the triumph of the Venetian schools of painting" (10:172).

Venetian Byzantine is remarkable in part because it continued to flourish after the architectural style of the mainland had become Gothic. This fact accounts for two characteristics of Venetian design: its late Byzantine architecture shows the healthy influence of Gothic and its Gothic, although not the finest example of the school, is from the start highly developed.

To understand Venetian Gothic and the way in which Gothic architecture might have influenced Byzantine, one must understand the nature of Gothic itself. The style, while it can be identified with certain structural forms, is the reflection of a spirit. The chapter "On the Nature of Gothic" in *The Stones of Venice,* volume 2, in which Ruskin defines this spirit is one of the central statements of his career.

The structural forms that define Gothic Ruskin summarizes as " '*Foliated* Architecture, which uses the pointed arch for the roof proper, and the gable for the roof-mask' " (10:260). Instead of the lintel or curbed arch used, respectively, by Greek and Roman builders, the pointed arch is the method of support characteristic of Gothic architecture. The roof (or "roof-mask") that covers and protects that system of support is a gable, both because a gable is the right form to cover a pointed arch and because it is also the best roof for throwing off snow and rain. Foliation Ruskin defines as "the adaptation of the forms of leafage" (10:256) to architectural ornament. Cusps are an example of foliation at its simplest. Either as cusps or as perforations in the stone, foliation accounts for the traceries that come to fill the arches of later Gothic.

The characteristic shared by these three elements is their capacity for variation. Unlike the curved arch, the pointed arch is susceptible to infinite variation in form. And as the arch varies, so must the gable above it. Foliation, as its name suggests, partakes of the boundless variety of plant life from which it is imitated. This capacity for variation enables Ruskin to identify Gothic architecture with the complex mentality of the Northern race—with, that is to say, his own race, and so with his own mind.

"The Gothic spirit within us" (10:182) he analyzes into six "characteristic or moral elements" (10:184): (in order of importance) Savageness, Changefulness, Naturalism, Grotesqueness, Rigidity, and Redundance. These characteristics he further identifies with six traits

of the Gothic builders: Savageness or Rudeness, Love of Change, Love of Nature, Disturbed Imagination, Obstinacy, and Generosity.

The Savageness of Gothic is in part a function of the savageness of the North itself—of fierce weather and rugged terrain. There is no indignity in the work of the Northern builder, who, "with rough strength and hurried stroke, . . . smites an uncouth animation out of the rocks which he has torn from among the moss of the moorland, and heaves into the darkened air the pile of iron buttress and rugged wall, instinct with work of an imagination as wild and wayward as the northern sea" (10:187). However the Savageness of Gothic is more than a function of climate; it is also a sign of religious principle. The flawless, standardized ornamentation of Greek architecture was only possible by reducing the inferior workman to the status of slave, totally obedient to a master designer. Christianity, with its respect for "the individual value of every soul" (10:190), calls for an architectural style that engages the highest faculties—the thoughtfulness, the imagination, and the love—of the workman. Admittedly, in the average person those faculties fall short of perfection. But it is in embracing that imperfection that "the savagery or rudeness" of Gothic architecture affirms its Christian origins, not only elevating the workman from the slavery of "servile ornament," but, in acknowledging its own imperfection, also teaching a lesson in humility.

These reflections lead Ruskin from the specific issue of Gothic architecture to the general view that to demand perfect workmanship is to reduce a thinking being into an animated tool. Nor does this rule only apply to the work of the laborer: *the demand for perfection is always a sign of a misunderstanding of the ends of art.* The mind of the artist "is always far in advance of his powers of execution." Moreover, imperfection is not only a sign of the imperfect but nevertheless real force of the individual worker; it is also a sign of life: "Nothing that lives is, or can be, rigidly perfect; part of it is decaying, part nascent. The foxglove blossom,—a third part bud, a third part past, a third part in full bloom,—is a type of the life of this world" (10:202–3).

Turning to Victorian England, Ruskin sees all around him examples of the misconceived demand for perfection. When he considers the lot of the laborer, this demand is a form of enslavement. To combat this slavery, he offers three rules:

 1. Never encourage the manufacture of any article not absolutely necessary, in the production of which *Invention* has no share.

2. Never demand an exact finish for its own sake, but only for some practical or noble end.

3. Never encourage imitation or copying of any kind, except for the sake of preserving records of great works. (10:196–97)

These three rules attack the system of division of labor and therefore the factory system itself. Just where this attack led Ruskin's social theory will be explored in later chapters.

In purely aesthetic terms, however, Ruskin repudiated mass-production for much the same reason he repudiated the neoclassical concept of "general nature" in *Modern Painters*. If each human action is meaningful, then its product must share that individuality. His ideal of what manufacture might be is exemplified by Venetian glass:

Our modern glass is exquisitely clear in its substance, true in its form, accurate in its cutting. We are proud of this. We ought to be ashamed of it. The old Venetian glass was muddy, inaccurate in all its forms, and clumsily cut, if at all. And the old Venetian was justly proud of it. For there is this difference between the English and Venetian workman, that the former thinks only of accurately matching his patterns, and getting his curves perfectly true and his edges perfectly sharp, and becomes a mere machine for rounding curves and sharpening edges; while the old Venetian cared not a whit whether his edges were sharp or not, but he invented a new design for every glass that he made, and never moulded a handle or a lip without a new fancy in it. And therefore, though some Venetian glass is ugly and clumsy enough when made by clumsy and uninventive workmen, other Venetian glass is so lovely in its forms that no price is too great for it; and we never see the same form in it twice. (10:199–200)

The Changefulness of Gothic is closely related to its Savageness. If imperfection is the price paid, variety is the reward received, for giving the inferior workman his independence. However, we are so accustomed to the sameness and repetitiveness of Renaissance architecture, that the changefulness of Gothic may not immediately strike us as a virtue:

It requires strong effort of common sense to shake ourselves quit of all that we have been taught for the last two centuries, and wake to the perception of a truth just as simple and certain as it is new: that great art, whether expressing itself in words, colours, or stones, does *not* say the same thing over and over again; that the merit of architectural, as of every other art, consists in its saying new and different things. (10:206)

The Naturalism of Gothic is an expression of the love of the Gothic worker for the forms of vegetation; and this love, as Ruskin was to explain in *Modern Painters,* volume 3, represents an important historical change in the intellect and affections of the human race.

In that careful distinction of species, and richness of delicate and undisturbed organization, which characterize the Gothic design, there is the history of rural and thoughtful life, influenced by habitual tenderness, and devoted to subtle inquiry; and every discriminating and delicate touch of the chisel, as it rounds the petal or guides the branch, is a prophecy of the development of the entire body of the natural sciences, beginning with that of medicine, of the recovery of literature, and the establishment of the most necessary principles of domestic wisdom and national peace. (10:237)

Ruskin postpones his examination of the Grotesque until the final volume of *The Stones of Venice,* taking it for granted that anyone familiar with Gothic architecture will have noted its "tendency to delight in fantastic and ludicrous . . . images" (10:239). The Rigidity of Gothic is "*active* rigidity; the peculiar energy which gives tension to movement, and stiffness to resistance, which makes the fiercest lightning forked rather than curved, and the stoutest oak-branch angular rather than bending . . ." (10:239). It, more than any other of the elements of Gothic, is a reflection of the Northern landscape. But it has its moral analogue in the "strength of will, independence of character, resoluteness of purpose, impatience of undue control, and that general tendency to set the individual reason against authority, and the individual deed against destiny" (10:241) characteristic of the Northern tribes. Indeed, "the moral habits to which England in this age owes the kind of greatness that she has,—the habits of philosophical investigation, of accurate thought, of domestic seclusion and independence, of stern self-reliance and sincere upright searching into religious truth" (10:242–43) can be traced, Ruskin believes, to the Rigidity of Gothic.

In contrast to the self-assertiveness of its Rigidity, the Redundance or Generosity of Gothic, Ruskin's final category, is an expression of humility. An architecture that does not pretend to perfection attempts to please through its accumulation of ornament. But Redundance is also a sign of sacrifice—of the unselfish desire to expend labor on the ornamentation of a building—and of the love of nature itself in its lavish abundance.

These six character traits offer Ruskin a vocabulary for the close

reading of Venetian Gothic he applies, first to the Gothic palaces of the city, then, in the extended chapter that closes *The Stones of Venice,* volume 2, to the Ducal Palace.

Volume 3 of *The Stones of Venice* ("The Fall") treats the third period of Venetian architecture—the Renaissance. Ruskin repeatedly proclaims "the architecture of the last three centuries to have been wrong; wrong without exception; wrong totally, and from the foundation" (11:356). But his case against the Renaissance, although more carefully reasoned than his dogmatism may suggest, remains the most questionable section of the work. It may be generally correct—Venice did suffer a decline during the period in which its dominant architectural style was that of the Renaissance—but Ruskin is unable to substantiate his thesis that moral decline and Renaissance architecture are linked by cause-and-effect: that weak morals necessarily produce weak art.

He acknowledges that it was not the strength of Renaissance style—its reintroduction of Roman architectural forms—but the decadence of late Gothic that led to the "victory" of the Renaissance. In its decadence, the rich variety of late Gothic became "voluptuous, and overwrought," and in contrast the plain lines and general severity of Renaissance architecture "had the appearance of a healthy movement. A new energy replaced whatever weariness or dulness had affected the Gothic mind" (11:14,15). In place of this "weariness or dulness," the artists of the fifteenth century offered "a perfection of execution and fulness of knowledge that cast all previous art into the shade, and which, being in the work of those men united with all that was great in that of former days, did indeed justify the utmost enthusiasm with which their efforts were, or could be, regarded" (11:14). Moreover, the greatest masters of the Renaissance—Michael Angelo, Raphael, Leonardo—gave the movement the sanction of their genius and originality; and the best examples of early Renaissance architecture, typified by the Casa Grimani in Venice, were masterpieces of design and construction: "There is not an erring line, nor a mistaken proportion, throughout its noble front; and the exceeding fineness of the chiselling gives an appearance of lightness to the vast blocks of stone out of whose perfect union that front is composed" (11:44).

The failure of the Renaissance lay in its subsequent development—in the spirit to which the rediscovery of classical models gave birth

and which, in turn, vitiated their architectural value. Once perfection had been exhibited in any of the arts, "it was required everywhere; the world could no longer be satisfied with less exquisite execution, or less disciplined knowledge" (11:14–15). And the demand for perfect execution and self-evident knowledge, whatever its value in the other arts, was particularly inappropriate to architecture, in which the work of the designer and the work of the laborer are all too readily divided. By the logic set forth in the earlier chapter "On the Nature of Gothic," Renaissance perfectionism meant the ruin of architecture.

Thus, it is not the Roman style itself that is bad—although it is a style Ruskin believes inferior to Gothic—but the spirit that espoused Renaissance classicism as the highest form of architecture. This spirit, like the spirit underlying Gothic, Ruskin analyzes in detail. Pride and Infidelity are the two characteristics of the post-Gothic mentality. Pride falls into three categories: Pride of Science, Pride of State, and Pride of System.

To explain Pride of Science, Ruskin argues that "the grand mistake of the Renaissance schools lay in supposing that science and art were the same things, and that to advance in the one was necessarily to perfect the other" (11:47). This supposition ignores the fundamental distinction between science, which "deals exclusively with things as they are in themselves" and art, which deals "exclusively with things as they affect the human sense and human soul" (11:47–48). Human beings see the world in perspective, but to call special attention to the rules by which the artist records perspective is to direct attention from the subject of the painting to the technical training of the painter. The structure of bones and muscles determines the form of a human arm, but to make the spectator aware of bones and muscles instead of the arm itself is to sacrifice the artistic truth of appearance to the scientific truth of anatomy.

This distinction, which reappears in *Modern Painters* as the distinction between the Science of Aspects and the Science of Essences, has more bearing on art than on architecture. Indeed, there is a sense in which it does not apply to architecture, because the expression of underlying structure is a legitimate source of architectural power. For this reason, when Ruskin turns from art to architecture, he shifts the grounds of his argument from the distinction between science and art to a distinction between the scientist and the artist in relationship to their respective audiences. The Gothic building is an expression of the individuality of its builders; the Renaissance building is an

expression of a set of abstract principles and precedents; hence, the Gothic building can address us as one human being speaks to another, while the Renaissance building demonstrates its architect's submission to a predetermined order, makes us aware of how well or poorly the architect has mastered that order, but communicates nothing of the individuality of the architect.

Pride of State is the "expression of aristocracy in its worst character; coldness, perfectness of training, incapability of emotion, want of sympathy with the weakness of lower men, blank, hopeless, haughty self-sufficiency" (11:74). It is reflected in an architecture that deliberately sets out to overawe the common man by its sheer size and to appeal to the tastes of an erudite few. The Renaissance architect "proclaims to us aloud. 'You cannot feel my work unless you study Vitruvius. I will give you no gay colour, no pleasant sculpture, nothing to make you happy; for I am a learned man' " (11:74–75).

Ruskin argues this point forcefully in a detailed contrast between the sculptured tombs of the Gothic and those of the Renaissance periods. The latter grow more secularized with time; symbols of religious piety give way to emblems of worldly power and the fear of death, which replaces the recumbent figures of the deceased, carved in attitudes of sleeplike death, with standing figures of the living, decked in the spoils of wealth or conquest.

Pride of System, "the curious tendency to formulization and system which, under the name of philosophy, encumbered the minds of the Renaissance schoolmen" (11:115), is closely related to Pride of Knowledge. In architecture, it showed itself as the desire to limit the forms of building to a set of rigorously defined classical precedents. Ruskin contemptuously dismisses the notion of "five perfect forms of columns and architraves" with "a fixed proportion to each": "Five orders! There is not a side chapel in any Gothic cathedral but it has fifty orders, the worst of them better than the best of the Greek ones, and all new; and a single inventive human soul could create a thousand orders in an hour" (11:119).

While it is easy to ridicule arbitrary rules, however, it is less easy to do so without espousing lawlessness. Ruskin is aware that he must distinguish the systematization of the Renaissance from the notion of obedience to a national school of architecture he advocated in *The Seven Lamps of Architecture*. This he accomplishes by suggesting that obedience to a true national school is obedience to a "higher and unwritten law" (11:116).

Submission to the written law is tempting because it subtly paro-

dies submission to the unwritten. But "all written or writable law respecting the arts is for the childish and ignorant. . . . For the true artist has that inspiration in him which is above all law, or rather which is continually working out such magnificent and perfect obedience to supreme law, as can in nowise be rendered by line and rule" (11:117). A national school of architecture is not a set of written laws, Ruskin implies, but a medium in which the artist works out his own inspiration.

The Infidelity of the Renaissance Ruskin relates, perhaps surprisingly, to its love of system. He does not attribute the decline of religious faith to the study of pagan authors; however, coinciding as it did with the decline of medieval Christianity, the rediscovery of the Greek and Roman classics "was itself productive of an effect tenfold greater than could have been apprehended from it at another time" (11:127). The study of a literature unrelated to the religious beliefs of Christianity tended to divorce literary style from its content. It led "the attention of all men to words instead of things." "To this study of words, that of forms being added, both as of matters of the first importance, half the intellect of the age was at once absorbed in the base sciences of grammar, logic, and rhetoric; studies utterly unworthy of the serious labour of men, and necessarily rendering those employed upon them incapable of high thoughts or noble emotion. Of the debasing tendency of philology, no proof is needed beyond reading a grammarian's notes on a great poet: logic is unnecessary for men who can reason" (11:127–28).

This attack on logic—on the substitution of a formal system of thought for thought itself—suggests that Ruskin was coming to understand both the strengths of his own mind—strengths that defy the rules of formal logic and disrupt his own attempts at systematization—and the inadequacy of a view of the mind and therefore human discourse grounded in abstract reason. The Renaissance, in idolizing the system of language, ignored the essential incompleteness of verbal expression—the incompleteness that leads to meditation and the recovery of unexpressed meaning.

Earlier in volume 3 of *The Stones of Venice* Ruskin had enunciated a prophecy that only now becomes fully understandable:

I trust that some day the language of Types will be more read and understood by us than it has been for centuries; and when this language, a better one than either Greek or Latin, is again recognized amongst us, we shall

find, or remember, that as the other visible elements of the universe—its air, its water, and its flame—set forth, in their pure energies, the life-giving, purifying, and sanctifying influences of the Diety upon His creatures, so the earth, in its purity, sets forth His eternity and His TRUTH. (11:41)

The "language of types" (or typology) is, of course, the technique of reading nature Ruskin practiced in *Modern Painters,* volumes 1–2.[1] It has its origins in his study of the Bible, in the tradition of reading theological or moral significance into historical events of the biblical narrative—in particular, seeing events in the Old Testament as prefiguring those of the New. Dante, whom Ruskin holds up as the exemplary medieval genius, is the master of typology: the three levels of symbolic meaning underlying the literal story of his *Divine Comedy* demand a response from the reader incompatible with the Renaissance concerns for logic or rhetorical style. Their significance is not in the abstract "logic" of Dante's narrative; rather, it can only be understood in terms of the totality of Christian religious belief—religious belief that holds the clue to Dante's meaning but is in turn enriched by the act of typological interpretation.

Biblical typology thus offered Ruskin the model of a mode of discourse in which significance was not determined by abstract logic, but by the place of the human mind both in history and in its own individual development; and in which language functioned dialectically, transforming its own meaning as it transforms the human consciousness by which it is employed.

Ruskin develops his contrast between the Gothic mind and the Renaissance (or modern) mind in the penultimate chapter of *The Stones of Venice,* "Grotesque Renaissance." He argues that the Grotesque is composed of two elements: the ludicrous (playful) and the fearful (11:151). Gothic playfulness is the expression of necessary rest from labor; Renaissance, the forced pleasure-taking of the self-indulgent. Gothic fearfulness expresses, albeit incompletely, confrontation with the genuine terrors of human existence; Renaissance, the attempt to rouse the jaded imagination through representations of ugliness or monstrosity. Ruskin analyzes this distinction in considerable detail. At its core, however, is a simple principle: Gothic (or noble) Grotesque is part of a noble vision, part of a whole life; Renaissance (or ignoble) Grotesque is adventitious: it does not express experience but attempts to evoke it; it is a sign without a signified, a system of language without meaning.

Interestingly enough, one of Ruskin's examples of that form of the noble Grotesque that derives from the ungovernableness of the imagination is human dreaming:

The grotesque which comes to all men in a disturbed dream is the most intelligible example of this kind, but also the most ignoble; the imagination, in this instance, being entirely deprived of all aid from reason, and incapable of self-government. I believe, however, that the noblest forms of imaginative power are also in some sort ungovernable, and have in them something of the character of dreams; so that the vision, of whatever kind, comes uncalled, and will not submit itself to the seer, but conquers him, and forces him to speak as a prophet, having no power over his words or thoughts. (11:178)

Furthermore, he connects this notion of dream symbolism with biblical typology:

so far as the truth is seen by the imagination in its wholeness and quietness, the vision is sublime; but so far as it is narrowed and broken by the inconsistencies of the human capacity, it becomes grotesque; and it would seem to be rare that any very exalted truth should be impressed on the imagination without some grotesqueness; in its aspect, proportioned to the degree of *diminution of breadth* in the grasp which is given of it. Nearly all the dreams recorded in the Bible,—Jacob's, Joseph's, Pharaoh's, Nebuchadnezzar's,—are grotesques; and nearly the whole of the accessory scenery in the books of Ezekiel and the Apocalypse. (11:181)

Ruskin suggests an important connection between the language of types and the language of dreams—in twentieth-century terms, the language of the unconscious mind. Typology, so conceived, holds out the possibility of understanding not only religious truths, but human truths as well; of grappling with the hidden depths and rational inconsistencies of human behavior. Ruskin is beginning to recognize the significance of "that mode of symbolical expression which appeals altogether to thought, and in nowise trusts to realization" (11:212).

In the closing chapter of *The Stones of Venice,* he argues that art is valuable both because it is "the work of the whole living creature, body and soul" and because "it likewise *addresses* the whole creature" (11:212–13). As he turns from Venice to nineteenth-century England, it is this possibility of an architecture that both expresses and addresses "the whole creature"—that "expresses the personality, activity, and the living perception of a good and great human soul" (11:201)—not his anticlimactic advocacy of modern Gothic, that continues to pose a challenge to the modern world.

Chapter Four

The End of the Beginning:
Modern Painters, volumes 3–5

The "Lectures on Architecture and Painting" Ruskin delivered in Edinburgh in 1853 were largely a collection of opinions drawn from the first volumes of *Modern Painters* and his works on architecture. However, they differed from these earlier writings in one important respect: they were addressed to a specific audience able to act upon what he had to say—to men who could buy paintings and build buildings. Ruskin flatters them with the assurance that "it is in your own private houses that the real majesty of Edinburgh must consist" (12:16); he addresses their practical sense with the argument that it is not beauty but "architectural ugliness that is costly" (12:57); and he grounds his appeal not in abstract principle but in concrete experience: "There is no law of right which consecrates dulness. The proof of a thing's being right is, that it has power over the heart; that it excites us, wins us, or helps us" (12:18). The art and the architecture he advocates are not, in other words, the privilege of a few; they are available to all persons who trust their natural feelings.

These emphases are rhetorical: they are aimed at persuading a particular audience at a particular time and place. But they also suggest the influence the presence of an audience could have on Ruskin's thought. In 1853 he had yet to become a widely known author. But he was no longer writing—or speaking—in a vacuum. And his awareness of an audience led Ruskin away from the highly artificial prose of *Modern Painters,* volume 2, to a style still richly complex, but closer to the rhythms of his own speaking voice. And it also encouraged a concern for art, not as a kind of religious sacrament, but as a human activity—created by human beings for human beings.

The Edinburgh lectures are no breakthrough in Ruskin's thought; rather, they suggest a dividing point in his career, at which he is caught between two roles—the quasi-clerical spokesman for immutable truth, whose lofty style is a reflection of his subject matter; and the man speaking to men, in search of practical means to improve his

society. The *Edinburgh Guardian* recognized this division in his lecture style itself: "Properly speaking, there were in the lectures two styles essentially distinct, and not well blended,—a speaking and a writing style; the former colloquial and spoken off-hand; the latter rhetorical and carefully read in quite a different voice,—we had almost said intoned."[1] These two voices continue their dialogue in Ruskin's writings of the later 1850s. Finding a way to blend them remained a problem to be solved.

Modern Painters, volume 3 (1856)

Its subtitle "Of Many Things" suggests that volume 3 of *Modern Painters* is less rigorously organized than volumes 1 and 2. However, it is simply organized in a new way. Ruskin's three major concerns are defining greatness of style in art, resolving the conflicts between truth and imagination apparent in his earlier formulation of the terms, and determining the moral value of art—specifically, of modern landscape painting. These are not, however, separate problems; Ruskin realized that the solution to one determined the solution to the others. And so his discussion moves back and forth among them, returning to points with an evolving grasp of their significance—a developmental strategy which, colored by occasional bits of autobiography, self-acknowledged digressions, and direct addresses to the readers, anticipates the technique of Ruskin's later writing, in which the complexities, even the contradictions, of the self become the model for literary form.

Ruskin's belief that certain artists and their work are of a higher order than others demands a concept of "Grand Style." But the concept of "Grand Style" he inherited from the eighteenth century faced him once again with the problem he had faced in *Modern Painters,* volume 1: advocating strict fidelity to detail without advocating photographic realism. He agrees with Sir Joshua Reynolds's notion that "Grand Style" entails something other than making the objects in a painting " 'seem real' " (5:20), but disagrees with his equation of greatness with " 'the invariable, the great and general ideas which are fixed and inherent in universal Nature' " (5:23–24). For if idealization means generalization, it is opposed to specificity, and " 'minute attention' " to specific natural detail must be " 'carefully avoided' " by the painter (5:21).

To identify himself with Reynolds's rejection of "seeming real" and

yet avoid this implication of Reynolds's theory, Ruskin must redefine the ideal so as to make it a function of detail. In the penultimate chapter of *Modern Painters*, volume 3, this effort will lead to Ruskin's differentiation of the Science of Aspects from the Science of Essences—a distinction which will, in turn, inform his later writing on science. He begins the line of argument that will lead—circuitously—to this conclusion, by acknowledging the possibility of a photographic realism that would indeed produce high art. But since a painter is great only if "he has laid open noble truths, or aroused noble emotions" (5:42), it follows that this possibility must be tested by its conformity to high art. Ruskin had answered this question in *Modern Painters*, volume 1, by observing that some truths are of greater significance than others, and that the artist who strives after deceptive realism sacrifices the greater for the sake of the lesser truth. But his notion of the relative importance of truths was based on theoretical assumptions rather than the actual human experience of art. Now, thirteen years later, the human experience of art—the practical matters of whether or not and, if it does, just how art can improve the lot of mankind—demand a new basis for his earlier opinion.

The characteristics of high art Ruskin enumerates in chapter 3—choice of a noble subject, love of beauty, sincerity, invention—do not in themselves evidence these concerns. But his explanation of them in subsequent chapters does. In particular, his effort to answer two related questions raised in his discussion of Beauty and Invention—"How may beauty be sought in defiance of truth?" and "How does the imagination show itself in dealing with truth?"—places the opposition between idealization and detail in the context of "men's proper business in this world" (5:70). The legitimate uses of the imagination (and that beauty which is imagined rather than factual) are, in order of importance: to visualize spiritual or religious truths; to re-create the events of the past; to invest mental truths with "some visible type in allegory, simile, or personification" (5:73); and to refresh the mind with harmless fantasies. Any other use of the imagination is an abuse. In dealing with religion or history, it is an abuse of the imagination to create false images instead of true ones; similarly, it is an abuse to use the lesser, fantasy-making capacities of the imagination to escape the hard facts of the here-and-now. Thus, realistic Christian art that idealizes events of biblical history, because the fact of idealization tends to undermine belief in their actuality, has not, on the whole, been of service to mankind (5:85). In contrast, religious art that idealizes truths that can only be grasped by the

imagination—the nature of paradise, the Last Judgement, etc.—
should be trusted "as possible statements of most precious truth"
(5:86).

In secular art, the pursuit of idealized beauty for its own sake now
appears to Ruskin a self-indulgent sensuality that turns its back on
the real condition of mankind—not, as in *Modern Painters*, volume 2,
an ignorance of the divine attributes expressed by Typical Beauty.
The development of this decadent idealization in secular art and the
decay of religious art that Ruskin identifies with the concern for tech-
nique instead of subject matter are both historical phenomena. And
their association with the Renaissance links the argument of *Modern
Painters*, volume 3, with that of *The Stones of Venice*, thus giving a
general coherence to Ruskin's writings on architecture and landscape
painting.

But Ruskin is not merely falling back on the argument of his ear-
lier work; the presence of history in *Modern Painters*, volume 3, marks
a necessary stage in the evolution of his theory of art. There were ref-
erences to history in the first and second volumes, but history was
not an essential component of their reasoning. The greatness of
Turner was a matter of absolute truth. In volume 3, the greatness of
Turner—and art in general—because it is a function of human needs
is also a function of the historical changes that bring about those
needs.

His three categories of legitimate ("true") idealism—Purist, Nat-
uralist and Grotesque—are not themselves limited to historical pe-
riods; however, they are "dispositions" that manifest themselves in
ways appropriate to specific historical periods. "Purist Idealism,"
Ruskin defines as the result of "the unwillingness of men whose dis-
positions are more than ordinarily tender and holy, to contemplate
the various forms of definite evil which necessarily occur in the daily
aspects of the world around them" (5:103–4). In an age of religious
piety, Purism will show itself in the idealized religious art of a Fra
Angelico, and it is under these conditions that Purism is most noble.
For without the backbone of religious faith, Purism degenerates from
naiveté into childishness and imbecility.

At the other extreme, Grotesque Idealism is a catch-all that in-
cludes all forms of art that seek neither idealized beauty nor plain
truth. The "irrational play of the imagination in times of rest"
(5:130) is a form of the Grotesque, as is art contemplative of evil.
That Ruskin associates these two functions suggests a fundamental

distrust of the unrestrained imagination—a fear, perhaps, of his own fantasy life. The "noble" expression of this class is allegory—the use of symbolism or typology to communicate truths that cannot be grasped by any other means.

Naturalist Idealism is not merely a mean between these two extremes: it is the product of technical skill and moral wisdom—of the evolution of the individual artist and his culture. As such, Ruskin's concept of Naturalist Idealism synthesizes the opposition between High Art and specific detail he objected to in Reynolds. Ruskin recognizes the apparent contradiction in his term: "The question is, therefore, how the art which represents things simply as they are, can be called ideal at all" (5:111). His answer falls back on the definition of Imagination Associative in *Modern Painters,* volume 2: the capacity to place and harmonize imperfect things in such a way "that they form a noble whole, in which the imperfection of each several part is not only harmless, but absolutely essential, and yet in which whatever is good in each several part shall be completely displayed" (5:111). This activity of the idealizing imagination is not simply a matter of rearranging predetermined objects. Great artists, Ruskin insists, "*see* what they paint before they paint it . . . whether in their mind's eye, or in bodily fact, does not matter" (5:114).

Ruskin's notion of the artist as visionary, "greater a million times in every faculty of soul than we" (5:187) was influenced by Thomas Carlyle, whose lectures *On Heroes, Hero-Worship and the Heroic in History* (1841) confirmed his Turner-idolatry and whose term "Natural Supernaturalism"[2] was the model for Ruskin's "Naturalist Idealism." However, the influence of Carlyle does not in itself explain Ruskin's insistence on the visionary role of the great artist. The shift in *Modern Painters,* volume 3, from the justification of art as "*the expression of a mind of a God-made great man*" (5:189) represents an effort to reground his philosophy of art, in which the weight of spiritual significance shifts from God to artist. *Modern Painters,* volume 3, requires an artist who is almost a god ("greater a million times in every faculty of soul than we") because he must take the place of the God of *Modern Painters,* volumes 1–2.

It follows from this notion that whatever the artist does to express his vision will be appropriate and necessary: that whatever else he does is superfluous and self-defeating. Finish for its own sake is merely an expression of the vanity of the artist and therefore wasted labor. Finish that adds to the expressive content of the work of art

"is always noble" (5:156): "labour without added knowledge can only blacken, or stain a picture, it cannot finish it" (5:164). This view does not, of course, explain why photographic realism is a sign of inferior art. Indeed, it seems to argue on behalf of absolute realism, for the greater, the more complete the artist's vision, the more finished his work of art. Moreover, Ruskin admits that, given the choice of a great painting of an Alp or the view of the Alp itself, he would prefer the real thing. The greatest art, in other words, falls short of perfection, for vision always exceeds technique. The fault of realism is not that it can be mistaken for the real thing, but that it accomplishes nothing more than that. Nature itself—the ultimate work of art—is both completely finished, completely "real," and infinitely significant.

But this admission raises yet another question. If art is necessarily less significant than nature, why bother with art? There are two answers. One returns us to the notion of the painter as *"a God-made great man,"* whose work is of interest to us because it is his self-expression. Such art may be less than nature, but it is also different from nature, and a worthy entity in its own right. The other answer raises yet another issue of major significance: the identity of modern consciousness.

It is not until volume 3 that Ruskin seems to recognize the full implication of his title *Modern Painters:* he is not merely treating a collection of artists who happen to live in the nineteenth century; he is defining the unique psychohistorical conditions that make these painters representative of their age. Landscape art, he recognizes in the title to chapter 11, is a "novelty" in the history of art. Interest in the external world as a thing in itself—both as an expression of beauty in itself (rather than as a background to human subjects) and as the object of scientific scrutiny—is a phenomenon of recent times in Western civilization.

To understand this phenomenon, he undertakes an extended examination of what he believes to be the dominant attitudes toward landscape in the classical and medieval periods. These chapters are among the most interesting in *Modern Painters.* In them, Ruskin undertakes to reconstruct a fragment of the history of human consciousness. His assumptions are often questionable—if only because they rely so strongly on his intuitions. We are free to doubt his assertion that the ancient Greek "lived, in all things, a healthy, and, in a certain degree, a perfect, life," having "no morbid or sickly feeling of

any kind" (5:230), and to question his image of the medieval knight talking "to the wayside flowers of his love, and to the fading clouds of his ambition" (5:253). But the effort itself, carried out largely through a close reading of representative literary texts, is Ruskin at his most brilliant.

What distinguishes his thought is his attempt to establish relationships—as, for example, between the religious beliefs of the Greeks and medieval Christians and their differentiation of the color spectrum. Ruskin tries to articulate a whole in which religious belief, economic and political systems, climate, geography, history, art, and literature are perceived as at once determinants and expressions of a single culture at a particular time in its development.

If classical and modern landscapes expressed different religious faiths, modern art expresses the want of faith (5:322). The two exemplars of the modern consciousness are Scott and Turner. And Scott, because of his particular faults and weaknesses, "is the representative of the mind of his age; and because he is the greatest man born amongst us, and intended for the enduring type of us, all our principal faults must be laid on his shoulders" (5:335–36).

Ruskin's examination of Scott (5:335–53) and the related chapter "On the Pathetic Fallacy" contain some of his most important criticism of literature. Indeed, the latter has given a term to the critical vocabulary.

By the "pathetic fallacy" Ruskin means the attribution of human characteristics (thoughts, emotions) to nature. This "fallacy" is acceptable when it expresses the intense feelings of a speaker; as conventionalized poetic diction, it is merely falsehood. And it is a falsehood Ruskin finds characteristic of the modern consciousness, unable to attribute the apparent purposefulness of the natural world to a god (as a Greek or medieval Christian would have done), but at the same time unwilling to treat it as a merely natural phenomenon.

Scott, Ruskin's representative modern, is not guilty of the pathetic fallacy, but he shares the modern "instinctive sense . . . of the Divine presence, not formed into distinct belief. In the Greek it created . . . the faithfully believed gods of the elements; in Dante and the mediævals, it formed the faithfully believed angelic presence: in the modern, it creates no perfect form, does not apprehend distinctly any Divine being or operation; but only a dim, slightly credited animation in the natural object, accompanied with great interest and affection for it" (5:341).

This affection Ruskin believes at the heart of the modern feeling for landscape. Insofar as it is an apprehension, however dim, of the divine, it is a wholesome instinct, and landscape painters whose work draws us to this affection improve our spiritual and physical lives. Yet there is a final problem to be solved before Ruskin can undertake his full-scale investigation of the truths of Turner's landscape paintings. Earlier in *Modern Painters*, volume 3, he distinguished between two experiences—his mistaking the glass roof of a workshop for an alp glittering in the sun and the actual experience of seeing the alp. The visual sensations were comparable, but not the total experience, because his perception of the real mountain was informed by his knowledge of its geological structure, its inhabitants, and his personal experience among its boulders. Such knowledge is integral to landscape art; "and, according to the degree of knowledge possessed, and of sensibility to the pathetic or impressive character of the things known, will be the degree of this imaginative delight" (5:178).

But too much knowledge has a deadening effect on the imagination: "let the reasoning powers be shrewd in excess, the knowledge vast, or sensibility intense, and it will go hard but that the visible object will suggest so much that it shall be soon itself forgotten, or become, at the utmost, merely a kind of keynote to the course of purposeful thought" (5:357). There is therefore potential conflict between natural science ("Truth," as Ruskin has been defining it) and the imaginative experience of nature. The natural sciences can raise us

from the first state of inactive reverie to the second of useful thought. . . . But in restraining us at this second stage, and checking the impulses towards higher contemplation, they are to be feared or blamed. . . . For most men, an ignorant enjoyment is better than an informed one; it is better to conceive the sky as a blue dome than a dark cavity, and the cloud as a golden throne than a sleety mist. (5:386–87)

There would seem, then, to be a limit to the factuality of landscape art—that is, if factuality is defined in terms of traditional science. Ruskin's solution to this dilemma is the "Science of Aspects"—"the study of the aspect of material nature" (5:353) as it appears to an ordinary human observer, in contrast to the "Science of Essences," which treats matters of internal structure and causality of no direct bearing on the appearance of a thing. Explaining the nature of this science will be the task of *Modern Painters*, volume 4.

Modern Painters, volume 4 (1856)

Volume 4 of *Modern Painters* is subtitled "Of Mountain Beauty," and more than half of the book is taken up with a detailed examination of mountain structure—Ruskin's first extended effort to practice the "Science of Aspects" he defined in volume 3. He takes up, in succession, the materials of mountains, the structures necessarily assumed by these materials, and the forms to which these structures are reduced by erosion. Much of this is indistinguishable from standard nineteenth-century geology. Although colored by his admiration for the late eighteenth-century manner of Horace Bénedict de Saussure,[3] Ruskin's observations rest on the dynamic vision of Sir Charles Lyell's *Principles of Geology* (first edition, 1830). He describes a mountainscape undergoing constant, gradual transformation. And the "aspects" of the scene to which he directs our attention are themselves expressions of process—the cleavage of weathering mountain summits, the forms taken by falling rock, the lines of eroding watercourses.

Yet the Science of Aspects is not the Science of Essences. Ruskin may rely on his knowledge of contemporary geology and his own painstaking observations in the Alps (and elsewhere), but his concerns go beyond those that were coming to be associated with natural science. The best example of this is his interest in curved lines. It is important to him that the "typical contour of a common crested mountain" is the same curve that expresses "the ruling forces of growth in a leaf" and "the base of form in all timber trees," that can be seen in the wings of birds and "the honeysuckle ornament of the Greeks." He induces "something, therefore, in this contour which makes its production one of the principal aims of Nature in all her compositions," and concludes with the rationale that "this is the simplest expression of opposition, in unequal curved lines" (6:243–44). In this respect, the Science of Aspects offers a means of perceiving disparate phenomena in terms of a single "law" of form—a synthesis that transcends the compartmentalization of knowledge into "geology," "botany," and the other "scientific" disciplines.

However, "all curvature . . . is not equally agreeable" (6:322), and Ruskin argues that "of two curves, the same in other respects, that which suggests the quickest attainment of infinity is always the most beautiful" (6:323). In contrast, a curve that can be completed—a circle, for example—is less beautiful, because it is finite. This reasoning is related to the notion of Typical Beauty in *Modern Painters,* volume 2,

but Ruskin now resists a theological explanation for the differences
between these two kinds of curvature. Preference for infinite curves is
simply "a sign of healthy taste, and true instinct" (6:327). When
Ruskin writes of erosion as the "finishing work by which Nature
brings her mountain forms into the state in which she intends us gen-
erally to observe and love them" (6:320), the laws of natural process
(or "Nature" capitalized) have replaced God as the explanation for
landscape beauty.

The strongest evidence of Ruskin's effort to de-theologize land-
scape is his reluctance to speculate on origins.

For a certain distance, the past work of existing forces can be traced; but
there gradually the mist gathers . . . and still, as we endeavour to penetrate
farther and farther into departed time, the thunder of the Almighty power
sounds louder and louder; and the clouds gather broader and more fearfully,
until at last the Sinai of the world is seen altogether upon a smoke, and the
fence of its foot is reached, which none can break through. (6:179).

The biblical rhetoric may remind one of the earlier volumes of *Modern
Painters,* but here, instead of grounding Ruskin's argument in reli-
gious certitude, it serves rather to evade a direct statement of reli-
gious belief. The confidence of his early Evangelicalism has given way
to an awareness of the limits of knowledge. He refuses to deny the
possibility of the earth's "having been, when first inhabitable, more
beautiful than it is now" (6:177), and he was later to look back on
chapter 4 ("The Firmament"), in which he expresses his "desire . . .
to receive God's account of His own creation as under the ordinary
limits of human knowledge and imagination it would be received by
a simple-minded man" (6:111), as "one of the last, and best, which
I wrote in the temper of my youth" (6:106n.). But his general view
is skeptical: "The earth, as a tormented and trembling ball," Ruskin
acknowledges, "may have rolled in space for myriads of ages before
humanity was formed from its dust; and as a devastated ruin it may
continue to roll, when all that human dust shall again have been
mingled with ashes that never were warmed by life, or polluted by
sin. But for us the intelligible and substantial fact is that the earth
has been brought, by forces we know not of, into a form fitted for
our habitation" (6:179).

The long discussion of mountain form in the center of *Modern
Painters,* volume 4, is framed by five introductory chapters, in which
Ruskin once again attempts to define the peculiar strength of Tur-

ner's landscapes, and by two closing chapters, "Mountain Gloom" and "Mountain Glory," which take up the influence of mountains on human character and the artistic temperament. The opening chapter returns Ruskin to the problem of explaining why Turner's paintings are more truthful than photographic realism—and the reason he can admire artists as apparently different in technique as Turner and the Pre-Raphaelites. His argument differs from earlier attempts to solve this problem in its more profound grasp of the psychology of the artist. The artist's (largely unconscious) memory of related scenes and experiences and his general emotional state at the time he conceives his work are new factors in Ruskin's analysis. In 1848, he had visited the Pass of St. Gothard in order to study the exact subjects of certain of Turner's drawings. Now, he compares his "exact" drawings of the gorge above Faido with Turner's drawing of the same location, in order to determine the reason for the changes Turner made in his rendition. Ruskin finds traces in Turner's version of the artist's recollection of a drawing he had made thirty years earlier; of his general state of mind on the day he made the Faido drawing—having just passed through a long stretch of road between other, higher cliffs, he exaggerates the cliffs at Faido; and of his fondness from childhood for a certain kind of English slope to which he gives special prominence in his drawing of the Alps. The result of these transformations is "Turnerian Typography": "Whenever Turner really tried to *compose,* and made modifications of his subjects on principle," Ruskin insists "he did wrong, and spoiled them; . . . he only did right in a kind of passive obedience to his first vision, that vision being composed primarily of the strong memory of the place itself which he had to draw; and secondarily, of memories of other places (whether recognized as such by himself or not I cannot tell), associated, in a harmonious and helpful way, with the new central thought" (6:41). This increasing emphasis on the subjectivity of the artist's vision makes it increasingly difficult for Ruskin to assert the objective "truth" of Turner's landscapes. Ruskin is forced to admit that Turner "neither was aware of the value of the truths he had seized, nor understood the nature of the instinct that combined them." Nevertheless, "the truth was assuredly apprehended, and the instinct assuredly present and imperative" (6:275).

If the introductory chapters of *Modern Painters,* volume 4, suggest a deepening of Ruskin's awareness of the psychology of artistic creation, the closing chapters suggest a growing awareness of the larger

context of art (or beauty in general) and his desire to address problems of a social nature. "Mountain Gloom" is the mixture of ignorance and willful ugliness Ruskin finds among the inhabitants of the most glorious Alpine scenery. When he seeks to explain its sources, they are partly religious—Roman Catholicism at its worst—and partly economic—the general poverty of the mountain regions. Moreover, it turns out to be a temperament not exclusively associated with mountains; under Ruskin's analysis, Mountain Gloom is perceived as a kind of death wish at large in European civilization. His interpretation betrays the remnants of his earliest prejudices—his distrust of Popery and his chauvinistic admiration for British industriousness. But his effort to get to the root of social malaise shifts the focus of *Modern Painters* from the "eternal" truths of God and nature to the practical business of contemporary European economics.

The concluding account of "Mountain Glory" expands the concerns of the volume still further. Its central argument is that proximity to mountains has a positive effect on the formation of the artistic sensibility. But the artist on whom he concentrates is Shakespeare—an illustration of the creative mind unfamiliar with mountains—and the question of mountains itself becomes secondary to his attempt to put together a psychological portrait of the playwright—much in the manner of G. Wilson Knight's twentieth-century studies of Shakespeare. Shakespeare is important for Ruskin not just because of his stature as an artist, but because he is an artist recognizably different from Ruskin. Unlike Wordsworth and Turner, with whom Ruskin feels a spiritual kinship, Shakespeare challenges Ruskin as an alternative to his own world view and reclusive life-style. His attempt to understand Shakespeare is thus an acknowledgment of his own need for change. Indeed, the chapter as a whole is vicarious self-analysis. Ruskin's own love of mountains, he admits in the first paragraphs, is a deeply personal experience (and therefore no longer necessarily applicable to anyone else). And later, when he addresses himself to the growing commercialization of Switzerland, he assumes the isolated voice of his later prose—a man speaking out against the abuses of a civilization.

Modern Painters, volume 4, concludes with a highly charged account of Christ and Moses among the mountains. Ruskin's stated purpose is to explain the importance of mountains in the biblical narrative. But the figures of Moses and Christ he offers are significantly humanized. The mountains have ceased to be merely representative of

a transcendent order; instead, they are the locus for intense, highly meaningful, but nevertheless entirely human, experiences.

Modern Painters, volume 5 (1860)

Ruskin forced himself to write the last volume of *Modern Painters* in order that his father might see the work completed. The final chapter of volume 5 is entitled "Peace." "Looking back over what I have written," it begins, "I find that I have only now the power of ending this work" (7:441). "Peace," by implication, is not merely the concluding subject of Ruskin's argument, but the state of mind he felt in bringing the two-decade project to an end.

There are several reasons why *Modern Painters* resisted completion. Social problems had replaced art as Ruskin's central concern. He recognized, too, the impossibility of his original project. If the final evaluation of landscape painting required conclusive understanding of all elements of landscape, then it demanded a range and depth of knowledge Ruskin could never hope to achieve. He may have understood mountains, but he lacked the knowledge of the sea and ships to complete the section on the sea to his satisfaction, and so he discarded it altogether. Similarly, the sections on vegetation remained incomplete, "in a detached form" (7:7). At best, he acknowledged, the book was "feebly and faultfully" done (7:8).

Yet the "feebleness" of *Modern Painters,* volume 5, is more than a sign of Ruskin's inadequacy in certain specialized areas or his recognition that the problems to which he had addressed himself admitted no easy solution. It is also a sign of his reluctance to close a work that had become so strongly identified with his own developing mind. Looking back over the "oscillations of temper, and progressions of discovery" that characterize the five volumes of *Modern Painters,* he argues that they should not "diminish the reader's confidence in the book." For "all true opinions are living, and show their life by being capable of nourishment; therefore of change" (7:9). *Modern Painters,* volume 5, ends with a rhetorical flourish, but without a strong sense of closure, in large part because Ruskin could not bring himself to terminate the process of his own intellectual growth.

The first half of the volume takes up "Leaf Beauty" and "Cloud Beauty," somewhat in the manner of the examination of mountains in volume 4. Ruskin had studied botany and meteorology for a number of years, but his knowledge of these sciences was less than his knowledge of geology. However, this is not the only reason why this

second exercise in the Science of Aspects is notably dissimilar from
conventional science. Like the geology, the botany and meteorology
of *Modern Painters* are dynamic; they stress patterns of growth and
change—not unlike the growth and change Ruskin associates with
"true opinion." Unlike his studies of mountain form, however, his
studies of vegetation and, to a lesser degree, clouds, adopt a deliber-
ately "unscientific" perspective. His classification of plants rests on
the child's division between trees and low-growing species, which
Ruskin designates with the terms "Building" and "Tented." In man-
uscript, he had used the term "Ground" for the second group, thus
clarifying the distinction between trees that build long-lived struc-
tures and plants that, growing close to the ground, "leave *no memo-
rials of themselves*" (7:21). "Tented" refers to the fact that these plants
"pass as the tented Arab passes" (7:21). Surely "Ground Plants" is a
more useful term in portraying the physical appearance of vegetation;
"Tented," on the other hand, is downright misleading. Ruskin's
preference for this metaphor suggests an unexpected willingness to
ignore "aspects" in favor of some other level of significance.

Nor is this the only symptom of a change in perspective toward
the natural world. There is a strong tendency toward animism in
Modern Painters, volume 5, that leads Ruskin again and again into
indulgence in his own earlier bugbear—the pathetic fallacy. Thus,
budding stems become children engaged in a sibling rivalry that may
result in "agonizing" failure for one and all (7:74). "Who shall say,"
he asks of a birch bud, "how many humours the little thing has in
its mind already" (7:98)? At its strongest, this impulse becomes a
simple identification with nature, as when Ruskin's account of the
Alpine black pine inexplicably shifts into the first person plural: "We
builders with the sword have harder work to do for man, and must
do it in close-set troops" (7:103).

This tendency to see nature in human terms reflects the childlike
point of view underlying his distinction between building and tented
plants, but it also reflects Ruskin's sense of a commonalty among all
forms of life—his feeling that a plant's struggle for existence is in
some real way comparable to man's. Nature, perceived from this
standpoint, is less a manifestation of divine order than a mirror of
human experience. Hence, the animism of *Modern Painters,* volume 5,
is logically related to Ruskin's growing concern for the condition of
his fellowman. Indeed, the beauty he finds in tree forms is now seen
to consist "from the first step of it to the last, in its showing their

perfect fellowship; and a single aim uniting them under circumstances of various distress, trial, and pleasure. Without the fellowship, no beauty; without the steady purpose, no beauty; without trouble, and death, no beauty; without individual pleasure, freedom, and caprice, so far as may be consistent with the universal good, no beauty" (7:97–98).

There is a daring here that distinguishes Ruskin's assertions from the conventional discovery of "sermons in stones." He is not merely drawing analogies between man and the natural world: he is postulating a fundamental sameness between them. And by this transformation the Science of Aspects finds itself in opposition to the form of science in which man the observer is essentially disconnected from the natural world he observes. When Ruskin asks his readers to get to the essence of a natural phenomenon, he asks them to draw it—not because drawing forces one to see the thing as it really is, but because the physical act of drawing re-creates the being of the phenomenon.

The important expression of this new version of the Science of Aspects is neither animism nor drawing, but mythology. Ruskin's account of cloud forms evolves into the reading of Greek myths of the storm he will later develop in *The Queen of the Air*. Here, it serves to show a way out of the problem of bringing *Modern Painters* to a close. Mythography is useful to Ruskin principally because it offers a means of giving nature transcendent significance without reference to a transcendent order of being. It is, above all else, not an expression of the divine, but an expression of the human. *Modern Painters,* volume 5, grapples with religious belief. A book written for his father, it could not very well deny his father's religion. Nevertheless, it offers a radical revision of the paradigm on which he had relied in the earlier volumes.

The notion of Typical Beauty he defined in *Modern Painters,* volume 2, made nature an intermediary between God and man: nature is beautiful because it is "in some sort typical of the Divine attributes" (4:64). Such beauty is therefore independent of man. In the chapter entitled "The Dark Mirror," *Modern Painters,* volume 5, argues very differently: "Desert—whether of leaf or sand—true desertness is not in the want of leaves, but of life. Where humanity is not, and was not, the best natural beauty is more than vain. It is even terrible; not as the dress cast aside from the body; but as an embroidered shroud hiding a skeleton" (7:258). He is able to adopt this position by basing his argument on the biblical assertion that man is made in the

image of God and that therefore "the soul of man is a mirror of the mind of God. A mirror, dark, distorted, broken, use what blameful words you please of its state; yet in the main, a true mirror, out of which alone, and by which alone, we can know anything of God at all" (7:260). It follows that the natural world is an expression of God only insofar as it is perceived as such by man. Thus, man is now an intermediary between nature and God: "Therefore it is that all the power of nature depends on subjection to the human soul. Man is the sun of the world; more than the real sun. The fire of his wonderful heart is the only light and heat worth gauge or measure. Where he is, are the tropics; where he is not, the ice-world" (7:262).

This revision of his earlier beliefs also entails a change in his notion of Vital Beauty—"the appearance of felicitous fulfillment of function in living things" (4:64). The earlier notion depended on Ruskin's assumption that "Every herb and flower of the field has its specific, distinct, and perfect beauty" (3:33)—an essence the landscape painter should aim to capture in all its individuality, subordinating his own identity to the identity of nature. Now, as we have seen, beauty is a function of "fellowship," "steady purpose," etc.—the characteristics by which the human observer identifies the plant's condition with his own. The earlier view had placed Ruskin in a dilemma, since its emphasis on strict objectivity tended to reduce the status of the painter. His attempts to resolve this dilemma generated much of *Modern Painters,* volumes 1–4—without ever reaching a satisfactory conclusion. *Modern Painters,* volume 5, solves the problem by dismissing it: the "facts" of nature are now subordinate to the consciousness of the artist. Factuality remains a criterion of great landscape art, but it is no longer the supreme criterion. The concept of "Turnerian Typography" in volume 4 emphasized the mind of the artist, but it was a mind determined by its experience of landscape; volume 5 praises the "audacity" (7:242) of Turner's modifications of landscape, rendering an imperfect scene a perfect formal composition.

The second half of *Modern Painters,* volume 5, tries to tie many things together, and the result is a general uncertainty of intention. Ruskin's recognition of the centrality of the human consciousness leads him to focus less on landscape painting itself than on the psychological conditions that generate it. These he explores through a series of paired comparisons—Dürer and Salvator, Claude and Poussin, Rubens and Cuyp, Wouvermann and Angelico, and, finally, in the chapter "The Two Boyhoods," Turner and Giorgione. He has

come at last to recognize both the strengths and weaknesses of Turner and to understand them as results of the conditions under which he lived. The moral achievement of *Modern Painters,* volume 5, is Ruskin's ability to grasp the interrelationship between strength and weakness, between good and evil. He sees it in the conditions of growth in plants. He sees it in the achievement of the man he continues to believe the greatest painter of his own century.

Life—vitality—have become more important to Ruskin. He turns from the "purist" religious paintings he had admired in *Modern Painters,* volume 2, to the more worldly Venetian artists—Tintoretto, Veronese, Titian—who are now the unqualified heroes of his study. He now prefers leaves to crystals, because the mineral "shows in every line nothing but a dead submission to surrounding force," while "the leaf, full of fears and affections, shrinks and seeks, as it obeys" (7:49).

Yet he recognizes that this vitality is inseparable from the presence of death, and, as a consequence, that "all great and beautiful work has come of first gazing without shrinking into the darkness. If, having done so, the human spirit can, by its courage and faith, conquer the evil, it rises into conceptions of victorious and consummated beauty" (7:271). But it does not always achieve this victory. Turner's confrontation with evil in two paintings, *The Garden of the Hesperides* and *Apollo and Python,* is the subject with which Ruskin brings *Modern Painters* to a close.

Because they are overtly mythological and therefore refer to a tradition of hermeneutic science, the two paintings enable Ruskin to bring his fullest resources to bear on their expressive significance. The liability of this approach is its inherent lack of control. Ruskin had been bothered in the past by the accusation that he attributed intentions to Turner that the painter did not in fact have. When the intentions are "scientific," it is not difficult to accept his proposition that Turner had an unconscious grasp of the true aspect of mountains. When intentions extend to classical interpretations of myth, Ruskin's willingness to assume Turner's familiarity with specific authors and works, without evidence other than the painting itself, becomes problematic.

But by his own logic he is being true to Turner by being true to himself. For the art criticism of *Modern Painters,* volume 5, is a creative act in its own right—a mode of self expression in which the mind of the critic is no longer subordinate to the work he investigates, but exists in real partnership with it. Here, as in his later more

purely mythographic writing, the myth becomes an organizing prin-
ciple for the diversity of Ruskin's thought.[4]
The subject of both paintings is the threat of evil—the dragon that
guards the Apples of the Sun, symbolically denying access to an
earthly paradise; Python, whom Ruskin identifies as "the worm of
eternal decay" (7:420). In both, Ruskin finds evidence of Turner's in-
sight; in both, evidence of his failure to entirely overcome his vision
of evil. Color—Turner's capacity to represent the hues of landscape as
no painter before him—is essential to Turner's greatness. This, Rus-
kin associates with Aeglé, the Hesperid of "Brightness" (7:395). But
it is the brightness of sunset—the brightness the Greek imagination
placed near the pillars of Hercules, at the western end of the world.
Apollo kills Python, but from the blood of the slain dragon "a
smaller serpent-worm" rises: "Alas, for Turner! This smaller serpent-
worm, it seemed, he could not conceive to be slain. In the midst of
all the power and beauty of nature, he still saw this death-worm
writhing among the weeds" (7:420).
But it is not for Turner alone that the image of the serpent remains
unexorcised. The dragon of the Hesperides, the worm that feeds on
human achievement, both reappear in the closing paragraphs of the
final chapter of *Modern Painters,* volume 5. Ruskin, as Turner, had
been able to reach only an incomplete victory.

Lectures (1856–60)

Ruskin delivered seventeen public addresses between March 1856
and March 1860. The experience of winning over a lecture audience
not only bolstered his ego; it also taught him that it was not water-
tight consistency that determines a convincing argument, and thus
freed him to develop a dialectical mode of reasoning more consonant
with his real patterns of thought. "I never met with a question yet,
of any importance," he acknowledged, "which did not need, for the
right solution of it, at least one positive and one negative answer,
like an equation of the second degree. Mostly, matters of any conse-
quence are three-sided, or four-sided, or polygonal. . . . For myself,
I am never satisfied that I have handled a subject properly till I have
contradicted myself at least three times" (16:187). One advantage of
this style is its potential for making connections, and the lectures of
this period were largely concerned with the connection between art
and economics.

Ruskin's concern with art led him to questions of political economy by more than one route. As we have seen, his examination of the historical conditions underlying Gothic architecture faced him with the conditions of labor in his own society. By a different logic, the problem of fostering and preserving fine art led him to question contemporary definitions of value and wealth. There had always been an economic dimension to Ruskin's interest in the arts. Paintings, watercolors, and drawings were things first his father, then Ruskin himself, bought and sold and always considered an investment. At the same time, Ruskin's acquaintance with artists, along with his firsthand experience working in artistic media, gave him a grasp of the effort that lay behind an individual work of art. The letters he wrote after Turner's death advising his father on the purchase of the artist's work evidence how natural it was for him to put a precise monetary value on art, both as a quality inherent in the work itself and as a function of the labor it represented.[5]

The two lectures on *The Political Economy of Art* that Ruskin delivered in Manchester, 10 and 13 July 1857, define the terms of his later writings on the political influence of the arts. When he republished them under the title *"A Joy Forever" (And Its Price in the Market)* in 1880, he appended lengthy notes, but saw no need to alter the text itself. He had given special care to the lectures, in part because they were to be given in the city linked by the "Manchester School" with the economic doctrine of laissez-faire—the belief that there should be no government regulation of commerce—against which he was addressing himself. *The Stones of Venice* had made pronouncements relative to buying and selling, but had not enunciated a theory of economics. The Manchester lectures are Ruskin's first public effort to suggest a theoretical basis for his critique of the economic system of nineteenth-century England.

Ruskin drew his 1880 title from the opening lines of Keats's *Endymion:* "A thing of beauty is a joy for ever: / Its loveliness increases; it will never / Pass into nothingness. . . ." For Ruskin, the endurance of art is not merely felicitous. Its beauty is itself "based on the conception of its honoured permanence" (16:11), and it is for this reason that the experience of "art" is differentiated from similar but transitory aesthetic experiences. Such a view is necessarily both economic and political. The commercial value of art is an impetus to artists who need to make a living as well as to buyers of their work who have a financial reason to take care of their investment. The

greatest works of art should belong, of course, to the nation as a whole; hence, it is the function of the state to acquire and preserve them. At the same time, the state has the responsibility to encourage the production of art, just as it has the responsibility to encourage other activities that benefit the nation as a whole, for the commercial system alone cannot—at least, given the opportunity, has not—fostered a great school of British art. Thus, Ruskin's notion of art as a form of national wealth entails the benevolent intervention of the state in the economic system—an intervention diametrically opposed to the laissez-faire model.

Ruskin admitted in his 1857 preface that he had "never read any author on political economy, except Adam Smith, twenty years ago"; he has looked into modern books, but found them "encumbered with inquiries into accidental or minor commercial results . . . by the complication of which, it seemed to me, the authors themselves had been not unfrequently prevented from seeing to the root of the business" (16:10). And "the root of the business," he insists, is not in the least complicated.

Whatever the rhetorical advantages of this calculated naiveté, it had two serious disadvantages: it discouraged Ruskin from allying himself with the contemporary economists whose views approximated his own,[6] and thus weakened his position; and it encouraged him to base important statements on dubious analogies. He compares the state to a private household and then to a farm, arguing that "Precisely the same laws of economy which apply to the cultivation of a farm or an estate, apply to the cultivation of a province or of an island" (16:23). The key term here is "cultivation": economics is not, for Ruskin, a means of describing a commercial system; it is instead a means of "cultivating" it. This distinction is a crucial one, but by grounding it on the baseless assumption that the affairs of a nation are no more complex than those of a family farm, Ruskin discourages the reader from considering it on its real merits. Instead of addressing himself directly to the advantages of a planned economy, he refines his analogy still further, "because the real type of a well-organized nation must be presented, not by a farm cultivated by servants who wrought for hire, and might be turned away if they refused to labour, but by a farm in which the master was a father, and in which all the servants were sons; which implied, therefore, in all its regulations, not merely the order of expediency, but the bonds of affection and responsibilities of relationship; and in which all acts and services were

not only to be sweetened by brotherly concord, but to be enforced by fatherly authority" (16:25).

These statements summarize Ruskin's ideal state—a social system characterized by the filial cooperation of its citizens under the guidance of a paternal ruler. He was to develop both ideals—cooperation and authority—at length, but the uniqueness of his later social and political writing will lie in its insistence on the interrelationship between socialist economics and benevolent but authoritarian government.

For Ruskin, seeing the artist's career from an economic perspective does not reduce his work to a statistic; rather, it faces him with the (probable) hard facts of a life in which the most productive years are spent in a degrading struggle to make ends meet and in which wealth, if it comes, comes too late to undo the spiritual harm effected by years of neglect. At the same time, seeing the created artifact as an economic entity encourages Ruskin to consider the practical aspects of accumulating and distributing the works of art he had praised in his earlier writing. Thus, the lectures on *The Political Economy of Art* lead to specific proposals. The government, for example, should intervene in the paper industry to assure the permanence of the paper on which watercolorists work; artworks of an appropriate quality and subject should be placed in the public schools; England should use her wealth to buy up and so preserve works of art in danger of destruction: "You should stand, nationally, at the edge of Dover cliffs," Ruskin proclaims, "and wave blank cheques in the eyes of the nations on the other side of the sea, freely offered, for such and such canvases of theirs" (16:78).

His concern with encouraging the production of art led Ruskin to a concern with education that became a main issue in his public speaking and writing. He was interested both in the training of professional artists and architects and in the role of art in what is now called "general education." He drew a firm line between these two kinds of schooling. To stress the role of art for the general student, he made it clear that the purpose of this instruction was not to produce artists. It disturbed him when his students at the Working Men's College expected their drawing lessons to lead to a new career. The study of art he recommends in his "Inaugural Address at the Cambridge School of Art" (1858) will encourage students to love the natural scenes they attempt to portray and to venerate the rare genius of the true artist. But "an amateur's drawing . . . is always valueless

in itself." It may be "precious as a memorial, or as a gift, or as a means of noting useful facts; but as *Art*," he repeats, reminding us of his own curious refusal to consider himself an artist, "an amateur's drawing is always wholly worthless" (16:182). On the other hand, amateur art is no more dilettantism than any other branch of the academic curriculum: "It ought to delight you as your studies of physical science delight you—but you don't call physical science dilettantism" (16:200).

The five lectures on art, architecture, and design Ruskin collected in *The Two Paths* (1859) are concerned with the professional training of artists and their role in the design of British manufactures. His title refers to two approaches to the conventionalized ornamentation appropriate to subordinate elements in architecture and manufactured goods—by way of figure and landscape drawing or by way of geometric or generally abstract form. Ruskin associates the second with the love of art for its own sake and not for the facts art expresses. Writing the year after the Indian Mutiny, he contrasts the Indian's highly refined love of abstract form with the Scottish Highlander's love of nature. The Indian, whose art *"never represents a natural fact"* (16:265), is capable of the basest behavior; the Highlander, bred in a landscape painfully bereft of art, exemplifies the highest virtue. For "the ornamental, or pleasurable power, though it may be possessed by good men, is not in itself an indication of their goodness, but is rather, unless balanced by other faculties, indicative of violence of temper, inclining to cruelty and to irreligion" (16:307). It follows that the better path to conventionalized forms is through training in the representation of natural fact: "good subordinate ornament has ever been rooted in a higher knowledge; and if you are again to produce anything that is noble, you must have the higher knowledge first, and descend to all lower service" (16:311–12).

But the formal education of the decorative artist is not sufficient to guarantee the quality of his work. His work will reflect the honor paid decorative art in general. One must "get rid, then, at once of any idea of Decorative art being a degraded or a separate kind of art. Its nature or essence is simply its being fitted for a definite place; and, in the place, forming part of a great and harmonious whole, in companionship with other art; and so far from this being a degradation to it—so far from Decorative art being inferior to other art because it is fixed to a spot—on the whole it may be considered as rather a piece of degradation that it should be portable" (16:320).

Subordinate decorative art flourishes only where the highest form of decorative art flourishes. An England intent on transforming itself into an industrial wasteland cannot hope its manufactures will be characterized by the beauty of their design: "Do not vex your minds, nor waste your money with any thought or effort in the matter. Beautiful art can only be produced by people who have beautiful things about them, and leisure to look at them; and unless you provide some elements of beauty for your workmen to be surrounded by, you will find that no elements of beauty can be invented by them" (16:338). And so the purely commercial issue of turning out well-designed factory goods becomes yet another route to social and economic reform.

Chapter Five

Disruption and Discovery: Ruskin in the 1860s

The sheer length of *Modern Painters* and *The Stones of Venice* reflects the mood of self-certainty in which Ruskin began both projects; similarly, the shorter, often fragmentary books he published in the 1860s reflect the state of doubt, inner turmoil, and discovery in which they were written. He had lost his faith in the Evangelical Christianity of his parents, and, with the death of his father in 1864, he lost the parent whose intellectual authority had, even in disagreement, anchored his thought. He had a fortune of his own now, but just how to spend it, just how to live his life, remained problematic. His attempt, early in the decade, to establish himself on a Swiss mountaintop had been an absurd failure. His proposal to Rose La Touche in 1866 threatened a far worse diaster. In seeking a broader audience for his writing, he had left the relative safety of art and begun his radical attack on laissez-faire political economy. Ruskin had known adverse criticism, but never before been subjected to abuse and ridicule so strong as that which followed the publication of *"Unto this Last"* in 1860. He was not only isolated from the religious beliefs of his childhood, he was also at odds, it appeared, with his nation itself.

"Unto this Last" (1860–62)

Eighteen months after Ruskin's four *Cornhill* essays on political economy—"The Roots of Honour," "The Veins of Wealth," "Qui Judicatis Terram," and "Ad Valorem"—had been "reprobated in a violent manner" by their original publisher, he collected them into a single volume, *"Unto this Last,"* and defended them as "the best, that is to say, the truest, rightest-worded, and most serviceable things I have ever written" (17:17). Although the book did not begin to reach a wide audience until the 1880s, when frequent new editions were called for, its subsequent influence suggests the truth of this judgment.[1]

The power of *"Unto this Last"* does not lie in its logic, but in the force of its argument. Not since his earliest defense of Turner did Ruskin feel so strongly the stirring of a cause. The two voices noted in his 1853 Edinburgh lectures are fused by the urgency of his message. The book reflects the excitement of discovery—Ruskin's discovery of the profound significance of economic determinants and his discovery of a new field of influence over the lives of his countrymen. The work, as a consequence, is dense with ideas, not all of which he is as yet able to explain fully or carry to a logical conclusion. Ruskin justified this shortcoming by regarding *"Unto this Last"* as a statement of theoretical principles introductory to a sequence of books he planned to write on political economy. Although *Munera Pulveris* (1862–63) initiated this project, it was never completed; and Ruskin's theory of political economy remains a series of interconnected statements rather than an articulated system. At its core, however, remained the definition of wealth "absolutely needed for a basis of economical science" (17:18) that he advanced in *"Unto this Last."*

Ruskin objected to John Stuart Mill's assumption (which he quotes from Mill's 1848 *Principles of Political Economy*) that this definition could be taken for granted. Being wealthy, he argued, is more than Mill's notion of having " 'a large stock of useful articles' "; it entails having a large stock of useful articles " 'which we can use' " (17:86–87). If we accept this two-pronged description, then it follows that wealth is at once the inherent attribute of a thing and a function of its human designation. Not only must it be potentially useful to a human being; it must also be in the hands of someone able to put it to use—and the more and greater use the better. A telescope, by this argument, is of no value to a blind person; it is of some value to a person with sight; it is of great value to a keen-eyed astronomer.

Usefulness, as Ruskin sees it, is always positive. An infestation of rats does not add value to a house: "A horse is useless, and therefore unsaleable, if no one can ride,—a sword, if no one can strike, and meat, if no one can eat" (17:81). "To be 'valuable' . . . is to 'avail towards life.' A truly valuable or availing thing is that which leads to life with its whole strength. In proportion as it does not lead to life, or as its strength is broken, it is less valuable; in proportion as it leads away from life, it is unvaluable or malignant" (17:84)—not wealth at all, regardless of its price in the marketplace, but "illth" (17:89). Linking this concept of value with his concept of wealth, Ruskin reaches a summary definition: "Wealth, therefore, is 'THE

POSSESSION OF THE VALUABLE BY THE VALIANT'; and in considering it as a power existing in a nation, the two elements, the value of the thing, and the valour of its possessor, must be estimated together" (17:88–89).

Ruskin's verbal play should not obscure the principle he is enunciating. His belief in inherent value—value which is potential insofar as it requires the right possessor if it is to be brought into being, but which is nevertheless intrinsic to the thing itself—opposes the economic relativism that conflates value with price and defines it as a function of supply and demand. More important, by making human need and human purpose a significant factor in economic analysis, his definition of wealth offers a radical attack on the attempt to reduce economics to a simple mathematical model. Because its value is not determined by its price and because of its human sign, wealth cannot be measured in dollars and cents. A plot of land is of more value than a bombshell, even if the second commands a greater price. "THERE IS NO WEALTH BUT LIFE" (17:105), Ruskin insists in capital letters. And the value of life exceeds calculation. Not only must someone be able to use wealth; someone must also want to use it. "Therefore, political economy, being a science of wealth, must be a science respecting human capabilities and dispositions" (17:81). Human feelings, human morality are thus matters of concern for the economist. And the assumption of the classical British economists that their "science" had nothing to do with feeling or morality renders their work trivial.

However, the problem, as Ruskin saw it, was not just that the professional economists ignored the complexity of economic behavior, but also that their simplifications assumed a debased form of human nature—an "economic man" motivated solely by self-interest. If wealth is a function of use and use implies human relationships—for the miser who hoards his gold for the sake of hoarding it is not, in Ruskin's view, wealthy—then the model of self-interest breaks down and what Ruskin calls the "social affections" begin to exert an influence on economics. He assumes that honesty, fairness, and fellow feeling influence economic behavior fully as much as greed and selfishness, and that the attempt of the laissez-faire theorists to define economic activity in terms of competition ignores the fact that cooperation is an equally characteristic form of human behavior. His criticism of classical economics is significant not because he attempts to replace a simple model of man based on avarice with a simple

model based on altruism, but because he rejects the act of simplification itself. Any theory of economics based on a narrow definition of human behavior, Ruskin suggests, is bound to be wrong. And it is in this recognition that economic phenomena are complexly determined that Ruskin, whether or not one agrees with his particular recommendations, must be reckoned with.

He writes not as a humanitarian decrying the heartlessness of economic science—although he was perceived as such by the majority of his early readers—but as a scientist critical of the methodology of contemporary economics. He rejects an economic model based on Newtonian physics that attempts to explain events in terms of a handful of "essential" forces operating on a set of discrete entities, not only because he disagrees with the designation of avarice as an essential or constant force and altruism as an accidental one, but also because he wisely recognizes that "the disturbing elements in the social problem . . . alter the essence of the creature under examination the moment they are added" (17:26). Neither avarice nor altruism is simply a force operating on a human being; both transform the human being into something other than he or she was. The desire to help another person may not only redirect an individual's capacity for work; it may also increase that capacity. And so the dynamic model of forces acting on particles is inappropriate; the forces change the nature of the particles on which they act and are in turn modified by that changed nature. For this reason economic forces must be seen to "operate, not mathematically, but chemically, introducing conditions which render all our previous knowledge unavailable" (17:26).

Ruskin's recognition, based on his definition of wealth, that economic phenomena are complexly determined and irreducible to a simple mathematical model leads to two general areas of consideration— to the various ways in which the "chemistry" of the social affections can be enlisted in the production of national wealth and to the moral implications of the fundamental indeterminacy of economic decisions.

The role of social affections underlies the consideration of labor-management relations that opens *"Unto this Last."* Ruskin opposes the notion that the two groups are necessarily either at odds or at one: "It can never be shown generally either that the interests of master and labourer are alike, or that they are opposed; for, according to circumstances, they may be either" (17:27–28). Moreover, even when there is a clear difference in the interests of the two parties, it does not follow that "they must necessarily regard each other with hostil-

ity, and use violence or cunning to obtain the advantage" (17:27).
"It is not the master's interest to pay wages so low as to leave the
men sickly and depressed, nor the workman's interest to be paid high
wages if the smallness of the master's profit hinders him from enlarg-
ing his business, or conducting it in a safe and liberal way" (17:28).
Ruskin is concerned with morality, but he is equally concerned, it
is important to note, with production. And

the universal law of the matter is that, assuming any given quantity of en-
ergy and sense in master and servant, the greatest material result obtainable
by them will be, not through antagonism to each other, but through affec-
tion for each other; and that, if the master, instead of endeavouring to get
as much work as possible from the servant, seeks rather to render his ap-
pointed and necessary work beneficial to him, and to forward his interests in
all just and wholesome ways, the real amount of work ultimately done, or
of good rendered, by the person so cared for, will indeed be the greatest
possible. (17:30)

A worker is most productive, Ruskin maintains, when he has a per-
manent interest in the establishment for which he works. It follows
that continuous employment at a lower wage is better for all con-
cerned than intermittent employment at a higher wage. For this pur-
pose, the rate of wages should be fixed at a just level and not allowed
to vary with the demand for labor.

We are so accustomed to regarding worker morale as a factor in
productivity that Ruskin's observations on this subject may strike us
as truisms. But it is precisely because men like Ruskin were willing
to speak out against the "truisms" of their own age that our views
differ from those of his contemporaries and that we accept his pro-
posals of a minimum wage and job security without astonishment.

What may surprise a modern reader is Ruskin's concern for the
morale of management. He seems to have realized that the calculated
indifference of many Victorian capitalists to their workers was a
symptom of their own inadequate self-esteem. A merchant could not
be expected to behave nobly if his society saw nothing noble in his
calling and "the merchant is presumed to act always selfishly"
(17:38). With the image of his own father in mind—as well as the
notion of "Captains of Industry" set forth in Thomas Carlyle's *Past
and Present* (1843)—Ruskin defines an ideal role for the businessman
that places him on a level with the other honorable professions:

he has to understand to their very root the qualities of the thing he deals in, and the means of obtaining or producing it; and he has to apply all his sagacity and energy to the producing or obtaining it in perfect state, and distributing it at the cheapest possible price where it is most needed.

And because the production or obtaining of any commodity involves necessarily the agency of many lives and hands, the merchant becomes in the course of his business the master and governor of large masses of men in a more direct, though less confessed way, than a military officer or pastor; so that on him falls, in great part, the responsibility for the kind of life they lead: and it becomes his duty, not only to be always considering how to produce what he sells, in the purest and cheapest forms, but how to make the various employments involved in the production, or transference of it, most beneficial to the men employed. (17:40–41)

Ruskin does not therefore question the fundamental need for managerial authority, and he is far from suggesting that workers should control the means of production. But the worker, as he argued in *The Stones of Venice*, should not be treated as a slave. Once again, the family offers him the example of authority he believes appropriate to industry: "Supposing the master of a manufactory saw it right, or were by any chance obliged, to place his own son in the position of an ordinary workman; as he would then treat his son, he is bound always to treat every one of his men. This is the only effective, true, or practical RULE which can be given on this point of political economy" (17:42).

This idealization of the businessman depends upon Ruskin's distinction between "political economy" and "mercantile economy." The second is concerned with the means by which an individual or a business makes or loses money; the first, as Ruskin defines it, with the economic prosperity of the nation as a whole, and "consists simply in the production, preservation, and distribution, at fittest time and place, of useful or pleasurable things" (17:44). It is his contribution to political economy that determines the social importance of the man of business and disproves the presumption that his actions are always selfish.

Ruskin denies that there is a fixed relationship between mercantile and political economy. What enhances the profits of a given business firm may or may not add to the wealth of a nation. Mercantile profit, Ruskin argues, is measured in money because it is essentially an increase in power over men (17:46). Without this power, the accumu-

lation of goods would be useless or burdensome: the owner of a great estate who cannot command servants to maintain it is poorer off than a cottager able to keep his own home in repair and tend his patch of garden. Because it encourages the existence of a class who neither produce, preserve, nor distribute, but merely consume the labor of others, "the establishment of the mercantile wealth which consists in a claim upon labour, signifies a political diminution of the real wealth which consists in substantial possessions" (17:51). Moreover, mercantile economics, because it is concerned with immediate profit and loss, may be opposed to the long-term interests of the nation as a whole: "there is not in history record of anything so disgraceful to the human intellect as the modern idea that the commercial text, 'Buy in the cheapest market and sell in the dearest,' represents, or under any circumstances could represent, an available principle of national economy. Buy in the cheapest market?—yes; but what made your market cheap? Charcoal may be cheap among your roof timbers after a fire, and bricks may be cheap in your streets after an earthquake; but fire and earthquake may not therefore be national benefits" (17:53–54).

Ruskin does not believe the social inequality inherent in the existence of riches is necessarily evil—"if there be any one point insisted on throughout my works more frequently than another," he maintains, "that one point is the impossibility of Equality" (17:74); however, because the pursuit of individual wealth can lessen what Ruskin believes to be the general wealth of a nation, he decries "The rash and absurd assumption that such inequalities are necessarily advantageous. . . . For the eternal and inevitable law in this matter is, that the beneficialness of the inequality depends, first, on the methods by which it was accomplished; and, secondly, on the purposes to which it is applied. Inequalities of wealth, unjustly established, have assuredly injured the nation in which they exist during their establishment; and, unjustly directed, injure it yet more during their existence. But inequalities of wealth, justly established, benefit the nation in the course of their establishment; and, nobly used, aid it yet more by their existence" (17:46–47).

Again and again, *"Unto this Last"* reminds us that "it is impossible to conclude, of any given mass of acquired wealth, merely by the fact of its existence, whether it signifies good or evil to the nation in the midst of which it exists" (17:52). Nor is it possible, even when placing an economic "fact" in the context of national welfare, to deter-

mine once and for all its value. That it has an inherent value, positive or negative, Ruskin has no doubt. But because "no man ever knew, or can know, what will be the ultimate result to himself, or to others, of any given line of conduct" (17:28), that value remains uncertain. And so the standard against which he measures economic decisions is not expediency—even expediency for a worthy end—but justice. "One thing only you can know: namely, whether this dealing of yours is a just and faithful one, which is all you need concern yourself about respecting it; sure thus to have done your own part in bringing about ultimately in the world a state of things which will not issue in pillage or in death. And thus every question concerning these things merges itself ultimately in the great question of justice" (17:54).

It is in supplying this standard of justice that the national government, Ruskin believes, should exert an influence over the marketplace. Because national prosperity is a national interest, it is up to the nation to concern itself with its own commerce. And because there is no guarantee that individual mercantile interests will be in the best interest of the nation as a whole, that concern will necessarily take the form of governmental regulations. A fixed standard of wages is just such a regulation. If, as required by laissez-faire theory, wages are determined by the supply of and demand for labor, then they need reflect neither the wealth produced by a worker's effort nor his own needs as a human being. The moral concept of a fair minimum wage takes both into consideration. Moreover, it is a moral concept that can have a positive impact on worker productivity. Ruskin does not, however, recommend that the government regulate working conditions and manufactured commodities themselves. Instead, he proposes a system of state workshops, where just standards will be defined. Despite his distrust of laissez-faire theory, he still believed that the example of honest goods at an honest price would win out in and therefore redirect the marketplace.

Yet the practical recommendations of *"Unto this Last"* remain subservient to its theoretical significance. Ruskin's definition of wealth entailed three fundamental challenges to what he took to be the prevailing economic theory. In positing an inherent value to material goods not determined by the forces of supply and demand, his definition enlarged the scope of political economy from a "science" merely concerned with describing the marketplace to one concerned with inherent value itself. In recognizing the mathematical indeter-

minacy of wealth, it denied the possibility of an expedient theory of economics and therefore demanded the application of moral values to economic decisions; and in distinguishing political (national) economy from mercantile (private) economy, it offered the rationale for a national economic policy at odds with the interests of the individual profiteer. Just how these challenges would be specified had to wait until Ruskin's later writings. However, even without that specification, they made *"Unto this Last"* a daring manifesto.

Munera Pulveris (1862–63, 1872)

As E. T. Cook points out, the six chapters of *Munera Pulveris* are "in some ways, a more important part of Ruskin's economical writings" than *"Unto this Last"* (17:lxiii). Its definition of terms clarifies much that was uncertain or only implicit in the earlier book. In *"Unto this Last"* Ruskin is grappling with a set of new beliefs; in *Munera Pulveris,* he is able to lay them out in more orderly form, and it is for this reason that he later called it "the first accurate analysis of the laws of Political Economy which has been published in England" (17:131). That the book never enjoyed the readership of its predecessor, Cook attributes to its "excursus into classical fields," the result of Ruskin's "occupying himself at that time with a minute study of Greek and Latin authors" (17:lxiii). But the source of the book's difficulty is not the classical texts Ruskin studied; it is the manner in which he wrote about them. As its cryptic title suggests— *Munera Pulveris,* "Gifts of the Dust," presumably an ironic reference to the fruits of laissez-faire economics—Ruskin was attempting to use classical mythology as a means of freeing himself from the oversimplifying logic of cause-and-effect analysis. The argument in *"Unto this Last"* against the valorization of expediency was, in fact, an argument against profit-and-loss argumentation itself. If value cannot be reduced to a price, then economic discourse based on mathematical calculations is inherently at odds with the truth. What Ruskin offers in place of conventional economic discourse is a discourse in which everything that avails toward life (and is therefore, by his definition, "valuable") is granted its due significance.

To make moral value an economic consideration, Ruskin could not try to give it an arbitrary price; its uncertain monetary sign would inevitably place morality at a disadvantage when weighed against the certain monetary signs of the marketplace. He recognized that a dis-

course based on calculations privileges the calculable and trivializes other factors. Hence, it was inadequate for him simply to add new factors to the old equations. He had to get rid of the equations themselves and replace them with a new way of thinking political economy. Ruskin believed this new way was in large part an old way, and could be recovered by a renewed understanding of "political economy, as understood and treated of by the great thinkers of past ages" (17:147). Hence, in the coda of *"Unto this Last"* he returns to the New Testament ethics from which he took the title of the book (Matt. 20:13). Hence, in *Munera Pulveris,* he offers elaborate analyses of classical myth and literature in order to explain the issues of wealth and government to which the book is addressed.

I shall take up Ruskin's mythography in the next chapter. For the present, it is important to note that the book's "excursus" into myth is not an accident, but fundamental to Ruskin's purposes. At the same time, the radical nature of the effort explains just why *Munera Pulveris* continues to be so difficult a book.

Ruskin characterized *Munera Pulveris* as "a dictionary of reference . . . for earnest readers" (17:145), but the book is less a dictionary of accepted usage than an effort to redefine the terms of political economy in such a way that the scope and significance of the discipline will be fully understood. His first redefinition is of political economy itself, which he designates "neither an act nor a science; but a system of conduct and legislature, founded on the sciences, directing the arts, and impossible, except under certain conditions of moral culture." Far from being a mere "investigation of some accidental phenomena of modern commercial operations," political economy is a central human concern—literally central, insofar as it connects morality with law, science with art, theory with conduct. The aim of its study is not "the accumulation of money, or of exchangeable property," but "the extension of life" itself (17:149). To this end, the accumulation of money or property may be of use, but accumulation must always be judged with reference to its ultimate object.

With this ultimate object in view, *Munera Pulveris* sets forth the areas of concern to political economy. It begins by distinguishing three terms often carelessly used as synonyms—wealth, money, and riches. Wealth, which "consists of things essentially valuable," rests on the definition of value advanced in *"Unto this Last"*: "the strength, or 'availing' of anything towards the sustaining of life," a power

which "is always twofold; that is to say, primarily INTRINSIC, and secondarily, EFFECTUAL."

"Value is the life-giving power of anything; cost, the quantity of labour required to produce it; price, the quantity of labour which its possessor will take in exchange for it" (17:153). Because wealth must be effectual as well as intrinsic, possessions a person cannot use are not really wealth, but a form of money (17:167). By placing such things in the hands of a person who can use them, they become wealth, and thus the total wealth of the nation is increased. For this reason, the appropriate ownership of wealth is a legitimate question for political economics, as is the nature of the goods that compose what Ruskin calls "the national store" of wealth.

Money, he recognizes, is neither wealth in itself, nor is it "merely a means of exchange. . . . It is a documentary expression of legal claim. It is not wealth, but a documentary claim to wealth . . . or of the labour producing it." The destruction of all the currency in the world would not make the world poorer, "but it would leave the individual inhabitants of it in different relations" (17:157–58). Since the "real worth" of money is a function of the wealth or labour to which it is the legal claim, increase in the quantity of money without increase in available wealth or labour depreciates the worth of money. Ruskin is strongly opposed to "the issue of additional currency to meet the exigencies of immediate expense," which he rightly judges "merely one of the disguised forms of borrowing or taxing." However, he also believes that "arbitrary control and issues of currency" which "affect the production of wealth, by acting on the hopes and fears of men" may be "under certain circumstances, wise" (17:159). In short, while he objects to a national debt, he recognizes that manipulation of the money supply is an important psychological means of regulating the economy for the best interests of the nation. With the exception of such "wise" manipulation, the money supply should always accurately reflect the real wealth of a nation. For this reason, "the use of substances of intrinsic value as the materials of a currency, is a barbarism;—a remnant of the conditions of barter, which alone render commerce possible among savage nations" (17:159). The gold standard, because gold is both a medium of exchange and a commodity in its own right, confuses the "real worth" of money as an index of national wealth with the commodity value of the metal. Instead of providing a sound basis for a nation's currency, the gold standard makes currency vulnerable to the vagaries of a commodities market

that may have no relationship to the economic well-being of the state.

Unlike "wealth" or "money," "riches" is a relative term, referring to the "greater or smaller share of, and claim upon, the wealth of the world" (17:160). It follows that relative riches necessarily entails relative poverty; hence, an inquiry into the conditions and processes that produce riches necessarily entails an inquiry into the sources of the poverty against which it is measured. To consider either wealth or poverty as a thing in itself, is to ignore the complex interrelationship among economic phenomena. Moreover, from the point of view of the nation, it is necessary to determine whether or not the distribution of riches affects the nature of wealth. If a king or "a few slave-masters are rich, and the nation is otherwise composed of slaves, is it to be called a rich nation?" (17:160–61). "We shall," he promises, "ultimately find it to be of incomparably greater importance to the nation in whose hands the thing is put, than how much of it is got" (17:206). Finally, in addition to these questions relating to the collection of riches, Ruskin raises questions relating to their administration. "The wholesome action of riches" would seem to depend "on the Wisdom, Justice, and Farsightedness of the holders," but "it is by no means to be assumed that persons primarily rich, must therefore be just and wise" (17:162). The feudal aristocracy Ruskin admired had become wealthy because it ruled; presumably its "right" to rule was derived from some source other than riches—if not justice and wisdom, then at least an instinct for leadership. To the modern industrial society in which that feudal aristocracy was rapidly being replaced by a capitalist plutocracy, whose claim to power would appear to be nothing more than its ability to make money, Ruskin poses a question that has yet to be answered: Is it in the best interests of a nation that its richest class, by virtue of its riches, also be its ruling class?

He asks this question without bias toward any given form of government. He may be suspicious of democracy and nostalgic toward the Venetian Senate, but "no form of government, provided it be a government at all, is, as such, to be either condemned or praised, or contested for in any wise, but by fools . . . all forms of government are good just so far as they attain this one vital necessity of policy— *that the wise and kind, few or many, shall govern the unwise and unkind. . . . if there by many foolish persons in a state, and few wise, then it is good that the few govern; and if there be many wise, and*

few foolish, then it is good that the many govern; and if many be
wise, yet one wiser, then it is good that one should govern" (17:248–
49). And who should govern, few or many or one, is among the chief
concerns of political economy.

"*Unto this Last*" may have begun as an attack on laissez-faire eco-
nomics, but as Ruskin pondered the questions he himself had raised,
he seems to have recognized that the problem was not that Victorian
economists were taken too seriously, but that they were not taken se-
riously enough; that economics was too important to be in the hands
of the narrowly oriented men who called themselves "economists."
The more thought he gave the subject, the more he was forced to
acknowledge the all-pervasive influence of economic forces, economic
decisions; and so what *Munera Pulveris* makes clear is that the impor-
tant thing is not the form of government, but the need for a govern-
ment willing to accept active responsibility for the nation's economy
and motivated by a vision of the fullest, most ennobled life of the
nation as a whole.

Sesame and Lilies (1865) and The Crown of Wild Olive (1866)

Sesame and Lilies was the first of Ruskin's works to achieve wide
popularity. The book was inexpensive (3s. 6d.), and the two chapters
of its 1865 version—"Of Kings' Treasuries" and "Of Queen's Gar-
dens" (respectively, the "Sesame" and "Lilies" of the title)—dealt
with subjects that were neither as formidable as those of his writing
on art or architecture nor, on the surface, as dangerous as his more
recent publications on political economy. The first, as Ruskin himself
summed it up, argued "that, life being very short, and the quiet
hours of it few, we ought to waste none of them in reading valueless
books; and that valuable books should, in a civilized country, be
within the reach of every one, printed in excellent form, for a just
price; but not in any vile, vulgar, or, by reason of smallness of type,
physically injurious form, at a vile price" (18:33). The second, which
has come to be a bête noire to feminists,[2] set forth Ruskin's notion
of the appropriate education and duties of gentlewomen. Here we
have—or seem to have—Ruskin at his most "Victorian," writing
about the proper form of a library and the responsibilities of middle-
class young ladies. And that the book was treated as appropriate read-
ing for middle-class young ladies would seem to confirm that
judgment.

Yet, despite its being treated as a "safe" book, *Sesame and Lilies* is another foray in Ruskin's radical attack on Victorian society. His remarks about books address themselves to the problem of universal education and consequent expansion of the reading public. Increased literacy is not cultural progress, he argues, if it merely leads to an expansion of the demand for throw-away literature: "The very cheapness of literature is making even wise people forget that if a book is worth reading, it is worth buying. No book is worth anything which is not worth *much;* nor is it serviceable, until it has been read, and re-read, and loved, and loved again; and marked, so that you can refer to the passages you want in it, as a soldier can seize the weapon he needs in an armoury, or a housewife bring the spice she needs from her store" (18:85). Just as Ruskin's economics defines value as that which "avails to life," *Sesame and Lilies* defines right education as advancement, not in social position, but in the qualities of mind that "make men thoughtful, merciful, and just" (18:107). Ruskin's ideal collection of books to be "read, and re-read, and loved, and loved again" is necessarily selective. But it is not enough to acquire the best books by the wisest men; one must also learn how to read. And so he seeks to rehabilitate the act of reading itself. By the example of his own analysis of a passage from Milton's "Lycidas," Ruskin defines "the kind of word-by-word examination of your author which is rightly called 'reading'; watching every accent and expression, and putting ourselves always in the author's place, annihilating our own personality, and seeking to enter into his, so as to be able assuredly to say, 'Thus Milton thought,' not 'Thus *I* thought, in mis-reading Milton' " (18:75).

To understand a text one must accept its fundamental alterity—its difference from and therefore resistance to the reader's point of view. Meaning is to be discovered by a careful examination of words, with concern not only for their contemporary usage but also for the resonances of meaning that lie in their historical origins. Even so, profound meaning, however closely sought, remains elusive, and the attempt to reduce it to a clear and distinct formulation is among the deadliest of misreadings. Reading, in other words, is a deeply subversive act. It denies the preconceptions of the reader without offering him a new form of certainty in exchange. Read by Ruskin's prescription, the "classics" that define the cultural heritage of the English-speaking world offer no fixed set of immutable values, but a constant challenge to the social order.

Ruskin exemplifies his concern for word origins in his explanation

of woman's role in society: "Lady means 'bread-giver' or 'loaf-giver,' "
a title which refers not only "to the bread which is given to the
household; but . . . to bread broken among the multitude" (18:138).
Thus, women have significant duties beyond those of wife and
mother. Despite this recognition, the idealized women Ruskin de-
scribes in "Of Queen's Gardens" echo a cultural stereotype. Taking
Shakespeare's plays as "testimony to the position and character of
women in human life," he finds them "infallibly faithful and wise
counsellors,—incorruptibly just and pure examples—strong always to
sanctify, even when they cannot save" (18:114). Yet high as is the
pedestal on which he places them, Ruskin's women remain subser-
vient to men. If he advocates education for women, it is education
aimed at perpetuating their role as "Lady": "All such knowledge
should be given her as may enable her to understand, and even to
aid, the work of men: and yet it should be given, not as knowl-
edge,—not as if it were, or could be, for her an object to know; but
only to feel, and to judge" (18:125). With the example of Rose La
Touche before him, he condemns women for meddling in theology,
but, with the exception of theology, "a girl's education should be
nearly, in its course and material of study, the same as a boy's; but
quite differently directed. A woman, in any rank of life, ought to
know whatever her husband is likely to know, but to know it in a
different way. His command of it should be foundational and pro-
gressive; hers, general and accomplished for daily and helpful use.
Not but that it would often be wiser in men to learn things in a
womanly sort of way . . . but, speaking broadly, a man ought to
know any language or science he learns, thoroughly—while a woman
ought to know the same language, or science, only so far as may en-
able her to sympathise in her husband's pleasures, and in those of his
best friends" (18:128)

 This idealized but restricted figure is a version of Ruskin's own
mother, whose "sympathy" with her husband's cultural and intellec-
tual interests in no way diminished her power over the household. If
he had difficulty imagining another type of woman, it is in large part
because his knowledge of women was limited—and his experience
with Effie so disastrous. In fairness to Ruskin, moreover, we must
recognize that in advocating extensive education of women he was in
advance of many of his contemporaries.

 These arguments do not, of course, challenge the fact that Ruskin's
view of women is, by contemporary standards, sexist, and, even by

an enlightened Victorian standard, old-fashioned. However, it is important to recognize that Ruskin was not merely articulating a program to keep women in their place. As his observation "that it would often be wiser in men to learn things in a womanly sort of way" suggests, he is considering an alternative to the way of knowing things he associates with a masculine stereotype—a way of knowing things characterized by sympathy rather than dominance. That he identified the two ways of knowing with the two sexes is both understandable and unfortunate. It precludes his acknowledgment that he himself very often thought "in a womanly sort of way" and that therein lay his strength as a writer. Trapped by his own sexual stereotypes, Ruskin's attempt to elevate womanly knowledge to a status equal to man's is doomed to failure, and "Of Queen's Gardens" remains something of a period piece. Yet the need to valorize a way of thinking that synthesized the habits of mind Ruskin denominates "male" and "female" remained a problem to be solved.

Later editions of *Sesame and Lilies* included a lecture "The Mystery of Life and its Arts," which Ruskin had delivered to a packed audience in Dublin, 13 May 1868. The title suggests how far Ruskin had come from the self-certainty of the first volumes of *Modern Painters*. Both life and art are now "mysteries," and his own attempts until now both to understand them and to promulgate his knowledge have met with dissapointment and frustration. Where before he had confidently asserted a divine plan, he now sees a mysterious perversity. The arts, he still insists, "never had prospered, nor could prosper, but when they had such true purpose, and were devoted to the proclamation of divine truth or law. And yet . . . they had always failed in this proclamation . . . poetry, and sculpture, and painting, though only great when they strove to teach us something about the gods, never had taught us anything trustworthy about the gods, but had always betrayed their trust in the crisis of it, and, with their powers at the full reach, became ministers to pride and to lust" (18:153). Moreover, the source of creativity itself remains a mystery. Although he resists the implications of his assertion, he asserts nevertheless "that art must not be talked about" (18:166).

If knowledge is uncertain, action is not. Rose La Touche was not in the audience, but Ruskin was sure she would soon come to know what he had said and to recognize he had her in mind when he addressed himself to "the morbid corruption and waste of vital power

in religious sentiment, by which the pure strength of that which should be the guiding soul of every nation, the splendour of its youthful manhood, and spotless light of its maidenhood, is averted or cast away." Instead of "grievous and vain meditation over the meaning of the great Book, of which no syllable was ever yet to be understood but through a deed," Ruskin calls for "true work." "On such holy and simple practice will be founded, indeed, at last, an infallible religion. The greatest of all the mysteries of life, and the most terrible, is the corruption of even the sincerest religion, which is not daily founded on rational, effective, humble, and helpful action" (18:185–86).

Ruskin did not, of course, give up his own search for knowledge, but "The Mystery of Life and its Arts" expresses a fundamental change in his understanding of the nature of knowledge. The rational consistency of his own arguments is no longer the sign of truth. Rather, truth lies in the consonance between thought and action. Writing, as Ruskin now conceives it, is not a self-enclosed activity; it is an act in a world of action. Its value depends on its action on the reader and leading in turn to further action. It is appropriate that "The Mystery of Life and its Arts" is a lecture. Lectures and letters became the dominant mode of Ruskin's later prose, because the audience had become an essential factor in the "truth" of what he had to say.

The Crown of Wild Olive (1866), a work which like *Sesame and Lilies* sold well, illustrates this change. It comprises three lectures to three very different audiences—"Work," addressed to the Working Men's Institute at Camberwell; "Traffic," to a group of businessmen and civic leaders at Bradford, who had asked Ruskin for architectural advice about the Exchange they were planning to build; "War," to the students and their families at the Royal Military Academy, Woolwich. The first two essays offer a good summary of Ruskin's thinking on economics and architecture. "Work" attempts to distinguish the necessary condition of the working class from the unnecessary conditions brought about by social injustice. "Traffic," a brilliant analysis of the values of the middle-class businessman, is notable for Ruskin's ironic suggestion that the Bradford bourgeoisie erect "in the innermost chambers" of their Exchange, "a statue of Britannia of the Market" (18:450). The essay on "War" is problematic. Like Carlyle, Ruskin admires the discipline and self-sacrifice of the model soldier

and he takes it as a lesson of history that "all the pure and noble arts of peace are founded on war" and that "no great art ever yet rose on earth, but among a nation of soldiers" (18:459–60). At the same time, however, he deplores modern mass warfare, in which techno-logical advantage, not the strength or courage of individual soldiers, decides the outcome, wars fought for no noble purpose, but to extend the power of capitalism. Seen with this double vision, war is yet an-other of the "mysteries of life" Ruskin is unable to solve.

Time and Tide, by Weare and Tyne (1867)

Time and Tide, a series of twenty-five letters addressed to Thomas Dixon, "a working corkcutter of Sunderland" (17:313), responds to the same political events that gave rise to Matthew Arnold's *Culture and Anarchy* (1869)—the defeat of the 1866 Reform Bill; the period of radical, working-class political demonstrations that followed the announcement by the leader of the conservatives, Benjamin Disraeli, six days after the opening of Parliament in February 1867, that his government intended to increase working-class suffrage; the Reform Bill that became law in August of that year. Arnold's essays were written with an eye to the liberal Parliament that emerged from the 1867 bill. Ruskin's letters, which appeared in the *Leeds Mercury* and *Manchester Daily Examiner and Times* from 27 February to 7 May 1867, were written for the working class at a time when its right to political power had at last been acknowledged by the party by which it had been long opposed. This difference in choice of audience is re-vealing. Arnold, with immediate practicality, addressed the middle class which had become the dominant force in British political life; Ruskin, with a further-reaching concern for the ultimate state of Britain, addressed the working class, not because he hoped that it would, in a matter of months, have the political clout to carry out his program, but because he believed that the working class was the one class with the potential for radical change. Because their values were not yet committed to the ethos of capitalism, "the working men of England must, for some time, be the only body to which we can look for resistance to the deadly influence of moneyed power" (17:442).

What Ruskin realized and Arnold did not is that the political struggle of the working class, if successful, would lead not merely to an extension of the franchise or a redistribution of wealth within a

permanent social structure, but rather to an altogether different state of society, about which certain knowledge is impossible. Arnold's view of history is linear and progressive: the future extends but does not displace the past. Ruskin's is dialectical: the future embodies a change in perspective that may or may not confirm the values of the past. (That he seems to be sure it will confirm *his* values is a limitation he shares with Hegel and Marx.)

What Ruskin believed could be certain is that if the newfound power of the working classes was dribbled away in quest of middle-class goals, it would be wasted. To avoid this waste a radical rethinking of the values and form of society was necessary. If, for example, members of the working class thought of education merely as a means of raising themselves into the middle class, then their education would be fundamentally valueless. (For this reason, his drawing lessons at the Working Men's College had carefully attempted to make no artists.)

Instead of social mobility, *Time and Tide* offers an elaborate, somewhat unrealistic set of utopian goals. One is inclined to question how seriously Ruskin meant his proposals—for example, to appoint "an overseer, or bishop" "over every hundred . . . families composing a Christian State" (17:378) or to institute a program of granting youths and maidens permission to marry "as the national attestation that the first portion of their lives had been rightly fulfilled" (17:420). No doubt he believed them admirable goals; however, his purpose was less to advance his own views than to hold out to his working-class readers the possibility of utopian vision in general and thus liberate them from existing models of social behavior.

In its utopianism, its choice of audience, and its wide-ranging epistolary format, *Time and Tide* foreshadows *Fors Clavigera* (1871–84). Like the later work, it is characterized by the radical conservatism that had lain, from the start, at the core of Ruskin's economic thinking. Even in advocating a fundamental transformation of economic and political systems, Ruskin is unable to reject the inevitability of social classes. There will, he writes, always be a working class, and its work will always be, to some extent, degrading. At best, the most degrading labor should be minimized and, by the program outlined in *The Stones of Venice,* the imaginative elements of craftsmanship encouraged. In this fragmentary account of an English utopia, with its "extinction of a great deal of vulgar upholstery and other mean handicraft" (17:427), Ruskin is close to William Morris's

News from Nowhere (1890) and essays like "How We Live and How
We Might Live" (1888)—writings for which Ruskin, of course, pro-
vided the leading influence.³ Yet his difference from Morris is also
clear. Ruskin cannot imagine a society without a rigorous code of law
and without a highly structured chain of authority. Individual human
nature, he believes, is too fallible to exist without external regula-
tion. Like Arnold—and unlike Morris—he fears anarchy. Different as
they otherwise are, *Time and Tide* and *Culture and Anarchy* both take
strong stands against the democratic ideal Arnold characterizes by the
phrase "Doing as One Likes." Arnold, however, conceives of anarchy
as political, while Ruskin conceives of it as psychological. Both men
recognize that what "one likes" may not in fact be what gives one
real satisfaction, but Ruskin grasps the perversity—the madness—of
human desire, as well as its economic determinants. Arnold's rela-
tively simple analysis of human behavior lends itself to prose of re-
markable clarity. Ruskin's sense of the complexity of human behavior
led to the flawed but extraordinary greatness of the work of his mid-
dle age.

Chapter Six
Synthesis: Ruskin in the 1870s

The 1870s were the busiest years of Ruskin's career. His Oxford lectures alone represent a considerable body of writing. During the same period, he published all or substantial parts of two books on natural history—*Proserpina* and *Deucalion*—and, beginning in 1871, the monthly installments of *Fors Clavigera*, which appeared regularly until his mental breakdown in 1878. (They were resumed in 1880 and again in 1883–84.) Nor were lecturing and writing his sole activities. *Fors Clavigera* involved Ruskin in a series of public ventures, the most important of which was the establishment of a museum of art and natural history at Sheffield. His personal life was also busy. In 1871 Ruskin had purchased and begun the extensive renovation of Brantwood. His life was now divided between this home in the Lake District; London, where, after his mother's death in 1871, he installed Joan and Arthur Severn in his family's old home at Herne Hill; Oxford, where, in addition to his duties as Slade Lecturer, he founded the Ruskin School of Drawing; and the Continent, which he continued to visit, sometimes for extended periods, both for pleasure and study.

It was not until the 1870s, after the deaths of both parents, that Ruskin's intellectual and emotional life achieved mature form. His concern for theoretical truth—the one area of expertise granted him by his "practical" mother and father—gave way to a concern for active achievement. The religious skepticism of the previous decade— in large part, a reaction against the Evangelical faith in which he had been raised—gave way to a uniquely Ruskinian Christianity, which united his native conservatism and his trust in the value of sacred books—the Bible and the writings of Plato, Dante, and others—with his belief in the need for radical social reorganization. In keeping with this transformation, the preference for Venetian art that characterized his break from Evangelicalism in *Modern Painters*, volume 5, was corrected by his discovery, in 1874, at Assisi, "that all Giotto's

'weaknesses' (so called) were merely absences of material science"; that "he was in the make of him, and contents, a very much stronger and greater man than Titian; that the things I had fancied easy in his work, because they were so unpretending and simple, were nevertheless inimitable" (29:91).

If Ruskin's genius lay in his ability to synthesize apparent contradictions into a higher perception of reality, then it is in this decade, when the dialectical pattern of his thought emerges most confidently, that his genius is fully realized. The writing of the 1870s is at once an attempt to "edit the fragments of himself" (26:150) and to recombine the elements of a divided society. Public purpose and private meaning merge in a set of utterances that, as much on account of as despite their idiosyncrasy, remain profoundly challenging to the foundations of modern industrial culture.

The Queen of the Air (1869)

The Queen of the Air both typifies and explains the eclecticism of Ruskin's late period. In his earlier work, digression had been a sign of germinating theory. The "truth" of a book like *Modern Painters* was to be seen in the broad applicability of its central ideas: the more a theory explained, the more certain it seemed to be. Conversely, the significance of landscape painting was affirmed by the serious issues into which Ruskin was led by his study of art. *The Queen of the Air*, in contrast, is a collection of disparate elements which Ruskin attempts to synthesize into a single vision of reality. Its ostensible subject is "Greek Myths of Cloud and Storm," but it draws together subjects as diverse as economics, warfare, and scientific nomenclature. The earlier works assumed a world organized by parallelism and analogy: their order is a function of the divine plan through which fundamental laws are echoed at all levels of being. Ruskin's later work assumes no a priori order. Because it is the human mind itself that organizes experience, ordering is a dynamic process. The strength of this writing is its power to bestow coherence. The greater the challenge to the writer's materials, the greater their heterogeneity, the greater—potentially—his accomplishment.

But Ruskin is not merely a juggler trying to see how many balls he can keep in the air. His stylistic daring reflects a felt need to confirm the wholeness and form of his own being—the need to achieve a coherent, purposeful identity made acute by his realization that,

well into middle age, he had thus far failed to do so. The disorder of
The Queen of the Air—the chaos of its third lecture ("Athena
Ergane")—is not, however, a symptom of "imbalance of mind or un-
certainty of purpose."[1] It is the act of a mind seeking to establish its
coordinates and willing to confront the distance between them. More-
over, disorder is a necessary precondition of the text's effort to organ-
ize itself around the mythic figure of Athena.

John D. Rosenberg rightly sees *The Queen of the Air* as an incanta-
tion to "the *anima mundi* which [Ruskin] worshipped all his life in
the cloud, the sea, the breathing leaf, and in man," for whom the
Protestant Athena offers an embodiment more suitable to his Protes-
tant soul than the Catholic Queen of Heaven.[2] But the book is more
than his personal statement of faith and desire. It is Ruskin's attempt
to find an alternative to the nineteenth-century consciousness in "an
earlier mode of cognition in which the worlds of nature, society and
self were not separate, but single; not divided, but whole."[3] The fail-
ures of his society against which he had for so many years been
waging a losing battle were, he had come to see, products of
fragmentary, compartmentalized thinking—thinking that could make
no connection between art and morality, moneymaking and national
honor. To combat these failures he needed a new way of thinking.
He had acknowledged the power of the mythic consciousness at least
as early as the fifth volume of *Modern Painters*; now he would attempt
to exploit its potential.

Ruskin found authority for *The Queen of the Air* in the philologically
based mythography of Friedrich Max Müller, whom he has princi-
pally in mind when he admits his own lack of qualifications for ex-
ploring "the fields of history opened by the splendid investigation of
recent philologists" (19:292). It was Müller's assertion that his recon-
structions of myth were a "science of mythology" that encouraged
Ruskin to advance his own intuitions as "research." For both men,
myths are primal poetry, because "poetry," Müller insists, "is older
than prose, and abstract speech more difficult than the outpouring of
a poet's sympathy for nature."[4] If somewhere beneath the myth of the
solar hero—the hero whose cyclic life reiterates the sun's zodiacal
year—lies man's root experience of the dawn, then Max Müller's "sci-
ence of mythology" could offer Ruskin the hope of recovering simul-
taneously both the true mythopoeic consciousness and the immediate
experience of physical nature he postulates as the birthright of primal
man.

Arguing the possibility of this heightened, synthetic perception of

the natural world, Ruskin asserts two sources for myths: "actual historical events, represented by the fancy under figures personifying them; or else . . . natural phenomena similarly endowed with life by the imaginative power, usually more or less under the influence of terror." And since "the stars, and hills, and storms are with us now, as they were with others of old . . . it only needs that we look at them with the earnestness of those childish eyes to understand the first words spoken of them by the children of men" (19:299–300). The gap between this primal "worship of natural phenomena" and Victorian positivism might be bridged by the continuity of the natural phenomena themselves, were it not for the limitations of a nineteenth-century consciousness incapable of recovering "the earnestness of those childish eyes." And so it is on the expressive potential of his own prose, not a shared experience of nature, that Ruskin must rely.

Ruskin acknowledges that "it may be easy to prove that the ascent of Apollo in his chariot signifies nothing but the rising of the sun," but then goes on to ask the pregnant question: "what does the sunrise itself signify to us?" His answer at once explains and illustrates the strategy of *The Queen of the Air*:

If only languid return to frivolous amusement, or fruitless labour, it will, indeed, not be easy for us to conceive the power, over a Greek, of the name of Apollo. But if, for us also, as for the Greek, the sunrise means daily restoration to the sense of passionate gladness, and of perfect life—if it means the thrilling of new strength through every nerve,—the shedding over us of a better peace than the peace of night, in the power of the dawn,—and the purging of evil vision and fear by the baptism of its dew; if the sun itself is an influence, to us also, of spiritual good—and becomes thus in reality, not in imagination, to us also, a spiritual power,—we may then soon over-pass the narrow limit of conception which kept that power impersonal, and rise with the Greek to the thought of an angel who rejoiced as a strong man to run his course, whose voice, calling to life and to labour, rang round the earth, and whose going forth was to the ends of heaven. (19:302–3)

Ruskin stretches the "if . . . then" structure to what might be its breaking point, were it not for the controlling repetitions of "if " and "for us also." As the terms of the conditional clause grow in number, the movement of the sentence toward resolution is halted again and again by appositional qualifiers, usually set off by commas, but three times by the stronger punctuation of dashes. This slowing down, in direct opposition to the natural thrust of the sentence toward a re-

solving clause, is essential to Ruskin's purposes. He is concerned with offering us more than a collection or even a causal sequence of perceptions, but a single syncretic and timeless analogue to the Greek experience of the rising sun. Subtly the "if it means" clauses shift into the redirected conditional "if the sun itself is." Ruskin's inclusive parallelism blurs the logical distinction between demands for human participation in nature and demands from nature itself. "Imagination" gives way to "reality." And just as "baptism" prepares us for "spiritual power" and finally, significantly, for "life and labour," the force of this rhetoric carries a willing reader irresistably into the evocative language and rhythm of the Psalm.[5] We are aware of an analysis into elements—"restoration," "passionate gladness," etc.—but the myth retains a semblance of its primal unity, for which the Judeo-Christian "angel" is at once a mythographic analogue and, both as a logical consequence of the imagery of Christian awakening and by way of literary allusion, a right and necessary expression.

Ruskin's examination of Hermes as a god of cloud formation (19:320–22) offers a more elaborate example of his technique. To explain the import of Hermes' birthplace on Mt. Cyllene, Ruskin first places us in the valley of Sparta, "one of the noblest mountain ravines in the world," then turns our attention to its "western flank . . . formed by an unbroken chain of crags, forty miles long, rising, opposite Sparta, to a height of 8,000 feet." We are directed to be concerned not merely with the geology of the scene, but with its particular associations for the Spartan imagination. The chain of Taygetus is named for the nymph Taygeta, "mythic ancestress of the Spartan race" and "one of the seven stars of spring." And Ruskin attempts to explain why this seasonal goddess is linked with a mountain range through an empathic description of

the pineclad slopes of the hills of Sparta and Arcadia, when the snows of their higher summits, beneath the sunshine of April, fell into fountains, and rose into clouds; and in every ravine was a newly-awakened voice of waters,—soft increase of whisper among its sacred stones: and on every crag its forming and fading veil of radiant cloud; temple above temple, of the divine marble that no tool can pollute, nor ruin undermine.

Once again, we encounter the notion of pollution implicit in the cleansing imagery of the sunrise passage, but here, pointedly, applied to the human transformation of the landscape. (It is precisely the refusal to dominate nature—with railway cuttings or copper mines—

that characterizes the "primitive" consciousness.) Only after having thus characterized the geographical area as an unspoiled whole—with the compelling tendency toward personification in "voice" and "whisper" and the explicitly metaphoric humanization of "temple above temple"—does Ruskin single in on the specific birthplace of Hermes:

And, therefore, beyond this central valley, this great Greek vase of Arcadia, on the "*hollow*" mountain, Cyllene, or "pregnant" mountain, called also "cold," because there the vapours rest, and born of the eldest of those stars of Spring, that Maia, from whom your own month of May has its name, bringing to you, in the green of her garlands, and the white of her hawthorn, the unrecognized symbols of the pastures and the wreathed snows of Arcadia, where long ago she was queen of stars: there—first cradled and wrapt in swaddling-clothes; then raised, in a moment of surprise, into his wandering power—is born the shepherd of the clouds, winged-footed and deceiving,—blinding the eyes of Argus,—escaping from the grasp of Apollo—restless messenger between the highest sky and topmost earth—

> "the herald Mercury,
> New-lighted on a heaven-kissing hill."

Structurally, this sentence first presents us with a collection of disparate elements, the uncertainty of whose relationship creates a tension which seems to be about to resolve itself in the image of the newborn god, but instead moves outward, like lines of light, in Ruskin's rapid catalog of the attributes of the adult Hermes. This hourglass shape and Ruskin's incredible syntax—the inverted subject and verb "is born the shepherd of the clouds" does not occur until after 103 words of modification—are intentional. He wants us intensely aware of place—of its geological and meteorological essences, its aesthetic aspects, with a familiarity comparable to that of a Spartan born and bred at the foot of the Taygetus and a mythic consciousness of the participation of the universal "evermore about to be" in the particular—so that the birth of Hermes is seen both as an event inherent in the perception of this totality and as the one symbol able to express the vital unity of its diverse elements. Concepts as apparently distinct as "pregnant" and "cold" are summoned etymologically and fused in the images of Spring, white hawthorn blossoms seen against green garlands—echoed in the larger images of pastures and snows—and the epithet "queen of the stars." We sense a possible focus for this body of images in the words "cradled and wrapt in swaddling-clothes." Ruskin uses the King James diction of Luke 2 to draw an

analogy between the birth of Hermes and the Christian miracle of the Incarnation: universal godhood seen as a helpless human child, historical moment in the ordinary details of childbirth. But by refusing to give us a noun to fix the two participles, Ruskin forces us to accept the essentially dynamic nature of this event. By his elliptical reference to Hermes as a baby, he suggests that infancy is a quickly passed stage in the god's process of becoming. The participles accelerate from perfect to present; we share Hermes' "surprise" at his instant elevation to "the shepherd of the clouds."

The timelessness of this event is suggested by the historical present "is born." The mental act Ruskin asks us to re-create imaginatively has its objective correlative in our struggle to make sense out of its prose statement. We want Hermes born if only to provide a grammatical structure for the otherwise chaotic sentence. (If some readers feel an inclination to misread the "that" preceding "Maia" as a pronoun—after all, the participles "cradled," "wrapt," and "raised" could be transitive verbs—the error attests to our longing for a subject.) At the same time, the "English" references to the month of May and hawthorn flowers and the concluding quotation from Hamlet suggest that the timelessness of the event makes it relevant to the present. Shakespeare conceiving the image of "the herald Mercury" is echoing the radical mythmaking of the Greeks. And Ruskin himself does much the same thing when he allows Taygeta's membership in the Pleiades to remind him of "the question to Job,—'Canst thou bind the sweet influence of the Pleiades, or loose the bands of Orion?' "

To extend the significance of a myth is itself a form of mythopoeia. Here, as in his remarks on the sunrise, Ruskin feels free to move from Greek to Hebrew mythology and end up with Shakespeare not because he believes in an historical "key to all mythologies," but because of his confidence that the mythopoeic consciousness is everywhere and at all times the same. Because "all true vision by noble persons . . . is founded on constant laws common to all human nature" and "its fulness is developed and manifested more and more by the reverberation of it from minds of the same mirror-temper," it follows that "you will understand Homer better by seeing his reflection in Dante, as you may trace new forms and softer colours in a hill-side, redoubled by a lake" (19:310).

This notion of "reverberation" applies, of course, to Ruskin's own prose, in which the significance of myth is made to resonate and ex-

pand. His interest in myth rests on more than the possibility of recovering a primitive consciousness of the natural world. Unlike Müller, Ruskin believed that "the real meaning of any myth is that which it has at the noblest age of the nation among which it is current" (19:301). The Greek myths of Athena, although they harken back to a much earlier time, were, for Ruskin, given their fullest statement at the apex of Hellenic civilization, "about 500 B.C.," in the sophisticated literary expressions of Pindar and Aeschylus (19:303). For Müller, the literary treatment of myth was a sign of decadence; for Ruskin, it was the most fully developed form of the myth—its treatment as the vehicle for "moral significance" (19:300). It is the strength of the myth, he believed, that its belated intellectualization, far from obscuring the truth of earlier meanings, becomes yet another element in a rich synthesis of thought. Myth not only enables one to recapture a lost consciousness of the natural world; it links that consciousness to moral interpretation and judgment. Appropriately, the metaphor he uses to express these relations is one of organic growth: the ur-myth "contains the germ of the accomplished tradition; but only as the seed contains the flower" (19:301).

The connection between landscape and morality *Modern Painters* had sought in a transcendent order of being is now seen as a function of human storytelling. The power of myth is typically human because it is typically human to desire synthesis—to enjoy, even in the simplest narratives, the coalescence of parts into wholes. In this respect, the mythopoeic consciousness can be identified with the creative force itself. *The Queen of the Air* identifies this force with the power that transforms mere conjunction of materials into coherent form (19:357). The mythmaker, by inference, does not simply perform an act comparable to that of the creating force of the universe; he participates in that force.

This assumption has two consequences that are born out in Ruskin's subsequent writing. It leads to a repudiation of scientific thought that seeks to reduce complexity to simplicity and it grants special authority to the consciousness of the artist. To argue that the purpose of the flower is to create the seed is to make a less complex form the purpose of a more complex: "The reason for seeds is that flowers may be; not the reason of flowers that seeds may be. The flower itself is the creature which the spirit makes; only, in connection with its perfectness, is placed the giving birth to its successor" (19:357–58). In the consciousness of the great artist, the seeds of primitive myth ef-

floresce into spiritual form. To represent that consciousness in all its fullness is thus a legitimate goal for Ruskin's prose. *Modern Painters* had worked, volume by volume, toward a greater respect for the mind of Turner. *The Queen of the Air* leads Ruskin to a greater respect for his own mind—or at least to the acknowledgment that the value of his work is inseparable from the value of his own consciousness:

> every past effort of my life, every gleam of rightness or good in it, is with me now, to help me in my grasp of this art, and its vision. So far as I can rejoice in, or interpret either, my power is owing to what of right there is in me. I dare to say it, that, because through all my life I have desired good, and not evil; because I have been kind to many; have wished to be kind to all; have wilfully injured none; and because I have loved much, and not selfishly; —therefore, the morning light is yet visible to me on those hills, and you, who read, may trust my thought and word in such work as I have to do for you; and you will be glad afterwards that you have trusted them. (19:396)

Fors Clavigera (1871–78, 1880, 1883–84)

The ninety-six "Letters to the Workmen and Labourers of Great Britain" that compose *Fors Clavigera* are the most difficult of Ruskin's writings to summarize. They range over an extraordinary variety of subjects—so many that no simple description of their contents is possible. The editors of the Library Edition group the materials of *Fors* under six headings: (1) "a Miscellany"; (2) "a treatise on Social Economy in the form of a criticism of the nineteenth century"; (3) "an essay in social reconstruction, or a study in Utopia; in which connexion it becomes (in its later numbers) the monthly organ of a Society, the St. George's Guild"; (4) "an Essay on the Principles of Education"; (5) "a book of Personal Confessions"; and (6) "a Confession of Faith" (27:xxxiii). The first of these headings ("a Miscellany") is itself a catchall, which is stretched to include readings (often in original translations) of Plato, the Bible, Virgil, Dante, Shakespeare, Froissart, Chaucer, Marmontel, and Gotthelf (whose story "The Broom Merchant" Ruskin serializes in its entirety); notes toward a biography of Sir Walter Scott; studies in heraldry, in Greek mythology, in Greek, English, and Italian history, in Carpaccio and other artists, in Venetian architecture, and in natural history.

Some of these topics are already familiar to us from Ruskin's earlier work. *Fors* is in part a restatement of his earlier ideas—or such of

them as he still held—for the benefit of the "Workmen" he hoped would read the letters. But it is not the breadth of Ruskin's subject matter that accounts for the real difficulty of *Fors*. It is the style in which the work is written. If it is often difficult to know just how to respond to a particular passage—whether to read it as ironic, humorous, or straightforward—it is because the letters address us in a voice intimately, even eccentrically, personal, but at the same time dead serious in its public concerns.

Critics have long noted this private-public dualism. Frederic Harrison, the English disciple of Auguste Comte whose correspondence with Ruskin figures in several of the letters, labels them "Ruskin's *Hamlet*" and "his *Apocalypse*." He finds them, like *Hamlet*, "the revelation of a mind of marvellous brilliancy, richness, and culture; of a nature of exquisite tenderness, generosity, and candour"; yet they are also the exposition of a social program Harrison calls "a real and very potent Gospel."[6] Paul Sawyer, in a recent essay, offers an interpretation of *Fors* based on the same dualism, reading the letters, on the one hand, as "a series of public sermons in which the St. George legend allegorizes the spiritual rebirth of the English nation," and, on the other, as "a series of confessions in which Ruskin records a private quest for a lost Eden, a 'Paradise within,' creating a myth out of his own actions and desires."[7]

What is remarkable about *Fors Clavigera* is not, however, that it works on both levels, but that it works on both—on all—levels at the same time: that the distinction between public and private is emptied of significant meaning.[8] In a literal manner, this refusal to distinguish two sets of values generates the section "Affairs of the Master" appended to the letters written after the Guild of St. George had begun to take form. Arguing that "the Companions of St. George are all to have glass pockets; so that the absolute contents of them may be known to all men" (28:528), Ruskin published a regular account of his personal income and expenditures. Also in a literal manner, the refusal to distinguish public and private results in the passages of autobiography scattered throughout the letters. (These reappeared in *Praeterita* and will be discussed in the next chapter.)

Less literally, more pervasively, Ruskin offers the readers of *Fors* an account of the processes of his own mind at work. The monthly installments are not formal epistles—essays in disguise—but personal letters, in which the writer felt free to transcribe whatever occurred to him. At times they verge on free association. But even when Rus-

kin has a clearly defined purpose, it is a purpose expressed through
the movement of his own thought. In one of the last letters (September 1883), he regrets having yielded "without scruple, to the eddies
of thought which turned the main stream of my discourse into apparently irrelevant, and certainly unprogressive inlets" (29:445). But
in 1877 he was still firm in defending the method of his work:

> *Fors is a letter,* and written as a letter should be written, frankly, and as the
> mood, or topic, chances; so far as I finish and retouch it, . . . it ceases to
> be what it should be, and becomes a serious treatise, which I never meant
> to undertake. True, the play of‚it (and much of it is a kind of bitter play)
> has always, as I told you before, as stern final purpose as Morgiana's dance;
> but the gesture of the moment must be as the humour takes me. (29:197)

To make his prose "the gesture of the moment" is to nullify the
distinction between "objective" language and "subjective" being.
Like the myths Ruskin explored in *The Queen of the Air,* the style of
Fors Clavigera restores the connection between intellection and experience. Writing is conceived not as a belated abstraction, much less
a translation of something intimately personal into the alien, socially
determined medium of the text, but as an element of the writer's here
and now. Current events become a leading issue in the text. The
Franco-Prussian War is a repeated theme in the earlier letters. The
latest statements in Parliament or by the press are taken up as material for discussion. More significantly, the actual place and time at
which Ruskin's prose comes into being is treated as a self-reflexive
component of the text. *"Rome, 12th May.*—I am writing at the window of a new inn," he informs the reader of the June 1872 letter.
"Standing in this balcony, I am within three hundred yards of the
greater Church of St. Mary, from which Castruccio Castracani walked
to St. Peter's on 17th January, 1328, carrying the sword of the German Empire, with which he was appointed to gird its Emperor, on
his taking possession of Rome, by Castruccio's help, in spite of the
Pope" (27:309). The meaning of such prose not only includes the locus of its composition—the quoted passage is partly an expression of
Ruskin, but also partly an expression of Rome; it also perceives that
locus with its full historical associations. Moreover, because it is for
the sake of the present that history is written, it occurs not as a discrete representation of the past—as it would in a book dedicated ex-

clusively to the history of medieval Italy—but as a collection of fragments scattered about in Ruskin's text.

The success of this style confirms the coherence of Ruskin's own mind. The sense, the feel of continuity "proves" the metarational organization of his thinking. Yet, as we have seen, the thrust of the work is not simply personal. The style of *Fors* is also a direct expression of Ruskin's aim to "overthrow . . . the entire system of modern society" (29:111). *Munera Pulveris* had sought to replace the equations of the economists with a new way of thinking that valorized the incalculable. *Fors* carries this project a step further, seeking, as Frederic Harrison realized, "to recast the thought of humanity *de novo.*"⁹

To effect this revolution in thought, it was necessary to free himself from his own intellectual predispositions. He could not offer an articulate, rational plan for the future, because wholeness of self—the aim of his revolution—is more complex and more inclusive than any single verbal formula. A truly dialectical thinker, he recognized that the fulfillment of his aspirations would take a form he could not be expected to anticipate.

This rejection of system was not easy for Ruskin. Like Carlyle, he had a strong need for authority. The fragments of utopian thought that constitute one of the main elements in *Fors* describe a rigorously authoritarian society. Yet its significant thrust is not toward a narrowly defined social system, but toward the habits of mind that may make such a system desirable. *Fors* and the projects related to it follow no defined plan because "to define it severely would be to falsify it." "All that is best in it depends," Ruskin explained, "on my adopting whatever good I can find, in men and things, that will work to my purpose. . . . Nay, I am wrong, even in speaking of it as a plan or scheme at all. It is only a method of uniting the force of all good plans and wise schemes: it is a principle and a tendency, like the law of form in a crystal; not a plan" (28:235). Scott's work is unique in modern fiction "*because* he did not 'know what was coming' " and wrote instead "with the same heavenly involuntariness in which a bird builds her nest" (29:265). It is precisely this prerational, instinctive power Ruskin wishes to attain in *Fors*. Responding to the letter of a "working woman" who complained of being unable to understand his plans, he replies, "She may be pleased to know that I don't yet understand some of my plans myself, for they are not, strictly speaking, mine at all, but Nature's and Heaven's, which are

not always comprehensible, until one begins to act on them"
(27:276). The power of *Fors,* it would seem, lies in its autonomy
from Ruskin himself—or at least in its autonomy from the rational-
ist, system-building side of his personality.

Ruskin's predilection for a society structured on rigorous lines of
authority and obedience determines the values he promulgates in
Fors. Yet the book remains open-ended, and its open-endedness is, in
effect, Ruskin's resistance to his own need for security. *Fors,* in other
words, is a struggle between two sides of Ruskin—his authoritarian-
ism and his hope for a radical transformation of consciousness. And
the desultory manner of the work, far from being self-indulgence, is
in fact an effort to oppose his own strongest instincts. (Free associa-
tion, as psychoanalysis demonstrates, is not always easy.)

To oppose order and surety is to accept the unknown, an intention
expressed in the title of the book, which is itself a kind of riddle.
Ruskin offers an extended definition of "Fors Clavigera" in the second
letter, and he returns to it repeatedly in later installments. " 'Fors,' "
he writes, "is the best part of three good English words, Force, For-
titude, and Fortune. . . . 'Force' (in humanity) . . . means power of
doing good work. . . . 'Fortitude' means the power of bearing nec-
essary pain, or trial of patience," and " 'Fortune' means the necessary
fate of a man: the ordinance of his life which cannot be changed."
"Clavigera" he derives from any of three Latin words—"Clava means
a club. Clavis, a key. Clavus, a nail, or a rudder"—combined with
the verb *gero* ("I carry"), "the root of our word gesture . . . and, in
a curious bye-way, of 'jest' ":

> Clavigera may mean, therefore, either Club-bearer, Key-bearer, or Nail-
> bearer.
> Each of these three possible meanings of Clavigera corresponds to one of
> the three meanings of Fors.
> Fors, the Club-bearer, means the strength of Hercules, or of Deed.
> Fors, the Key-bearer, means the strength of Ulysses, or of Patience.
> Fors, the Nail-bearer, means the strength of Lycurgus, or of Law.
> (27:27–28)

In this initial definition, the Third Fors is identified with Law in gen-
eral, but later Ruskin stressed its more specific identity with "the
laws of Fortune or Destiny, 'Clavigera,' Nail bearing; or, in the full
idea, nail-and-hammer bearing; driving the iron home with hammer-
stroke, so that nothing shall be moved; and fastening each of us at

last to the Cross we have chosen to carry" (27:230–31). And it is this third figure in Ruskin's trinity who presides over the work itself, "the contents of the letters being absolutely as the Third Fors may order, she orders me here and there so fast sometimes that I can't hold the pace" (27:553).

One aspect of Ruskin's strategy is clear. The Third Fors is his own liberated consciousness elevated to the status of destiny. But the cryptic nature of his title is more than a means of sanctioning his method of composition. Ruskin's play with Latin roots suggests at once richness of meaning and the impossibility of certain meaning. And, because its meaning is a riddle, the reader is necessarily an active participant in the text. *Fors* is, one might almost say, a collection of symbolic events left to the reader for final analysis. If it is not quite such a collection, it falls short because Ruskin gives so many clues to its meaning. Notably, he teaches the method of problem-solving appropriate to his own text. The typological method of *The Stones of Venice* is here refined to the acute analysis of a society based on its manufactured artifacts or the trivial details of common life. An Italian fig-seller is shown to be emblematic of the fall, both of Venice, and of modern civilization, "to any one who could read signs, either in earth, or her heaven and sea" (27:336).[10] The absence of sugar tongs at a Parisian breakfast table is analyzed to similar effect (28:209). The iron bench legs at Kirkby—cast in the form of "the Devil's tail pulled off, with a goose's head stuck on the wrong end of it"—become a "perfect" symbol "of our English populace, fashionable and other, which seats itself to admire prospects, in the present day" (28:300).

The events of *Fors* call out for interpretation, and it is in this respect that the letters illustrate the theory of education that occupies much of Ruskin's attention, particularly in the later numbers. His purpose is suggested by the passage he translates from Plato's *Phaedrus* in letter 17, in which the demigod Theuth, having invented writing, is chastised by the king of Egypt:

"this art of writing will bring forgetfulness into the souls of those who learn it, because, trusting to the external power of the scripture, and stamp of other men's minds, and not themselves putting themselves in mind, within themselves, it is not medicine of divine memory, but a drug of memorandum, that you have discovered, and you will only give the reputation and semblance of wisdom, not the truth of wisdom, to the learners: for . . . becoming hearers of many things, yet without instruction, they will seem to

have manifold opinions; and the most of them incapable of living together
in any good understanding; having become seeming-wise, instead of wise."
(29:295)

When Ruskin returned to this passage in letter 94, he revised his
translation to make his characterization of writing more strongly
worded: " 'It is not medicine (to give the power) of divine memory,
but a quack's drug for memorandum, leaving the memory idle' "
(29:483).

To avoid being yet another "quack's drug," *Fors* can never be al-
lowed to take the place of real learning. The printed pages of Rus-
kin's letters can never be allowed to replace the memory of their
readers. Moreover, this distrust of writing is not an issue limited to
the text of *Fors*. It raises a question that applies to writing in general
and the role of the written word in teaching. By 1884, when letter
94 was composed, Ruskin's distrust of the emerging form of British
public education was strong. The alternative St. George's Schools he
projected would be radically different, even to the rejection of the
three *R*'s: "I do not care that St. George's Children, as a rule, should
learn either reading or writing, because there are very few people in
the world who get good by either" (29:479–80). Ruskin was not ad-
vocating general illiteracy. He assumed that most children would
learn to read and write through natural curiosity, and that they
would learn elementary mathematics when they discovered its useful-
ness in the affairs of day-to-day living. What he objected to was the
privilege of reading, writing, and arithmetic in the school curriculum
over the disciplines he believed more important. Because he chooses
"to teach the elements of music, astronomy, botany, and zoology, not
only the mistresses and masters capable of teaching them should not
waste their time on the three *R*'s; but the children themselves would
have no time to spare, nor should they have" (29:479).

The assumption that underlies these judgments is that education
should develop a child's capacity to experience the world around him.
The three sciences he chooses to teach are sciences of aspects. Astron-
omy, as he conceives it in this context, is not stellar physics, but a
familiarity with the night sky. Moreover, in contrast to a system of
national standards, the curriculum of St. George's Schools should be
a function of its setting: "You need not teach botany to the sons of
fishermen, architecture to shepherds, or painting to colliers; still less
the elegances of grammar to children who throughout the probable

course of their total lives will have, or ought to have, little to say, and nothing to write" (29:496). Music entails elementary experience of the "natural" laws of harmony and rhythm. Hence, music education should *not* teach the ability to appreciate a professional performance: "For persons incapable of song to be content in amusement by a professional singer, is as much a sign of decay in the virtue and use of music, as crowded spectators in the amphitheatre sitting to be amused by gladiators are a sign of decline in the virtue and use of war" (29:239).

Ruskin's ideal education is designed to make human beings joyfully content with the world in which they are born. It recognizes the difference between individuals and judges each student by the standard of his or her own abilities. In contrast, the modern education Ruskin deplores assumes a common standard of ability, with rewards to those best able to compete against their fellows. "The madness of the modern cram and examination system arises principally out of the struggle to get lucrative places; but partly out of the radical blockheadism of supposing that all men are naturally equal, and can only make their own way by elbowing" (29:496).

The danger of an education that encourages indiscriminate reading is that bad literature develops unwholesome discontent. It arouses passions that cannot be assuaged in the real world, desires that cannot be fulfilled—save in further reading of the same sort. The danger of an education that concentrates on writing and arithmetic is that the possession of these skills, in advanced form, holds out the possibility of social advancement and makes advancement itself an end—rather than the fullest experience of the here and now. A system of education based on the faith that everyone can rise in the world destroys more happiness than it creates.

Ruskin's identification of happiness with the immediate, rich experience of the world in which one is placed by fate or circumstance leads to a concern for the environment that foreshadows that of the late twentieth century. Whatever threatens this immediate experience he attacks ruthlessly. *Fors Clavigera* is one of the great diatribes against industrial pollution. It holds a mirror to a Victorian England excoriated by its railway cuttings, poisoned by its streams, choked by its own dustheaps. But it is not merely the destruction of the physical environment that blocks human experience. Music, as we have seen, is important to Ruskin as an immediate personal experience; once it becomes secondary—as it is for the audience at a formal musical

event—its power has been perverted. Steam machinery is banished
from the land Ruskin hopes to assemble for St. George's Guild, not
only because it creates noise and smoke, but also because it disrupts
what he believes to be a fundamental relationship between the laborer
and the soil. Political theory, if it takes the place of political action,
has the same deadening effect. And, by the same logic, a religion
centered in theological creed rather than actual human experience is
a destructive force.

The religious message of *Fors*—increasingly strong as the letters
progressed—is the preference for works over faith. The religion of
Ruskin's last years, although it takes sustenance from the biblical
readings that had been his regular practice since childhood, is essen-
tially a religion of humanity: "One thing we know, or may know, if
we will,—that the heart and conscience of man are divine; that in his
perception of evil, in his recognition of good, he is himself a God
manifest in the flesh; that his joy in love, his agony in anger, his
indignation at injustice, his glory in self-sacrifice, are all eternal, in-
disputable proofs of his unity with a great Spiritual Head; . . . that
so far as he confesses, and rules by, these, he hallows and makes ad-
mirable the Name of his Father, and receives, in his sonship, fulness
of power with Him, whose are the kingdom, the power, and the
glory, world without end" (28:330). Such a religion does not express
itself in liturgical forms or ecclesiastical privilege. *Fors,* accordingly,
becomes a savage attack on the established church and its clergy. Not
only have the clergy substituted a comfortable position in British so-
ciety for their professed role as preachers of the Gospel of Christ; as
a conservative voice that has "repelled the advance both of science and
scholarship," Ruskin believed them responsible for all that is wrong
with "the existing 'state of things' in this British nation" (28:364–
65). Moreover, the non-conformist Evangelical ministry seemed to
him just as bad, since its literalist reading of the Bible is yet another
substitution of word for deed; its smug self-righteousness, the denial
of human fellowship.

The clergy, however, is not the only target of Ruskin's scorn. He
rails against the hypocrisy of a nation that professes a religion based
on love yet at the same time espouses an economic creed of devil-
take-the-hindmost competition, bolstered by a biological theory of
man's predatory nature. Such a nation "has no 'social structure' what-
soever; but is a mere heap of agonizing human maggots, scrambling
and sprawling over each other for any manner of rotten eatable thing

they can get a bite of" (29:320). To combat this degeneration, the Guild of St. George becomes, in time, a nineteenth-century version of primitive Christianity; Ruskin's "Letters to the Workmen and Labourers of Great Britain," a latter day continuation of the New Testament epistles: "My dear children," he writes an 1876 correspondent, "the rules of St. George's Company are none other than those which at your baptism your godfather and godmother promised to see that you should obey—namely, the rules of conduct given to all His disciples by Christ" (28:608).

To profess such a religion, Ruskin must give it existential expression. His St. George's projects make an effort in this direction, but it is *Fors* itself that becomes less a statement of belief than an act of faith. Like Kierkegaard's *Attack upon Christendom* letters to the Danish press, *Fors* is a public gesture in which the writer's theoretical criticism of his nation becomes an open challenge.

The deeply personal element in *Fors Clavigera* is part of its challenge—its demand that the reader, like Ruskin, integrate public responsibility and private desire. But it is also a challenge to Ruskin himself. *Fors* puts the value and coherence of his self on the line, month by month, year after year. When Ruskin brashly declares himself "a Communist of the old school—reddest also of the red" (27:116) and, three months later, "a violent Tory of the old school (Walter Scott's school, that is to say, and Homer's)" (27:167), he deliberately lays himself open to charges of inconsistency. His aim, of course, is to give the lie to any simple account of either political view. But the price he pays in order to make this point is an increase in his own vulnerability. To resist the reader's glib categorization, he reveals the indeterminacy of his own being.

This price is particularly high when he feels called upon to defend himself against what he interprets as personal attack, because his habitual defense—self-revelation—often betrays what could be taken as weakness. In letter 41, for example, he sums up a long passage listing his strengths of character with the ironic conclusion that "therefore the hacks of English art and literature wag their heads at me, and the poor wretch who pawns the dirty linen of his soul daily for a bottle of sour wine and a cigar, talks of the 'effeminate sentimentality of Ruskin' " (28:81). Cook and Wedderburn searched for the source of Ruskin's reference (which Ruskin himself later attributed to the *Saturday Review*) and decided that, although Ruskin had been called "sentimental," the term "effeminate" was probably a lapse of

memory. It is clearly more. It is the charge Ruskin believed he heard beneath the other criticism and sought, through *Fors,* to bring into the open. Similarly, letter 86 brings the details of his quarrel with his old friend Octavia Hill—who, after many years of managing Ruskin's slum properties, made the mistake of charging him with impracticality—into embarrassing notice, quoting in their entirety a series of letters in which Ruskin betrays his own stubborn arrogance.

The *Fors Clavigera* letters have, for this reason, the curious effect of at once offering an intimate portrait of their writer and distancing him from the reader. Ruskin complains of "the separation between me and the people round me" (28:146), of "the sense of my total isolation from the thoughts and ways of the present English people" (28:694). But the act of complaint seems to have done more to heighten his feeling of alienation than to have removed it. He recounts the events of Christmas 1876—the manner in which his vision of St. Ursula has shown him the solution to the Eastern Question (the problem of England's relations with the rival powers Christian Russia and Islamic Turkey)—but the record does little to dispel his hallucinatory state of mind.

Reducing its writer to human size, *Fors Clavigera* tempts the reader into dismissing Ruskin as merely human—as an idiosyncratic old man on or over the edge of madness. But it is their nearness to madness that is the strength of the letters. They are indeed "on the edge." They offer no resting place, only a point of departure. Ruskin may speak as a sage or, in his words, "master," yet he resists the role of a father figure to whom one can turn for surety or protection. He never allows his readers to forget that he is more alone than they may ever be. And so they are forced back on their own resources—forced to work out their own fates with whatever materials their own personal *Fors* brings to hand.

Deucalion (1875–83)
and *Proserpina* (1875–76)

In the 1875 introduction to *Deucalion,* Ruskin himself declared that "had it not been for grave mischance in earlier life . . . my natural disposition for these sciences would certainly long ago have made me a leading member of the British Association for the Advancement of Science; or—who knows?—even raised me to the position which it was always the summit of my earthly ambition to attain, that of President of the Geological Society" (26:97). Ruskin's interest in

natural history was not unlike that of other Victorians who made important contributions to science. The sciences—particularly geology—were incompletely professionalized, and there was no contradiction in being a gentleman-amateur and a man of science. Ruskin's writings on art and architecture were initially dismissed by the professionals, but his writings on geology were taken seriously by established geologists. His lectures on crystallography and mountain formation were noted by scientific journals; his remarks on the debate between James Forbes and John Tyndall over the motion of glaciers were treated as an important contribution to the controversy.[11]

Given his interest in science and his powers of observation and analysis, the question is not why Ruskin chose to write books about natural history, but why the books on natural history he wrote in the 1870s and 1880s diverge so sharply both from the "respectable" science of his earlier career and from the general direction of development undergone by the sciences themselves during the course of the century.

The answer is simple. He saw the development of "respectable" science and he detested it. Science, as Ruskin perceived it, was not merely a form of knowledge; it was a loving relationship between the human observer and the world around him. The "literal guide" for the education Ruskin imagines in *Fors Clavigera* is the line from Wordsworth's *Excursion,* "We live by admiration, hope, and love." "My final object, with every child born on St. George's estate," he wrote in 1875, "will be to teach it what to admire, what to hope for, and what to love" (28:255). Admiration and love, then, are the aims of Ruskin's science. The "Science of Aspects" he had defined in *Modern Painters,* volume 3, had carefully distinguished itself from the "Science of Essences," with its "tendency to chill and subdue the feelings, and to resolve all things into atoms and numbers" (5:386). *Deucalion* and *Proserpina*—Ruskin's books on geology and "Wayside Flowers"—along with *Love's Meinie* (1873), his Oxford lectures on ornithology, not only offer an alternative to the Science of Essences; they question its human significance.

The three books counter the scientific reductionism he had attacked in *The Queen of the Air;* they also counter the link with technology implicit in reductionist science. In letter 4 of *Fors Clavigera* Ruskin had reproved his readers for confusing science with "mechanical art": "You have put a statue of Science on the Holburn Viaduct with a steam-engine regulator in its hands. My ingenious friends, science has no more to do with making steam-engines than with making

breeches" (27:63). If science is founded on love and admiration, it cannot also be a desire to dominate the world, to transform it to human purposes. This desire, explicit in technology, is present in any science that privileges the elements of nature that lend themselves to manipulation—that identifies essential being with causation. Ruskin countered this identification with the argument that knowledge of its cause is only one element of an object and that concentration on this single element to the exclusion of all others necessarily distorts human perception.

The causal sciences Ruskin most often has in mind are the evolutionary biology of Charles Darwin and Alfred Russel Wallace and the uniformitarian geology of Sir Charles Lyell.

As much as he disliked the theory of evolution, Ruskin could not reject the evidence of "Mr Darwin's unwearied and unerring investigations" (19:358n.). What he felt free to reject, however, were the implications of the theory. Darwinian biology disturbed Ruskin for three reasons: (1) by making species a relative concept, it drew attention from the individual type; (2) by identifying development with sexual selection, it emphasized the element of human experience with which he was least able to cope; and (3) by defining man as an evolved primate, it cast doubt on absolute standards of human conduct. Regarding all species as transitional types, the eye of the Darwinians perceived a bird or flower not in terms of its individual identity, but in terms of its evolutionary relationship to past and future organic forms. The characteristics of a species were not reflections of a central, fixed essence, but the common denominators of a varying population. More disturbing to Ruskin, Darwinism focused too much attention on the reproductive processes that made evolution possible. "It is very possible," he writes in *Proserpina,* "that the recent phrenzy for the investigation of digestive and reproductive operations in plants may by this time have furnished the microscopic malice of botanists with providentially disgusting reasons, or demoniacally nasty necessities, for every possible spur, spike, jag, sting, rent, blotch, flaw, freckle, filth, or venom, which can be detected in the construction, or distilled from the dissolution, of vegetable organism" (25:390–91). Finally, when evolutionary science turned to man, it tended to reduce human nature to a collection of refined but basically animal instincts. To say that man is descended from an earlier primate is not in itself an insult to the human race, but it becomes one when the notion of man as a predator is used to vindicate economic competition.

Ruskin's alternative to Darwinian science is most clearly stated in *Proserpina,* in which "the gentle and happy scholar of flowers," relieved of studying the "obscene process and prurient apparitions" (25:391) of floral reproduction, is offered a taxonomy of wayside flowers based on "the special character of the plant, in the place where he is likely to see it; and therefore, in expressing the power of its race and order in the wider world, rather by reference to mythological associations than to botanical structure" (25:340). "Special character" is thus a function of the human experience of nature. And the mythological nomenclature that Ruskin proposes is intended both to facilitate that experience (through appropriate associations) and, by virtue of its self-confessed arbitrariness, to diminish the authority of scientific taxonomy itself. His "Systema Proserpina" might enhance the experience of nature; it can never take its place.

In its way, *Proserpina* is as radical an attack on established ways of thinking as *Fors Clavigera.* If it seems trivial, this is because the science Ruskin presents was deliberately restricted in its intentions. Explicitly, *Proserpina* refuses to offer more than an enlarged appreciation of wayside flowers. Implicitly, it questions the value and meaning of any science that tries to do more.[12]

Deucalion, because Ruskin was more closely identified with geology than with botany, is less certain in its intentions. Also, although he specifies its four subjects as "denudation, cleavage, crystallization, and elevation, as causes of mountain form" (26:274), it is less a coherent—if fragmentary—project, than a collection of materials on geology drawn together in order to make a book. Like *Proserpina,* however, *Deucalion* bases its science on the human observer. Hence, he has little use for Sir Charles Lyell's theory of uniformitarianism— the principle that the earth was shaped by the same forces presently effecting geological change (as opposed to earlier theories based on the assumption of catastrophic floods or vulcanism). Theories of long-term geological formation may be valid, but, like Darwinian biology, they too easily interfere with present perceptions of the natural world. Ruskin is primarily interested in the aesthetic properties of banded agates, not the historical conditions, distant millenia ago, that brought them into being. He is primarily interested in the actual appearance of mountains, not in theories that purport to explain how they came to be that way. "We must begin where all theory ceases; and where observation becomes possible,—that is to say, with the forms which the Alps have actually retained while men have dwelt among them, and on which we can trace the progress, or the power,

of existing conditions of minor change" (26:112–13). In connection with the study of crystallization, he admires the "principles of microscopic investigation . . . established by Mr. Sorby" (26:207), but in general he deplores "the prevailing habit of learned men . . . to take interest in objects which cannot be seen without the aid of instruments" (26:114). What is important for Ruskin is what human beings can and regularly do see with the naked eye, not only because it is the familiar that it is most useful to understand, but also, because, as he had argued before in *Modern Painters,* "investigations of internal anatomy, whether in plants, rocks, or animals, are hurtful to the finest sensibilities and instincts of form" (26:102).

However, it was not merely its emphasis on an unknowable past that led Ruskin to be critical of Lyellian geology. His own observations had taught him that erosion was a continuous process, but they had given him no evidence of mountain building to compensate for the evidence of mountain collapse. It pleased him, moreover, to think of himself living in a latter stage of the earth's history—a period of geological decadence akin to the social and aesthetic decadence of the nineteenth century.

Deucalion contains some experimental science—accounts of Ruskin's attempts to replicate the folding of mountain strata with layers of colored pie paste—and various precise observations, such as those of agates. And Ruskin, despite what he says about Lyellian geology, cannot resist his own speculations about long-term development of the earth's crust. Nevertheless, the strength of *Deucalion,* like that of *Proserpina,* is its assertion of a human purpose to scientific activity. "Science," the two books argue, is not a self-enclosed, self-determined discipline, but part of the interconnected totality of human experience. To stress this totality, both books offer a view of the world permeated with mythic significance, in which the hierarchical cosmos of *Modern Painters* gives way to a universe of mutually reflecting mirrors. Their weakness is that science, so conceived, is unable to transcend the limitations of the individual; that the universe of mirrors becomes a trap. Viewed through the mythopoeic consciousness of *Deucalion* and *Proserpina,* nature can all too easily turn into a projection of the inner fears and turmoils of John Ruskin, in which even the precise observation he treasures is undermined by his own subjectivity. Once again, Ruskin's critique of a prevailing mode of thought raises questions without providing a comfortable answer to them. But, as he had written in the third volume of *Modern Painters,*

it is "in raising us from . . . inactive reverie to . . . useful thought, that scientific pursuits are to be chiefly praised" (5:386). Ruskin's alternative science, stimulating the mind and awakening it to a keener perception of the world, refuses, however, to pose as an absolute system of meaning. "Useful thought" is thus not an end in itself, but a stage "towards higher contemplation." And this, Ruskin suggests, is an appropriate goal for all scientific writing.

Chapter Seven
Final Years

The failure of his friends to support the Guild of St. George disappointed Ruskin sorely. At a time when he seemed to be gaining a wide audience for his work, he felt he was losing the respect and confidence of his peers. At a time when he seemed finally to be saying what all along he had wanted to say, he found himself written off as an eccentric. Isolated and angry, he lapsed into one period of mental disorder after another—each characterized by explosions of sadistic violence followed by prolonged depression.

Ruskin's madness has made it easy to label some of his later writings "insane" or at least symptomatic of insanity and to patronize the rest as islands of temporary lucidity, radically detached from his earlier work. Both interpretations are questionable. Ruskin's rage was not always mania; his clarity, more than a transient clearing of the heavens, often carried his intellect to a firmer grasp of old problems.

The weakness of his later work is not its incoherence but its excessive focus on childhood. Ruskin was never able to transcend the parent-child relationship. It had always been central to his paternalist notions of government. Late in life, he addressed his readers more and more as if they were children. Kate Greenaway's drawings of little girls and boys appeared—incongruously—on the headings of the final issues of *Fors Clavigera*. *Proserpina* was an account of "Wayside Flowers . . . in the Scotland and England Which My Father Knew"; *The Bible of Amiens* was first in a planned series under the general title "Our Fathers Have Told Us." The paradigm of the child at Herne Hill under the guidance of his stern, fallible, but all-protecting parents, became a resting place for Ruskin in his final years. At worst, it encouraged him to be alternately coy and patronizing, to play at being a child himself and to play at being a wise old man for whom the rest of mankind seemed necessarily children. At best, it encouraged him to retell the story of his childhood in the pages of *Praeterita*.

Minor Writings of the 1880s

If Ruskin had not written *The Stones of Venice, The Bible of Amiens* (1880–85) would rank higher among his writings. A much shorter work, lacking the extensive detail of the earlier one, it is equally lucid as a statement of Ruskin's belief in the historical and cultural bases of architectural style. Unlike *The Stones of Venice,* however, it is encumbered with no thesis—no need to demonstrate that the decline of a nation's morality shows itself immediately in its art—and is therefore more flexible in its response to the complex determinations of architecture. Ruskin does not deny that the pure Gothic of Amiens Cathedral is a function of the nobility and faith of its builders; however, he places their nobility and faith in the larger context of the history of Western civilization and sees that these attributes, too, must be understood in terms of a complex geographical and historical matrix. Amiens Cathedral is a product not only of Christian culture, but also of its antecedents on all shores of the Mediterranean. "Who built it?" he asks. "God, and Man,—is the first and most true answer. The stars in their courses built it, and the Nations. Greek Athena labours here—and Roman Father Jove, and Guardian Mars. The Gaul labours here, and the Frank: knightly Norman,—mighty Ostrogoth,—and wasted anchorite of Idumea" (33:131–32).

This view of history does not devolve into amoral relativism because Ruskin believes "all human creatures, in all ages and places of the world, who have had warm affections, common sense and self-command, have been, and are Naturally Moral" (33:173). What has changed since *The Stones of Venice* is not his belief that great architecture is an expression of the moral strength of its builders, but his definition of morality.

Yet if an event—in this instance, a building—is only understandable in terms of an infinitude of causes, then how can the prose of the historian mirror this inclusiveness? Ruskin's implicit answer is that it cannot. *The Bible of Amiens* does not attempt to be inclusive. It is, rather, an exercise in hermeneutics, intended to teach a method of interpretation and in no way exhaust its possibilities. Ostensibly a guidebook to the cathedral—a set of instructions for reading the "Bible" contained in its ornamentation—the book prefaces its final chapter of "Interpretations" with three excursions into the past—into the geography of France and the history of its Merovingian rulers; into

the condition of the Franks as a central European tribe; into early
Christian monasticism and its pagan origins. In each case, it is the
apparent irrelevance to or distance from his immediate subject that
Ruskin emphasizes, in order to lead the reader to an unanticipated
connection between what otherwise might seem to be unrelated his-
torical moments.

In this respect, *The Bible of Amiens* offers a reading of history that
clarifies "the fragmentary expressions of feeling or statements of doc-
trine" that have heretofore characterized Ruskin's work. These, he
hopes, "will be found now by an attentive reader to bind themselves
together into a general system of interpretation of Sacred literature,—
both classic and Christian, which will enable him without injustice
to sympathize in the faiths of candid and generous souls, of every age
and every clime" (33:119). *The Bible of Amiens* thus signals a with-
drawal from the social activism of *Fors Clavigera,* in which it was
practical application that promised to unify Ruskin's theoretical state-
ments. His teaching is no longer offered as a call to social revolution,
but as a guide to interpretation of the past—or, more precisely, to
the state of broad, human sympathy on which serious interpretation
is based.

It can be argued that Ruskin's sympathy for medieval Christian-
ity—a fascination with the cult of the saints and Virgin that led some
of his contemporaries to believe him about to convert to Roman Ca-
tholicism—were signs of a weakening intellect, reaching out after
representations of order and security. The only completed section of
a larger work on Christian architecture that remained incomplete, *The
Bible of Amiens* is also a sign of Ruskin's inability to carry through a
project of the scope of his earlier writings. Yet it is also evidence that
his mind continued to evolve; that he was able to refine and correct
his earlier thinking; and that, when he turned his back on the social
questions that drew him to despair and madness, he was capable of
calm perception and intelligent thought.

Similar qualities can be found in many of his Oxford lectures from
this period. When he turned to other subjects, however, the violence
of his feelings was not to be controlled. *Fiction, Fair and Foul* (1880–
81) dismisses most contemporary fiction, which he believes corrupted
by "the hot fermentation and unwholesome secrecy of the population
crowded into large cities"—conditions which lead, in part, to a fas-
cination with "mental ruin and distress" and "a corresponding science
of fiction, concerned mainly with the description . . . of disease"

(34:268). More disturbing to Ruskin, the sense of powerlessness that characterizes urban life "brings every law of healthy existence into question" and encourages "a philosophy . . . partly satiric, partly consolatory, concerned only with the regenerative vigour of manure . . . showing how everybody's fault is somebody else's, how infection has no law, digestion no will, and profitable dirt no dishonour" (34:269–70). At the same time, the routine and monotony of city life, "in streets where summer and winter are only alternations of heat and cold; where snow never fell white, nor sunshine clear," leads to a taste, at least for mischief, at worst for violent death (34:271).

The rhetorical fury of Ruskin's analysis obscures the nature of his effort—his attempt to "read" Victorian fiction, like the carvings at Amiens, as a function of its historical setting and thus—rightly—see the novel as a product of urban culture. Unfortunately, he cannot discuss urban culture without lapsing into vituperation. The essays make a few, largely unfair, jabs at George Eliot and Dickens, but save themselves from ill temper by lapsing into a more congenial subject—the novelist, Scott, and the poets, Byron and Wordsworth, whom Ruskin associates with his own childhood.

Significantly, the one novel of Dickens he separates "with honour, from the loathsome mass to which it typically belongs" (33:277) is *Oliver Twist.* For Ruskin, Dickens's "greatest work" is the one in which a sentimentalized child-hero escapes contamination by the urban world and, unlike Dickens's other sentimentalized children, Paul Dombey and Little Nell, does not die. George Eliot's *Mill on the Floss,* in contrast, he dismisses as a novel hanging "mainly on the young people's 'forgetting themselves in a boat' " (34:282): a girl who falls from innocence—and dies—is a heroine for whom Ruskin has no sympathy.

Ruskin's rejection of modern urban society is also the keynote of *The Storm-Cloud of the Nineteenth Century,* two lectures delivered at the London Institution, 4 and 11 February 1884. The lectures are both a postscript to the studies of cloud form in *Modern Painters,* volume 5, and a further example of the deconstructive Science of Aspects he had practiced in *Deucalion* and *Proserpina.*

Ruskin had made careful observations of skies and clouds since boyhood, and the argument of *The Storm-Cloud of the Nineteenth Century* is based on meteorological phenomena recorded in his diaries over many decades. What this documentation reveals, Ruskin believes, is a profound transformation in the weather of England and

Western Europe in general. In the past, there were two kinds of wet-weather clouds—the "beneficent rain-cloud" and the electrically charged storm cloud (34:10). Now there is a third kind—a "loathsome mass of sultry and foul fog, like smoke" (34:37). And with this "filthy" cloud comes the "plague-wind"—a wind that darkens the sky, with the "malignant *quality*" of being "unconnected with any one quarter of the compass"; that "always blows *tremulously,* making the leaves of the trees shudder as if they were all aspens"; that "is also *intermittent* with a rapidity quite unexampled in former weather"; and that "degrades, while it intensifies, ordinary storm" (34:33–35).

It has long been recognized that there is a correlation between the coming of Ruskin's storm cloud and a dramatic increase in industrial—largely coal smoke—pollution,[1] and more recently noted that Ruskin's lectures were composed at a period of unusually poor weather.[2] The lectures are based on fact, but, as Ruskin himself argues, the study of light is "a *moral* Science" (34:27), whose chief concern is human sensation. At issue is not weather, but Ruskin's perception of weather. And for Ruskin, the "plague-cloud" was a symbolic darkening of the heavens against his nation and against himself.

Recognizing the source of the cloud in industrial smoke, he could identify it with the economic forces against which he had long striven. They had, it would seem, won. Yet their prize was a land wasted by their own quest for power: "For the last twenty years, England, and all foreign nations, either tempting her, or following her, have blasphemed the name of God deliberately and openly; and have done iniquity by proclamation, every man doing as much injustice to his brother as it is in his power to do" (34:40). Ruskin hesitates to call the plague-wind a divine punishment for this blasphemy, but he acknowledges that "the men of old time" would have recognized it as such (34:40). It is enough for him to see that the final product of Victorian industrialization is "Blanched sun,—blighted grass,—blinded man" (34:40).

If the storm cloud were only a judgment on his contemporaries, its effect would be to confirm Ruskin's long-held position that economic competition was morally wrong. However, it also has a more personal significance. His ability to respond to the brightness of the sky and the pure colors of the setting sun had always been for Ruskin a sign of his special being. The cloud-obscured heavens not only deprived him of an intense aesthetic experience; they also signified the com-

plete isolation of his self. Ruskin had felt cut off from his fellow humans; now nature, too, had closed itself to him. His only resource was to turn inward.

Praeterita (1885–89)

Praeterita was written, as Ruskin admitted, "frankly, garrulously, and at ease; speaking, of what it gives me joy to remember, at any length I like . . . and passing in total silence things which I have no pleasure in reviewing" (35:11). This "most charming autobiography in English"[3] is not really an autobiography at all, but a set of happy recollections. It does not attempt to trace a life; rather, it attempts to capture a series of—largely—felicitous moments in that life. Its opening chapters bring together the autobiographical fragments Ruskin originally published in *Fors Clavigera,* and its eclectic manner, particularly toward the end, continues that of *Fors,* personal recollection giving way to an account of the benevolence of the Burgundian Queen Bertha or the moral effects of the Scottish landscape.

To criticize Ruskin for what he omits is, of course, beside the point. That he tells us nothing of his wife—beyond mentioning her as the little girl for whom he wrote *The King of the Golden River*—is not an evasion of the past. It simply indicates how little importance Ruskin placed in his marriage. What is important about *Praeterita* is not what Ruskin omits—the list is long—but what he chooses to include. But even this criterion is tricky. He chose to include what it gave him pleasure—or comfort—to write about in the increasingly brief intervals between periods of insanity. Insofar as his madness frequently took the form of sadistic outbursts, the self-effacing style of *Praeterita* compensates for it. Insofar as his madness obscured his thinking, the careful lucidity of *Praeterita* is an effort to stave off the growing darkness.

Since they are the chief source of material relating to Ruskin's childhood and appear, quoted or paraphrased, in all his biographies, the opening chapters of *Praeterita* are the most well known. However, they are not representative of the work as a whole. Unlike the later sections, these passages were written not to amuse his friends and well-wishers, but to justify himself to the readers of his social theory. Because the argument of *Fors Clavigera* depended on the dramatized consciousness of its writer, Ruskin felt called upon to explain the circumstances of childhood that determined the strengths and weaknesses of that consciousness. His purpose demanded total honesty,

but, because he wished to be taken seriously as a reformer, he wished to present himself as a fixed, rather than an indeterminate personality. He could freely acknowledge his limitations, but not appear wavering or uncertain in his self-appraisal.

Ruskin summarizes this self-appraisal in chapter 2, counting as his principal blessings the childhood gifts of peace, obedience, and faith, along with the ancillary gifts of "the habit of fixed attention with both eyes and mind" and "an extreme perfection in palate and all other bodily senses" (35:44). The "equally dominant calamities" he lists are: "First, that I had nothing to love"; second, that "I had nothing to endure"; third, that "I was taught no precision nor etiquette of manners" and, "Lastly, and chief of evils. My judgment of right and wrong, and powers of independent action, were left entirely undeveloped." In fine, he judges his early education "at once too formal and too luxurious; leaving my character, at the most important moment for its construction, cramped indeed, but not disciplined; and only by protection innocent instead of by practice virtuous. My mother saw this herself, and but too clearly, in later years; and whenever I did anything wrong, stupid, or hard-hearted,—(and I have done many things that were all three,)—always said, 'It is because you were too much indulged' " (35:44–46).

This effort to define himself in terms of a set of fixed traits may have been appropriate in *Fors Clavigera,* but it is less useful in an extended autobiography, and soon falls victim to Ruskin's characteristic "polygonal" treatment of his subject matter. In explaining the ill effects of having nothing to love, he maintains it did not make him "selfish or unaffectionate; but that, when affection did come, it came with violence utterly rampant and unmanageable, at least by me, who never before had anything to manage" (35:45). Yet he admits, too, to being in later years "hard-hearted," and, in a subsequent chapter, he confesses "*My* times of happiness had always been when *nobody* was thinking of me. . . . My entire delight was in observing without being myself noticed,—if I could have been invisible, all the better. I was absolutely interested in men and their ways, as I was interested in marmots and chamois, in tomtits and trout" (35:165–66). Ruskin, it would seem, had at once too much and too little human affection. The more he reveals of himself, the more inadequate his original model of a self determined by its childhood becomes.

Once the *Fors Clavigera* materials have been exhausted, however, Ruskin switches to a new point of view. He no longer perceives him-

self as a creature fixed by childhood experience, but also as one capable of growth and change. He repeatedly compares his jejune self to a tadpole or a chrysalis, awaiting metamorphosis into a higher, very different form of being—as if it were an inherent biological program that accounts for development, and the form of the adult were difficult or impossible to discover in the child. Yet this—generally ironic—view of the self is less important than one based on a sequence of conversion experiences, which has its literary sources in St. Augustine and Wordsworth and offers a psychological analogue to Evangelical accounts of "inner light."

The most notable of these experiences of conversion or sudden illumination are two related events in 1842 that transformed his perception of nature, and his religious "deconversion" at Turin in 1858.

The Turin experience—itself reversed sixteen years later when Ruskin rediscovered the power of Giotto at Assisi—links his rejection of Evangelicalism with a newfound pleasure in material life. Having dutifully gone to attend Sunday services at a Waldensian chapel, where the "solitary and clerkless preacher, a somewhat stunted figure in a plain black coat, with a cracked voice," assured his congregation of "three or four and twenty" of "the wickedness of the wide world, more especially of the plain of Piedmont and city of Turin," and of their own "exclusive favour with God," Ruskin

walked back into the condemned city, and up into the gallery where Paul Veronese's Solomon and the Queen of Sheba glowed in full afternoon light. The gallery windows being open, there came in with the warm air, floating swells and falls of military music, from the courtyard before the palace, which seemed to me more devotional, in their perfect art, tune, and discipline, than anything I remembered of evangelical hymns. And as the perfect colour and sound gradually asserted their power on me, they seemed finally to fasten me in the old article of Jewish faith, that things done delightfully and rightly were always done by the help and in the Spirit of God. (35:495–96)

He goes on to explain that his "hour's meditation in the gallery of Turin only concluded the courses of thought which had been leading . . . to such end through many years"; the events at Turin, in other words, were less a conversion than a confirmation. Nevertheless, it was through this aesthetic experience that Ruskin chose to express the change in his religious beliefs. His confidence in the spiritual meaning of art is thus born out by the events in his own life—or, con-

versely, he uses the highly selective narration of his autobiography to confirm his belief in the morality of art. In either case, it is the essential unity of life and art that *Praeterita* affirms.

The Turin episode is fairly straightforward; the earlier conversion experiences are more elusive in their significance. "One day on the road to Norwood," he writes,

I noticed a bit of ivy round a thorn stem, which seemed, even to my critical judgment, not ill "composed"; and proceeded to make a light and shade pencil study of it in my grey paper pocket-book, carefully, as if it had been a bit of sculpture, liking it more and more as I drew. When it was done, I saw that I had virtually lost all my time since I was twelve years old, because no one had ever told me to draw what was really there! All my time, I mean, given to drawing as an art; of course I had the records of places, but had never seen the beauty of anything, not even of a stone—how much less of a leaf! (35:311)

Close upon this awakening, he attempted to sketch an aspen at Fontainebleau: "Languidly, but not idly, I began to draw it; and as I drew, the langour passed away: the beautiful lines insisted on being traced,—without weariness. More and more beautiful they became, as each rose out of the rest, and took its place in the air. With wonder increasing every instant, I saw that they 'composed' themselves, by finer laws than any known of men. At last, the tree was there, and everything that I had thought before about trees, nowhere. . . . that all the trees of the wood . . . should be beautiful—more than Gothic tracery, more than Greek vase-imagery, more than the daintiest embroiderers of the East could embroider, or the artfullest painters of the West could limn,—this was indeed an end to all former thoughts with me, an insight into a new sylvan world" (35:314–15).

Both experiences depend on the act of drawing as a mode of perception and thus explain Ruskin's crusade to include art instruction in the public school curriculum. They also offer an existential basis for his concern with factuality in *Modern Painters*—his belief that the artist must humble himself before the beauty and organization of the natural world. However, what is most striking about these two experiences, placed in the context of *Praeterita,* is their denial of Ruskin's own abilities as an artist.

Given the fact that his public success rested primarily on his writings, it is surprising how little space in *Praeterita* Ruskin devotes to his literary career, how much, instead, to his career manqué as an artist. His development is not measured in terms of his growing com-

mand of language, but in terms of his growing mastery of the media of art. Writing, *Praeterita* suggests, was not the material of growth or change: he recollects no circumstances in which the act of putting words on paper resulted in epochal rethinking or self-discovery. He admits the influence of writers; however, inevitably, it is art—his own or someone else's—that affects him most powerfully. What *Praeterita* almost comes to terms with is the crucial decision in Ruskin's life not to become an artist, to reject the model of Turner and become something different—a man who wrote prose about Turner and who produced the countless drawings and engravings and watercolors, intended to record natural or architectural facts, that Ruskin again and again reminds his reader—and himself—are not "art." The Norwood and Fontainebleau experiences, while they pretend to mark Ruskin's discovery of nature, in fact record his realization—or decision—that he would not himself be an artist.

The models of a self fixed by its childhood, of a self that metamorphoses into adulthood, and of a self that develops through a series of "awakenings" suggest at worst stasis, at best growth. There is, however, a fourth model underlying much of *Praeterita,* a model Ruskin associates with Wordsworth's "Ode: Intimations of Immortality," which equates maturation with loss of visionary power. "On the journey of 1837, when I was eighteen, I felt, for the last time," Ruskin tells us, "the pure childish love of nature Wordsworth so idly takes for an intimation of immortality" (35:218). Adulthood, according to this model, entails a falling away from the freshness and intensity of youth, and the sense that what has been lost can never be recovered.

This view is present, for example, when Ruskin, remarking on his family's move from Herne Hill to the relative splendor of Denmark Hill, notes that "for all these things, we were never so happy again. Never any more 'at home' " (35:318). Much of *Praeterita* is a record of lost moments of intense perception—like Ruskin's first sight of the Alps; and his evident loss of interest in his own life's story after the account of its first decades may be a sign, not only that his health was deteriorating, but that it was those first decades, richest in such experiences, that most mattered to him.

To affirm his present self, he must, however, deny, as much as possible, its difference from that past self. Hence, while he admits he has lost the ability to see nature in the way of his youth, he insists that his mind has remained, in other respects, constant. His opinion of the Uffizi collection at the time of his first visit to Florence in 1840 was "on the whole" "precisely" the same he held "when I last

walked through the Uffizi in 1882" (35:269). He was just as aware of Turner's faults when he first saw his work as he is now when he is an old man—the only difference is that now he speaks about them more frankly (35:255). He is pleased to note the same question concerning hoar-frost in his 1841 diary as he thought he had "asked for the first time in my ice-study of '79, and which is not answered yet" (35:308).

In the later chapters this need to predicate continuity of self becomes an impulse to memorialize not only moments of the past, but persons as well—to sustain relationships by embedding them in prose. Ruskin uses *Praeterita* to affirm his long-standing friendships with John Brown and Charles Eliot Norton. Against the wishes of other friends, he tells part of the story of Rose La Touche; and in the final chapter—written with great difficulty—he pays tribute to Joan Agnew, on whose care he now entirely depended.

In the closing pages of *Praeterita,* Ruskin's effort to recall the past achieves remarkable if ominous success: the boundary between past and present fades. The voice of the aged writer seems to merge with that of all his former selves. Ruskin is at once an old man and a child. Historical and remembered pasts become a single memory trace. By cruel but perhaps inevitable irony, the literary coherence of self—the identity of writer and text—is realized at the very moment the real self crumbles. "How things bind and blend themselves together," he observes in the last paragraph he was able to write:

Fonte Branda I last saw with Charles Norton, under the same arches where Dante saw it. We drank of it together, and walked together that evening on the hills above, where the fireflies among the scented thickets shone fitfully in the still undarkened air. *How* they shone! moving like fine-broken starlight through the purple leaves. How they shone! through the sunset that faded into thunderous night as I entered Siena three days before, the white edges of the mountainous clouds still lighted from the west, and the openly golden sky calm behind the Gate of Siena's heart, with its still golden words, "Cor magis tibi Sena pandit," and the fireflies everywhere in sky and cloud rising and falling, mixed with the lightning, and more intense than the stars. (35:561–62)

The reader unfamiliar with Ruskin's final years would not be aware of the enormous effect that lay behind his richly evocative, complexly synthetic passage. Knowing the circumstances of its composition, one cannot escape the feeling that Ruskin himself knew they were the closing words of his life's work.

Chapter Eight
Conclusion

In the year of his death, Ruskin's reputation appeared firmly established. His final birthday had been a national celebration. Six years later, in response to a questionnaire, the Labour members of Parliament named *"Unto this Last"* most often among the books that had influenced their lives; whether or not they actually read Ruskin, he was at the top of the 1906 Great Books list for British radicalism. William Morris, although he died four years before Ruskin, had carried many of Ruskin's ideas into practical application; through the disciples of Morris, Ruskin became an influence on twentieth-century design. George Bernard Shaw, who lived well into this century, ranked Ruskin beside Karl Marx as the political theorist behind his own program for social change. Nor was Ruskin's reputation limited either to the political left or to his own homeland. Cecil Rhodes, the apostle of British imperialism, "regarded his copy of Ruskin's Inaugural [Slade lecture] as his most precious possession."[1] Marcel Proust, who later translated *The Bible of Amiens* into French, wrote, on the occasion of Ruskin's death, "how mightily this dead man lives."[2] Tolstoy boasted of having read all of Ruskin's later works; Gandhi acknowledged that *"Unto this Last"* had been a leading influence on his life and work.

In light of this international acclaim, E. T. Cook and Alexander Wedderburn believed the monumental "Library Edition" of Ruskin's works they edited in the early years of the twentieth century would insure their fortunes. Instead, the Library Edition proved unsaleable. Ruskin, like many of his contemporaries, fell victim to a wave of anti-Victorianism, sinking all the deeper on account of the height of his fame—at the very time when writers he had influenced, like Shaw and Proust, whose *Remembrance of Things Past* is based on the autobiographical technique of *Praeterita,* became twentieth-century classics.

Lewis Mumford self-consciously carried on Ruskin's program of social criticism in the 1930s, and a small band of the faithful continued—and continue—the Guild of St. George. However, the rediscovery of Ruskin by the general reader had more to do with his weaknesses than with his strengths. R. H. Wilenski's pioneer 1933 study fo-

cused on Ruskin's psychological abnormalities—his sexual attraction
to young girls and his later mania—and concluded that it was his
"secret fears and disquietudes" that "belong to the living present."[3]

Wilenski was partly right. What often strikes a modern reader
about Ruskin is his prescient grasp of the ills of our civilization.
Moreover, as we have seen, Ruskin's personality was, as time pro-
gressed, more and more, by deliberate choice, central to his writing.
He expected the readers of *Fors Clavigera* to be very much aware of
the individual character of its writer. Nor would psychoanalytic crit-
icism have surprised him; his own interpretations of art often attempt
to uncover the unconscious motivations of the artist and seek their
roots in childhood experience. If Wilenski and many of the critics
who followed his lead are unable to avoid psychological reductionism,
it is a trap Ruskin himself carefully prepared for them.

One cannot ignore the man; his works will not allow it. And yet,
at the same time, one cannot allow Ruskin's work to take second
place to his biography—much less, to allow the fact of his terminal
madness to color the reading of his life as a whole.

Fortunately, the last decade has seen a countertrend to this exces-
sive psychologism. Beginning with George Landow's *Aesthetic and
Critical Theories of John Ruskin* (1971), there has been a growing effort
to read Ruskin's work with new seriousness and to evaluate its suc-
cesses and failures in terms of what Ruskin himself set out to ac-
complish.

In many respects the book for which he was best known by his
contemporaries, *Modern Painters,* is the least accessible of his major
works for the modern reader. Ruskin's effort to link eighteenth-cen-
tury natural religion with romantic landscape painting no longer
seems of particular importance. What remains relevant about *Modern
Painters,* however, is its secondary effort to link art with science. Rus-
kin's distinction between the Science of Aspects and the Science of
Essences may appear to draw a line between the two disciplines; in
fact, the distinction is a rationale for exploring the common ground
shared by art and science. In affirming the "truth" of artistic repre-
sentation, he affirms the role of art as a mode of knowledge, capable
of teaching human beings to perceive the world around them and
thus enriching their experience of life. Ruskin's insistence on the
presence of a human consciousness in scientific observation cannot be
interpreted as an anticipation of modern physics, in which the ob-
server is acknowledged an element in the observation; it does, how-

ever, anticipate the modern recognition that there is no such thing as "pure" research, and that the attempt to ignore the human purposes and human consequences of scientific discovery is to abdicate responsibility for the future of the race.

Just as *Modern Painters* and related works heighten the reader's capacity for perceiving the natural world, Ruskin's writings on architecture teach an enlarged response to architectural structure and detail. If the thesis of *The Stones of Venice* eludes demonstration, there remains significant value in Ruskin's effort to interpret the artifacts of a society as the expression of its beliefs and values. Marxist literary criticism is only one example of a subsequent movement grounded on the assumption that such interpretations are not only possible but of the greatest importance. Granted, Ruskin did not originate the technique. But he carried it out with remarkable perceptiveness. And, granted, many of his interpretations, colored by the religious presuppositions he brought to bear on Venice, may no longer seem convincing. But the integrated context in which he places them—the context of history, religion, geography, economics, and whatever else determined the nature of the city state of Venice—remains unavoidably right.

Ruskin's political economy founders on its untenable analogies. Ruskin was never able to understand that there is a significant difference between running a nation and running a private estate, and so places himself in the company of the oversimplifiers he normally rejects. And, in light of twentieth-century dictatorships, Ruskin's paternalistic ideal of government may strike us as dangerously naive. What still rings true, however, is the moral force of Ruskin's political theory. William Morris, who recognized the inadequacy of Ruskin's practical schemes, acknowledged that "it was through him I learnt to give form to my discontent."[4] Ruskin's great achievement in this area of his work was in raising the political consciousness of his Victorian audience. He led them to understand that economics was more than the concern of a few men of affairs: that it determines the course of a society and is therefore of vital concern to all its members.

Moreover, even Ruskin's oversimplifications have their role. They question the assumption that magnitude necessarily changes morality—that it is less wrong to kill a thousand men than it is to kill one; that the affairs of a nation are somehow outside the range of moral determination.

In every case, the strength of Ruskin's vision lies in his refusal to compartmentalize. Neither art nor science exists for him in isolation; both are part of the totality of interrelated human experience; to ignore their connections may give a temporary rush of power—simple solutions are always exciting—but it is in the long run destructive of the best work of artist and scientist alike. In the words of Robert Hewison, "It is precisely his refusal to distinguish between the normally accepted divisions and compartments of thought—aesthetic, ethical, social, economic, philosophical and personal—that is the source of his most important insights."[5] What Ruskin teaches is this way of thinking—a way of thinking that not only bridges intellectual disciplines, but fuses intellect with perception and feeling.

What Ruskin recognized, in advance of most other critics of society, was the divisiveness of modern industrial civilization itself, in which the affairs of government tend, by virtue of their size and scope, to be more and more removed from the experience of the common person; in which specialization of labor, specialization of technological skill, divide persons from one another; in which rapid change disrupts the continuity of history and isolates the individual in a world he or she can no longer fully understand. Ruskin does not offer an escape from this alienation. He does, however, offer a way to understand it; a kind of thinking that restores to the human mind its capacity for judgment and therefore for self-determination. He remains, for this reason, one of the dead who continue to live "mightily."

Notes and References

Chapter One

1. Derrick Leon, *Ruskin: The Great Victorian* (1949; reprint ed., Hamden, Conn., 1969), p. 8.
2. *The Works of John Ruskin,* ed. E. T. Cook and Alexander Wedderburn, 39 vols. (London, 1903–12), 35:126; hereafter cited in the text.
3. Quoted by Richard D. Altick, *The English Common Reader: A Social History of the Mass Reading Public 1800–1900* (Chicago: University of Chicago Press, 1957), p. 111.
4. R. H. Wilenski, *John Ruskin: An Introduction to Further Study of His Life and Work* (1933; reprint ed., New York, 1967), p. 38.
5. E. T. Cook, *The Life of Ruskin,* 2d ed. (London, 1912), 1:56.
6. Mary Lutyens, *The Ruskins and the Grays* (London, 1972), p. 24.
7. Ibid., p. 81.
8. The passages occur in two letters, dated 25 and 27 April 1849, in ibid., p. 185.
9. Mary Lutyens, *Effie in Venice: Unpublished Letters of Mrs. John Ruskin Written from Venice between 1849–1852* (London, 1965), p. 99.
10. Ibid., p. 262.
11. Mary Lutyens, *Millais and the Ruskins* (London, 1967), p. 30.
12. Ibid., p. 43.
13. Ibid., p. 108.
14. Ibid., p. 109.
15. Mary Lutyens, "The Millais–La Touche Correspondence," *Cornhill,* no. 1051 (Spring 1967), p. 14.
16. Lutyens, *Millais and the Ruskins,* p. 230.
17. Cook, *Life of Ruskin,* 1:416.
18. Leon, *Ruskin,* p. 311.
19. My account follows *John Ruskin and Rose La Touche: Her Unpublished Diaries of 1861 and 1867,* ed. Van Akin Burd (Oxford, 1980).
20. *The Diaries of John Ruskin,* ed. Joan Evans and John Howard Whitehouse (Oxford, 1958), 2:659.
21. Burd, ed., *John Ruskin and Rose La Touche,* p. 118.
22. Lutyens, "The Millais–La Touche Correspondence," pp. 13–14.
23. *Letters of John Ruskin to Charles Eliot Norton,* ed. Charles Eliot Norton, 2 vols. (Boston, 1904), 2:37.
24. Leon, *Ruskin,* p. 550.

Chapter Two

1. Wordsworth, *Excursion*, bk. 4, ll. 978–92. In addition to the in-
dicated ellipsis, Ruskin also omits the words "three score years" at the end
of line 980 and the entire line 986 ("Swayed by such motives, to such ends
employed").
2. For an examination of Ruskin's debt to the tradition of treating
painting as a "sister art" to poetry, see George P. Landow, *The Aesthetic and
Critical Theories of John Ruskin* (Princeton, 1971), pp. 43–86.
3. *The Renaissance* (New York: Random House, Modern Library,
n.d.), p. 199.

Chapter Three

1. Victorian typology has received detailed attention in two recent
studies: George P. Landow, *Victorian Types, Victorian Shadows: Biblical Ty-
pology in Victorian Literature, Art, and Thought* (Boston: Routledge & Kegan
Paul, 1980) and Herbert L. Sussman, *Fact into Figure: Typology in Carlyle,
Ruskin and the Pre-Raphaelite Brotherhood* (Columbus, Ohio, 1979).

Chapter Four

1. Leon, *Ruskin*, p. 189.
2. The title of a chapter in Carlyle's *Sartor Resartus* (1836).
3. For his fifteenth birthday, Ruskin had, at his own request, re-
ceived a copy of de Saussure's *Voyages dans les Alpes* (Geneva, 1787); de Saus-
sure's mixture of precise observation, philosophy, and romantic love of
nature became a model for Ruskin's scientific writings.
4. For an account of Ruskin's interpretation of these two paintings,
see Robert Hewison, *John Ruskin: The Argument of the Eye* (Princeton, 1976),
pp. 81–84.
5. See, for example, *Ruskin's Letters from Venice, 1851–1852*, ed. John
L. Bradley (New Haven, 1955), p. 145.
6. See Alan Lee, "Ruskin and Political Economy: A Reading of *Unto
this Last*," in *New Approaches to Ruskin*, ed. Robert Hewison (London, 1981),
pp. 68–88.

Chapter Five

1. It had gone into twelve editions by 1898 and was selling at the
rate of two thousand copies a year.
2. Kate Millett finds it "one of the most complete insights obtainable
into that compulsive masculine fantasy one might call the official Victorian
attitude" ("The Debate over Women: Ruskin versus Mill," *Victorian Studies*

14 [1970]:64); for a counter argument see David Sonstroem, "Millett versus Ruskin: A Defense of Ruskin's 'Of Queens' Gardens,' " *Victorian Studies* 20 (1977):283–97.

3. See, for example, E. P. Thompson, *William Morris: Romantic to Revolutionary*, 2d ed. (New York: Pantheon Books, 1977), pp. 32–39.

Chapter Six

1. John D. Rosenberg, *The Darkening Glass: A Portrait of Ruskin's Genius* (London, 1963), p. 176.
2. Ibid., pp. 171–73.
3. Janet Burstein, "Victorian Mythography and the Progress of Intellect," *Victorian Studies* 18 (1975):315.
4. Friedrich Max Müller, "Comparative Mythology," *Chips from a German Workshop* (London: Longmans, Green, 1867), 2:63–64.
5. Psalms 19:5–6.
6. Frederic H. Harrison, *John Ruskin* (New York, 1903), pp. 182–83.
7. Paul Sawyer, "Ruskin and St. George: The Dragon-Killing Myth in 'Fors Clavigera,' " *Victorian Studies* 23 (1979):7.
8. According to John D. Rosenberg, "No quality of *Fors* is more remarkable than its disregard of the conventional boundaries separating the public from the private" ("Ruskin's Benediction: A Reading of *Fors Clavigera*," in *New Approaches*, ed. Hewison, p. 129).
9. Harrison, *John Ruskin*, p. 179.
10. See Rosenberg, "Ruskin's Benediction," for a detailed analysis of this episode.
11. See *Fors Clavigera*, letter 34 (37:635–43); also, J. S. Rowlinson, "The Theory of Glaciers," *Notes and Records of the Royal Society of London* 26 (1971):189–204.
12. For an amplification of this point, see my "Science against Sciences: Ruskin's Floral Mythology," in *Nature and the Victorian Imagination*, ed. U. C. Knoepflmacher and G. B. Tennyson (Berkeley: University of California Press, 1977), pp. 246–58.

Chapter Seven

1. Cook and Wedderburn made this point in 1908 (34:xxiv–xxvi).
2. Rosenberg, *The Darkening Glass*, p. 212.
3. Ibid., 216–17.

Chapter Eight

1. Quoted by Leon, *Ruskin*, p. 581.
2. Wilenski, *John Ruskin*, p. 368.

3. Kenneth Clark, *Ruskin at Oxford* (London, 1947), p. 10.

4. William Morris, "How I Became a Socialist," *The Collected Works of William Morris,* ed. May Morris (London: Longmans, Green, 1910–15), 23:279.

5. Hewison, *The Argument of the Eye,* p. 192.

Selected Bibliography

PRIMARY SOURCES

Ruskin's bibliography is complicated. He published many works in parts or "lectures" that were soon—often in the same year—combined in a single volume. Some works, like the early volumes of *Modern Painters*, underwent considerable revision in subsequent editions; others, like *The Cestus of Aglaia*, were quarried for later publications. His shorter articles, prefaces, and letters to the press are too numerous to cite in the present context. Fortunately, E. T. Cook and Alexander Wedderburn's "Library Edition" of *The Works of John Ruskin*, 39 vols. (London: George Allen, 1903–12) presents his complete writings in a standard edition of exemplary thoroughness, both in its text and in its notes, introductions, and bibliographic apparatus. Recent criticism has challenged certain of Cook and Wedderburn's editorial decisions—in particular, their treatment of *Praeterita;* however, the "Library Edition" remains on the whole a model text.

While Cook and Wedderburn published a substantial number of Ruskin's letters, these represent only a fraction of the total. Ruskin's letters to various correspondents continue to appear, presented with varying degrees of editorial competence and no general plan of publication.

1. Books

The Poetry of Architecture. London: George Allen, 1893. First published in *Architectural Magazine,* November 1837–December 1838.

Modern Painters. Vol. 1. London: Smith, Elder & Co., 1846.

Modern Painters. Vol. 2. London: Smith, Elder & Co., 1849.

Poems. London, 1850.

The King of the Golden River. London: Smith, Elder & Co., 1851.

Pre-Raphaelitism. London: Smith, Elder & Co., 1851.

The Stones of Venice. Vol. 1. London: Smith, Elder & Co., 1851.

Notes on the Construction of Sheepfolds. London: Smith, Elder & Co., 1851.

The Stones of Venice. Vols. 2–3. London: Smith, Elder & Co., 1853.

Giotto and his Works in Padua. 3 pts. Arundel Society, 1853–60.

Lectures on Architecture and Painting. London: Smith, Elder & Co., 1854.
Modern Painters. Vols. 3–4. London: Smith, Elder & Co., 1856.
The Elements of Drawing. London: Smith, Elder & Co., 1857.
The Political Economy of Art. London: Smith, Elder & Co., 1857. Reprinted
 as *"A Joy Forever."* London: George Allen, 1880.
The Elements of Perspective. London: Smith, Elder & Co., 1859.
The Two Paths. London: Smith, Elder & Co., 1859.
Modern Painters. Vol. 5. London: Smith, Elder & Co. 1860.
"Unto this Last." London: Smith, Elder & Co., 1862. First published in
 Cornhill 2 (August–November 1860).
"Essays on Political Economy." *Fraser's Magazine* 66–67 (June 1862–April
 1863). Reprinted as *Munera Pulveris* (London: Smith, Elder, & Co.,
 1872).
Sesame and Lilies. London: Smith, Elder & Co., 1865.
"The Cestus of Aglaia." *Art Journal,* n.s. 4–5 (January 1865–April 1866).
 Parts were reprinted in *The Queen of the Air* and *On the Old Road.*
The Ethics of the Dust. London: Smith, Elder & Co., 1866.
The Crown of Wild Olive. London: Smith, Elder & Co., 1866.
Time and Tide, by Weare and Tyne. London: Smith, Elder & Co., 1867.
"On Banded and Brecciated Concretions." *Geological Magazine* 4–7 (August
 1867–January 1870).
The Queen of the Air. London: Smith, Elder & Co., 1869.
Lectures on Art. Oxford: Clarendon Press, 1870.
Fors Clavigera. London: George Allen. Published in monthly parts as fol-
 lows: 1–84 (January 1871–December 1877); n.s. 85–96 (at intervals
 until 1884).
Aratra Pentelici. London: Smith, Elder & Co., 1872.
The Eagle's Nest. London: Smith, Elder & Co., 1872.
Love's Meinie. 3 pts. London: George Allen, 1873–81.
Ariadne Florentina. 6 pts. London: George Allen, 1873–76.
Val d'Arno. 10 pts. London: George Allen, 1874.
Proserpina. 10 pts. London: George Allen, 1875–76.
Mornings in Florence. 6 pts. London: George Allen, 1875–77.
Deucalion. 8 pts, 2 vols. London: George Allen, 1875–83.
The Laws of Fésole. 4 pts. London: George Allen, 1877–78.
St. Mark's Rest. 3 pts. London: George Allen, 1877–84.
Letters to the Clergy on the Lord's Prayer and the Church. Edited by F. A.
 Malleson. Privately printed, 1879. Rev. ed. London: Strahan & Co.,
 1880.
"Fiction, Fair and Foul." *Nineteenth Century* 7–9 (June 1880–October
 1881). Reprinted in *On the Old Road.*
*Arrows of the Chase: Being a Collection of Scattered Letters Published Chiefly in
 the Daily Newspapers, 1851–1880.* London: George Allen, 1880.
The Bible of Amiens. 5 pts. London: George Allen, 1880–85.

The Art of England. London: George Allen, 1883.
The Storm-Cloud of the Nineteenth Century. London: George Allen, 1884.
The Pleasures of England. 4 pts. London: George Allen, 1884–85.
In Montibus Sanctis 2 pts. London: George Allen, 1884–85. Selections from *Modern Painters.*
On the Old Road: A Collection of Miscellaneous Essays, Pamphlets, etc., Published 1834–1885. Edited by Alexander Wedderburn. London: George Allen, 1885.
Praeterita. 28 pts, 2 vols. London: George Allen, 1885–89.
Coeli Enarrant. London: George Allen, 1885. Selections from *Modern Painters.*
Dilecta: Correspondence, Diary Notes, and Extracts from Books, Illustrating Praeterita. 2 pts. London: George Allen, 1886–87.

2. Diaries and Personal Letters
Bradley, John Lewis, ed. *The Letters of John Ruskin to Lord and Lady Mount-Temple.* Columbus: Ohio State University Press, 1964. Important letters relating to Rose La Touche.
————, ed. *Ruskin's Letters from Venice, 1851–1852.* New Haven: Yale University Press, 1955. Bradley sets the standard for editions of Ruskin's letters. These date from his second winter in Venice with Effie, during which he gathered material for the second and third volumes of *The Stones of Venice.*
Burd, Van Akin, ed. *The Ruskin Family Letters: The Correspondence of John James Ruskin, His Wife, and Their Son, John, 1801–1843.* 2 vols. Ithaca: Cornell University Press, 1973. Indispensable for an understanding of Ruskin's relationship with his parents.
————, ed. *The Winnington Letters: Ruskin's Correspondence with Margaret Alexis Bell and the Children at Winnington Hall.* London: George Allen & Unwin, 1969. Letters from 1858 to 1889.
Cate, George Allan, ed. *The Correspondence of Thomas Carlyle and John Ruskin.* Stanford: Stanford University Press, 1982.
Evans, Joan, and Whitehouse, John Howard, eds. *The Diaries of John Ruskin.* 3 vols. Oxford: Clarendon Press, 1956–59. Not the complete diaries, but an inadequately annotated selection.
Fleming, Albert, ed. *Hortus Inclusus.* London: George Allen, 1887. Charming letters mainly to Ruskin's Coniston neighbor Susan Beever.
James, Admiral Sir William. *The Order of Release: The Story of John Ruskin, Effie Gray and John Everett Millais Told for the First Time in Their Unpublished Letters.* London: John Murray, 1948. A biased, incomplete account of Ruskin's marriage, edited by Effie's grandson.
Links, Joseph G. *The Ruskins in Normandy: A Tour in 1848 with Murray's Handbook.* London: John Murray, 1968. A combination of letters and narrative.

Lutyens, Mary. *The Ruskins and the Grays*. London: John Murray, 1972.

————. *Effie in Venice: Unpublished Letters of Mrs. John Ruskin Written from Venice between 1849–1852*. London: John Murray, 1965.

————. *Millais and the Ruskins*. London: John Murray, 1967. Lutyens's three books (in the above order) trace the story of Ruskin's marriage through a combination of narrative and (many hitherto unpublished) letters.

————. "The Millais–La Touche Correspondence." *Cornhill*, no. 1051 (Spring 1967), pp. 1–18.

Norton, Charles Eliot, ed. *The Letters of John Ruskin to Charles Eliot Norton*. 2 vols. Boston: Houghton Mifflin, 1904. Norton omitted "passages too personal, too intimate . . . for publication"; however, this collection is an important record of Ruskin's intellectual development.

Shapiro, Harold, ed. *Ruskin in Italy: Letters to His Parents, 1845*. Oxford: Clarendon Press, 1972. Ruskin's first unaccompanied tour abroad, in preparation for *Modern Painters*, volume 2.

Spence, Margaret E., ed. *Dearest Mama Talbot: A Selection of Letters Written by John Ruskin to Mrs. Fanny Talbot*. London: George Allen & Unwin, 1966. Letters to one of the strongest supporters of the Guild of St. George.

Surtees, Virginia, ed. *Reflections of a Friendship: John Ruskin's Letters to Pauline Trevelyan, 1848–1866*. London: George Allen & Unwin, 1979. Include confidences about Ruskin's relationships with Effie and Rose La Touche.

————, ed. *Sublime & Instructive: Letters from John Ruskin to Louisa, Marchioness of Waterford, Anna Blunden and Ellen Heeton*. London: Michael Joseph, 1972. Letters to three disciples in the years 1853–64.

Unwin, Rayner, ed. *The Gulf of Years: Letters from John Ruskin to Kathleen Olander*. London: George Allen & Unwin, 1953.

Viljoen, Helen Gill, ed. *The Brantwood Diary of John Ruskin, Together with Selected Related Letters and Sketches of Persons Mentioned*. New Haven: Yale University Press, 1971. The diaries cover the years 1876–84. The background sketches are particularly useful.

————, ed. *The Froude–Ruskin Friendship as Represented through Letters*. New York: Pageant Press, 1966. Letters recounting an important relationship.

SECONDARY SOURCES

Biographical and critical writing about Ruskin is extensive. The best guide is Francis Townsend's chapter on Ruskin in *Victorian Prose: A Guide to Research*, ed. David J. DeLaura (New York: Modern Lan-

guage Association, 1973), pp. 221–48; however, much has been published on Ruskin since 1973. Annual bibliographies of Ruskin studies are published by the Modern Language Association and *Victorian Studies;* the second offers brief synopses of books and references to reviews as well as original writings. The *Ruskin Newsletter,* published by the Ruskin Association, is also of bibliographic value. The following list is highly selective:

Abse, Joan. *John Ruskin: The Passionate Moralist.* London: Quartet Books, 1980. A readable modern biography.

Alexander, Edward. *Matthew Arnold, John Ruskin, and the Modern Temper.* Columbus: Ohio State University Press, 1973. Compares the reactions of Arnold and Ruskin to "the crisis that gripped English thought and society between 1848 and 1867."

Ball, Patricia M. *The Science of Aspects: The Changing Role of Fact in the Work of Coleridge, Ruskin and Hopkins.* London: Athlone Press, 1971. Sees *Modern Painters* as a transition between Coleridge's and Hopkins's observation of natural fact.

Beetz, Kirk H. *John Ruskin: A Bibliography, 1900–1974.* Scarecrow Author Bibliographies, no. 28. Metuchen, N.J.: Scarecrow Press, 1976. Neither accurate nor complete.

Bell, Quentin. *Ruskin.* Edinburgh: Oliver & Boyd, 1963. A brief summary of Ruskin's work by a twentieth-century art critic.

Bradley, John L. *An Introduction to Ruskin.* Boston: Houghton Mifflin, 1971. A short but excellent introduction to Ruskin's work.

Burd, Van Akin, ed. *John Ruskin and Rose La Touche: Her Unpublished Diaries of 1861 and 1867.* Oxford: Clarendon Press, 1980. Burd's detailed introduction is the fullest account of Ruskin's relationship with Rose.

Clark, Kenneth. *Ruskin at Oxford: An Inaugural Lecture Delivered before the University of Oxford, 14 November 1946.* Oxford: Clarendon Press, 1947. Discusses the largely ignored subject of Ruskin's Slade lectures.

Clegg, Jeanne. *Ruskin and Venice.* London: Junction Books, 1981. The background and events of Ruskin's eleven visits to Venice.

Collingwood, R. G. *Ruskin's Philosophy: An Address Delivered at the Ruskin Centenary Conference, Coniston, August 8th, 1919.* Kendal: Titus Wilson, 1922. Reprinted in *Essays in the Philosophy of Art,* ed. Alan Donagan (Bloomington: Indiana University Press, 1964), pp. 3–41. An evaluation of Ruskin's thought by a major twentieth-century philosopher.

Collingwood, William Gersham. *The Life of John Ruskin.* 2 vols. London: Metheun, 1893. Available in various editions and reprints, the soundest of the early biographies.

Conner, Patrick. *Savage Ruskin*. Detroit: Wayne State University Press,
 1979. Investigates "Britain's most influential art critic as a *critic*—not
 as a theorist, but as a judge of paintings, architecture and society."
Cook, Edward Tyas. *The Life of John Ruskin*. 2d ed. 2 vols. London:
 George Allen, 1912. Based largely on biographical material in the in-
 troductions to the "Library Edition." A primary source, flawed by its
 author's adulation of his subject.
Dearden, James S. *Facets of Ruskin: Some Sesquicentennial Studies*. London:
 Charles Skilton, 1970. Miscellaneous essays intended to supplement
 standard biographical and critical studies.
————, ed. *The Professor: Arthur Severn's Memoir of John Ruskin*. London:
 George Allen & Unwin, 1967. A firsthand account of Ruskin's later
 years.
Evans, Joan. *John Ruskin*. London: Oxford University Press, 1954. A bi-
 ography, informed by Evans's study of the diaries; now superseded.
Fellows, Jay. *The Failing Distance: The Autobiographical Impulse in John Rus-
 kin*. Baltimore: Johns Hopkins University Press, 1975.
————. *Ruskin's Maze: Mastery and Madness in his Art*. Princeton: Prince-
 ton University Press, 1981. Fellows's two empathic accounts of Rus-
 kin's consciousness are difficult books that have antagonized some
 readers.
Fitch, Rayond E. *The Poison Sky: Myth and Apocalypse in Ruskin*. Athens,
 Ohio: Ohio University Press, 1982.
Garrigan, Kristine Ottesen. *Ruskin on Architecture: His Thought and Influ-
 ence*. Madison: University of Wisconsin Press, 1973. Argues that
 "Ruskin's approach to architecture was basically two dimensional . . .
 and ornamental."
Geddes, Patrick. *John Ruskin: Economist*. Round Table, ser. 3. Edinburgh:
 William Brown, 1934.
Harrison, Frederic H. *John Ruskin*. London: Macmillan, 1903. One of
 the best early evaluations of Ruskin's achievement.
Helsinger, Elizabeth K. *Ruskin and the Art of the Beholder*. Cambridge:
 Harvard University Press, 1982. A wide-ranging study of the influ-
 ence and intellectual context of Ruskin's thought.
Herrmann, Luke. *Ruskin and Turner: A Study of Ruskin as a Collector of
 Turner*. London: Faber and Faber, 1968.
Hewison, Robert. *John Ruskin: The Argument of the Eye*. Princeton: Prince-
 ton University Press, 1976. A perceptive introduction to Ruskin's
 work.
————, ed. *New Approaches to Ruskin: Thirteen Essays*. London: Routledge
 & Kegan Paul, 1981.
————. *Ruskin and Venice*. London: Thames & Hudson, 1978. The cata-
 log for a major exhibit of Ruskin's original art.

Holland, Faith M., and Hunt, John Dixon, eds. *The Ruskin Polygon: Essays on the Imagination of John Ruskin.* Manchester: Manchester University Press, 1982. A multidisciplinary collection of essays.

Hunt, John Dixon. *The Wider Sea: A Life of John Ruskin.* London: J. M. Dent & Sons, 1982. A biography informed by recent research; not, however, definitive.

Ladd, Henry Andrews. *The Victorian Morality of Art: An Analysis of Ruskin's Esthetic.* New York: Ray Long and Richard R. Smith, 1932. An attempt to systematize Ruskin's aesthetic theories. Superseded by Landow.

Landow, George P. *The Aesthetic and Critical Theories of John Ruskin.* Princeton: Princeton University Press, 1971. An indispensable study.

Leon, Derrick. *Ruskin: The Great Victorian.* 1949. Reprint. Hamden, Conn.: Archon Books, 1969. Until Abse and Hunt, the best modern biography.

McLaughlin, Elizabeth T. *Ruskin and Gandhi.* Lewisburg, Penn.: Bucknell University Press, 1973.

Pevsner, Nikolaus. *Ruskin and Viollet-le-Duc: Englishness and Frenchness in the Appreciation of Gothic Architecture.* London: Thames & Hudson, 1969. Places Ruskin in the context of European thought.

Quennell, Peter. *John Ruskin: The Portrait of a Prophet.* London: Collins, 1949.

Rhodes, Robert, and Janik, Del Ivan, eds. *Studies in Ruskin: Essays in Honor of Van Akin Burd.* Athens: Ohio University Press, 1982. Essays by a number of eminent Ruskinians.

Rosenberg, John D. *The Darkening Glass: A Portrait of Ruskin's Genius.* New York: Columbia University Press, 1961. An influential modern study.

Shaw, George Bernard. *Ruskin's Politics.* London: Ruskin Centenary Council, 1921. A 1919 lecture.

Sherburne, James Clark. *John Ruskin: Or, The Ambiguities of Abundance.* Cambridge: Harvard University Press, 1972. Argues the modernity of Ruskin's recognition that the potential of economic abundance in industrial society renders classical economic theories based on scarcity invalid.

Stein, Richard L. *The Ritual of Interpretation: The Fine Arts as Literature in Ruskin, Rossetti and Pater.* Cambridge: Harvard University Press, 1975. Links the transformation of the reader through art in *Modern Painters* with Ruskin's later social utopianism.

Stein, Roger Breed. *John Ruskin and Aesthetic Thought in America, 1840–1900.* Cambridge: Harvard University Press, 1967. A thorough study of Ruskin's influence in nineteenth-century America.

Sussman, Herbert L. *Fact into Figure: Typology in Carlyle, Ruskin and the*

Pre-Raphaelite Brotherhood. Columbus: Ohio State University Press, 1979. Traces Ruskin's influence on the "symbolic realism" of the Pre-Raphaelites.

Townsend, Francis. *Ruskin and the Landscape Feeling: A Critical Analysis of His Thought During the Crucial Years of His Life.* Illinois Studies in Language and Literature, no. 35. Urbana: University of Illinois Press, 1951. A study of the actual experience of landscape behind *Modern Painters* and later works.

Unrau, John. *Looking at Architecture with Ruskin.* Toronto: University of Toronto Press, 1979. A "simple concentrated survey of how Ruskin looked at buildings and how he interpreted what he saw."

Viljoen, Helen Gill. *Ruskin's Scottish Heritage: A Prelude.* Urbana: University of Illinois Press, 1956. The first volume of what would have been a definitive biography, had Viljoen lived to complete her work.

Walton, Paul H. *The Drawings of John Ruskin.* Oxford: Clarendon Press, 1972.

Whitehouse, John Howard. *Vindication of Ruskin.* London: George Allen & Unwin, 1950. A reply to James's *Order of Release.*

Wilenski, Reginald Howard. *John Ruskin: An Introduction to Further Study of His Life and Work.* 1933. Reprint. New York: Russell & Russell, 1967. The first modern study of Ruskin. Evaluates the relationship between his work and his mental disorder.

Index

DATE DUE

DEMCO 38-297